펴낸이 김기훈 김진희

펴낸곳 ㈜쎄듀/서울시 강남구 논현로 305 (역삼동)

발행일 2019년 11월 5일 제3개정판 1쇄

내용 문의 www.cedubook.com

구입 문의 콘텐츠 마케팅 사업본부

Tel. 02-6241-2007

Fax. 02-2058-0209

등록번호 제22-2472호

ISBN 978-89-6806-179-0

978-89-6806-178-3 (세트)

◆ Grammar is Understanding ◆

GRAMMAR Q

Advanced ❶

GRAMMAR Q
Advanced 1

지은이	김기훈, 쎄듀 영어교육연구센터
디렉터	오혜정
편집	라임나무
마케팅	콘텐츠 마케팅 사업본부
영업	문병구
제작	정승호
인디자인 편집	금호기획
디자인	윤혜영
일러스트	날램, 리지, 그림숲
영문교열	Adam Miller

Grammar Q 시리즈, 이렇게 바뀌었습니다.

대한민국 영어교육의 최전선에서 다년간 수많은 학생들을 지도해 오면서 얻은 교수 경험과 연구 성과를 바탕으로 만들어진 Grammar Q 시리즈는 출간 이후 우리나라 영어 학습 환경에 최적화된 교재로 자리매김하였습니다. 외국어로서의 진정한 영어 학습뿐만 아니라 효과적인 내신 대비를 위해 철저한 이론적 분석과 현직 교강사의 검토를 거쳐 만들어진 Grammar Q 시리즈가 더욱 알차게 바뀌었습니다.

새로워진 Grammar Q의 특징은 다음과 같습니다.

❶ 개정 교육과정 완벽 반영

개정 교육과정과 새로운 중학교 검정 교과서 10종을 연구하여 이를 토대로 Grammar Q의 수록 문법 규칙을 선정하였습니다. 개정 교육과정에 명시된 중학 수준에서 목표하는 문법 규칙을 모두 포함하고 있으며, 개정 후 중학 수준에서 배제되는 항목들은 중요도와 기출빈도를 고려하여 수록하였습니다.

● 기존 교육과정 ● 개정 교육과정

		초	중	고	수록 여부
If를 생략한 가정법	Had I had enough money, I would have bought a cell phone.		●	●	×
not A but B	He came not to complain, but to help us.		●	●	○

위와 같이 개정을 통해 중학교 교과과정에서 고등학교 교육과정으로 이동한 일부 문법 규칙은 중요도와 난이도, 기출빈도를 함께 분석하여 Grammar Q 시리즈에서 학습하기도 합니다.

❷ 최신 기출 유형 & 서술형 보강

전국의 중학교 1~3학년 내신 문법 문제를 취합·분석하여 신유형의 출제 경향을 반영했습니다. Unit마다 다양한 연습 문제 유형으로 문법 규칙을 바르게 이해하였는지 확인하고 실제와 유사한 수준의 최신 유형의 문제를 풀며 실전 감각을 키우도록 합니다. 또한, 서술형 문제의 중요도와 비율이 커지고 있음을 적극 반영하여 이를 충분히 연습할 수 있도록 구성했습니다.

❸ 자세하고 친절한 설명

영어 자체를 이해하는 데 방해가 되는 어려운 용어 사용을 지양하고, 지나치게 간결하고 딱딱한 개념 설명은 아주 쉽고 친절하게 풀어 썼습니다. 또한, 흥미롭고 유익한 예문을 통해 설명함으로써 어려운 영문법에 쉽게 접근할 수 있습니다.

모든 학습자들이 새로워진 Grammar Q 시리즈와 함께 진정한 이해를 바탕으로 영문법을 체득하기를 바라며, 여러분의 GQ(문법활용능력지수)가 쑥쑥 올라 학업에 큰 정진이 있기를 기원합니다.

저자

PREVIEW

01 기본 개념&용어 Review

• 학습을 시작하기 전에 주요 개념을 한 눈에 살펴보세요.

❶ 그림, Q&A, 도식과 같은 다양한 구성으로 기본 개념에 쉽게 접근

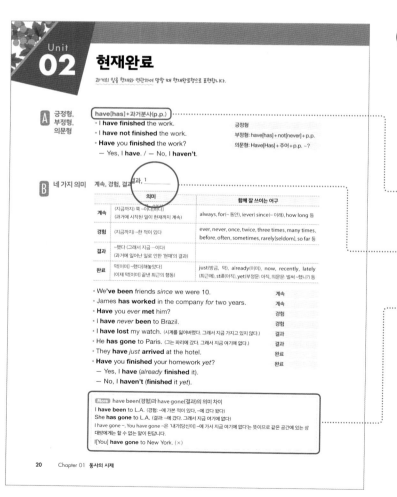

02 문법 개요

• 쉽고 친절한 설명과 실용적이고 자연스러운 예문으로 효과적인 학습이 가능해요.

❶ 문법 항목마다 이해를 돕기 위한 한 줄 핵심 요약

❷ 설명의 빈칸을 직접 채우며 공부할 수 있는 능동적 구성

❸ 놓치기 쉬운 심화 문법 포인트와 문제 풀이를 까다롭게 하는 주의 사항까지 학습

03 PRACTICE

- 신유형을 포함한 다양한 유형의 연습문제로
 학습 이해도를 확인합니다.

- 문제 난이도와 풀이 과정의 수준을 고려하여
 쉬운 문제부터 고난도 문제까지 단계적으로
 정복할 수 있도록 구성했습니다.

04 내신 적중 Point

- 최신 출제 경향을 반영한 포인트별 빈출 유형을 확인
 할 수 있습니다.

① 포인트별 대표 기출 문제에 대한 출제 의도와
 해결책 제시

PREVIEW

05 Overall Exercises

- 여러 문법 사항을 한데 통합한 문제로 실전에 대비합니다.

- 이전 챕터의 내용이 자연스럽게 반복되어 누적학습 효과를 보입니다.

06 Writing Exercises

- 영작을 통해 학습한 규칙을 적용해보세요.

- 시험에 꼭 나오는 서술형 문제로 완벽한 내신 대비가 가능합니다.

- 서술형을 포함한 다양한 유형의 추가 문제로 충분한 연습과 복습을 할 수 있습니다.

학습을 돕는 다양한 무료 부가 학습자료

www.cedubook.com에서 다운로드 하세요.

1. 어휘리스트

2. 어휘테스트

3. 예문응용문제

4. 예문영작연습지

5. 예문해석연습지

6. 서술형 추가문제

7. 종합평가

8. Study Planner

CONTENTS

Advanced 1

[책속책] WORKBOOK
정답 및 해설

Advanced 2

CHAPTER

01

동사의 시제

| 기본 개념 & 용어 Review |

동작이나 상태가 언제 일어나는지를 나타내기 위해 동사의 형태를 바꾸거나
조동사 등을 이용하여 시제를 표현해요.

현재시제 동사원형(+(e)s)

과거시제 동사의 과거형

미래시제 will+동사원형, be going to+동사원형, be about to+동사원형, be+ -ing

진행형 be동사+ -ing

현재완료 have[has]+과거분사(p.p.)

과거완료 had+과거분사(p.p.)

각각의 의미와 같이 자주 쓰이는 부사(구)를 알아두면 좋아요.
또, 하나의 시제가 여러 의미를 나타낼 수 있음에 유의해요.

Unit 01 현재·과거·미래시제와 진행형

동작이나 상태가 언제 일어난 것인지를 나타내기 위해 동사의 형태를 변화시키거나 조동사 등을 이용해요.

A 현재시제

❶ 동사원형을 씀

단, she, he, it 등의 3인칭 단수 주어는 「동사원형+(e)s」을 쓰고, be동사는 am/are/is, have동사는 have/has를 씁니다. 의미는 크게 세 가지예요.

• I'm 15 years old.	현재 상태/동작
• I go and watch movies every weekend.	습관, 반복적 행동
• The Earth goes around the Sun.	일반적 사실, 진리, 격언

❷ 시간·조건을 뜻하는 절에서는 '미래'의 의미

when, before/after, as soon as, till/until, by the time, every time, whenever, if, unless 등이 이끄는 부사절에서 현재시제가 미래를 대신해요.

• I'll call you *as soon as* I **get** the news.	시간
• *If* it **rains**, we'll take a taxi.	조건

> **More** 현재시제가 미래를 나타내는 또 다른 경우
>
> 확실히 정해진 일정과 관계되는 동사(come, go, leave, arrive, begin, start, finish, end 등)는 가까운 미래를 나타내는 어구와 함께 쓰여 1_____로 미래를 나타낸답니다.
>
> The train **leaves** *in 15 minutes*.

B 과거시제

동사의 과거형

be동사는 was/were를, have동사는 had를 씁니다.

• I **was** at the library last night.	과거의 상태, 동작
• He **had** a short walk after lunch.	
• World War Ⅱ **ended** in 1945.	역사적 사실

C 미래시제

미래를 나타내는 2_____나 미래를 나타내는 표현 사용

• I **will** *be* fifteen years old next year.	시간이 지나면 자연히 그렇게 되는 것
• All right. I **will** *do* it.	화자의 의지
• He **is going to** *attend* the meeting tomorrow.	~할 예정이다
• It's 11 p.m. and I'm **about to** *go* to bed.	막 ~하려던 참이다
• I'm **entering** the university next month.	가까운 미래의 예정: ~할 것이다

D 진행형

❶ am/are/is+-ing (~하고 있다)

- She **is making** dinner now.
- I**'m taking** piano lessons this semester.
- People **are retiring** earlier these days.
- Bill **is coming** tomorrow.
- He**'s** *always* **complaining**.

현재 진행 중인 동작

제한된 기간 동안 진행되는 동작

최근의 경향: ~하고 있다

가까운 미래의 예정: ~할 것이다

습관: 언제나 ~하다

*화자의 불만을 나타내며 보통 always, all the time 등의 부사구와 함께 쓰인다.

❷ was/were+-ing (~하고 있었다)

- I **was studying** when you called me yesterday.

과거에 진행 중이었던 동작

E 진행형으로 쓰지 않는 동사

'~하고 있다'라는 ³＿＿＿＿＿, 계속의 의미를 이미 담고 있는 동사

- He **loves** you.
- You **see** her painting, don't you?
- Ted **has** a big family.
- This car **belongs to** my dad.

감정: 사랑하고 있다

감각: 보고 있다

소유: 가지고 있다

소유: ~의 것이다

진행형을 만들 수 없는 동사

감정	like, love, prefer, hate 등
감각	see, hear, smell, feel(~하게 느껴지다), taste(~한 맛이 나다) 등
소유	have, belong to(~에 속하다), own, possess(~을 소유하다) 등
상태	be, want, need, seem, look(~처럼 보이다) 등
인식	know, remember, understand, think(~라고 생각하다) 등

위와 다른 뜻이거나 일시적인 동작·상태임을 강조할 때는 같은 동사라도 진행형을 쓸 수 있어요.

She **is tasting** the food.　　　　　(~을 맛보고 있다)
We **are having** a good time.　　　　(~을 보내고 있다)
I**'m having** a nice meal.　　　　　　(~을 먹고 있다)
He**'s having** difficulty with money.　(~을 경험하고 있다)
I**'m thinking** about the problem.　　(~을 생각하고 있다)

PRACTICE

STEP 1

괄호 안에 주어진 동사를 빈칸에 알맞게 〈보기〉의 시제 중 하나로 바꿔 쓰세요.

〈보기〉	현재형	현재진행형	과거형	과거진행형

1 These days, I _____ to school for the exercise. (walk)

2 I _____ the book the other day, and I look forward to reading it. (receive)

3 Most of us already know that water _____ ice at 0℃. (become)

4 A: Charlie, can't you hear the phone? Answer it!
B: Will you get it? I _____ _____ my favorite TV show. (watch)

5 The first World Cup _____ held in 1930 in Montevideo, Uruguay. (be)

6 I first _____ this song when I was about 13 years old. (hear)

7 While I _____ _____ my car yesterday, I discovered the small scratch. (wash)

8 I was crying because of the pain, but he _____ me feel comfortable right away. (make)

STEP 2

밑줄 친 동사가 실제로 나타내는 때를 〈보기〉에서 골라 그 기호를 쓰세요.

〈보기〉	ⓐ 현재	ⓑ 현재진행	ⓒ 미래

1 My father works in a hotel as a chef.

2 We leave for Daegu in an hour.

3 This year, my grandparents are coming to see us on Christmas.

4 Jane can't hear me because she is listening to music.

5 This class consists of students between the ages of 13 and 15.

6 If you take the subway, you will get there on time.

7 The concert starts at 4 p.m. Please don't be late!

STEP
3

괄호 안에서 문맥과 어법에 맞는 것을 고르세요.

1 He drinks a cup of coffee before he [went / goes / will go] to work.

2 I will wait here until the concert [was / is / will be] over.

3 Linda had to choose between art and math for her major. She finally [chose / chooses / will choose] math and she enjoys her studies now.

4 A: We are moving this weekend because we found a great apartment on 45th Street.
B: That's terrific. I [helped / help / will help] you on moving day if you want.

5 As we arrived in Seoul, the beauty of the city became more clear. We crossed over the Han River, which [flew / flows / will flow] through the city.

6 Before you [began / begin / will begin] to study, get some exercise. It will be good for you.

STEP
4

밑줄 친 부분이 어법상 바르면 ○표를 하고, 틀리면 바르게 고치세요.

1 She <u>was tasting</u> the soup to see if it needed more salt.

2 Tim <u>is having</u> trouble with his car, so he has to take the bus to work today.

3 This bag is not mine. It <u>is belonging to</u> my sister.

4 Thank you for your kind explanation. Now I <u>am understanding</u> that lesson.

5 A: Did you hear what I just said?
B: Sorry. I <u>was thinking</u> about something else.

PRACTICE

STEP 5

다음 물음에 알맞은 답을 고르세요.

1 다음 중 밑줄 친 동사가 미래를 나타내는 문장을 <u>모두</u> 고른 것은?

> ⓐ Our flight <u>departs</u> in half an hour.
> ⓑ Look at those dark clouds. When class <u>is</u> over, it will probably rain.
> ⓒ Watch out! A car <u>is coming</u>.

① ⓐ, ⓑ ② ⓑ, ⓒ ③ ⓒ

④ ⓐ, ⓒ ⑤ ⓐ, ⓑ, ⓒ

2 다음 중 밑줄 친 동사가 나타내는 때가 나머지 넷과 <u>다른</u> 하나는?

① Hurry up! They <u>are waiting</u> for you.

② We <u>are spending</u> next weekend at home.

③ I <u>am looking</u> at Janet. She looks angry.

④ The police helicopter <u>is flying</u> overhead in circles.

⑤ He <u>is having</u> a good time with his friends now.

STEP 6

우리말과 뜻이 같도록 괄호 안의 단어를 이용하여 문장을 완성하세요. (단, 굵게 표시한 단어의 형태를 변화시킬 수 있음)

1 밖을 봐! 눈이 내리고 있어. 모든 것이 새하얘. (**snow**, it)

→ Look outside! _____ Everything is white.

2 그들은 우리의 새 학교 도서관을 짓는 중이다. (new, **build**, they, our, library, school)

→ _____

3 아들이 잠들었을 때 Susan은 이야기를 읽어주던 중이었다. (a story, **read**, her, son)

→ _____ when he fell asleep.

4 수업이 끝나면 내게 알려줘. 집에 같이 가자. (**be**, class, when, over)

→ Let me know _____. Let's go home together.

내신 적중 Point

Point 01 어법상 바른 문장 찾기
동사의 시제와 실제 나타내는 때가 맞는지 문장을 해석해서 확인하세요.

Point 02 어법상 틀린 문장 찾기
때를 나타내는 부사(구)와 동사의 시제가 맞는지 확인하세요.

Point 03 우리말에 맞게 문장 완성하기
기본 형태로 주어진 동사를 주어와 때에 맞게 올바른 형태로 바꾸세요.

정답 및 해설 p.2

Point 01 ● 다음 중 밑줄 친 부분이 어법상 바른 문장은?

① When he <u>saw</u> me, he always asks about my family.
② After he <u>finishes</u> dinner, he watched TV.
③ I'll go back home when I <u>complete</u> my studies.
④ My father often <u>takes</u> me to the zoo in my childhood.
⑤ She <u>spills</u> some milk on her skirt when she fell down.

Point 02 ● 다음 중 어법상 **틀린** 문장은?

① Hurry up! The bus is coming.
② I'm taking piano lessons this year.
③ It was raining when I left the house this morning.
④ Jack wasn't at home. He is studying at the library then.
⑤ We watched TV while he was sleeping last night.

Point 03

서술형 ▶
● 다음 우리말과 뜻이 같도록 주어진 단어를 이용하여 문장을 완성하세요.
(단, 굵게 표시한 단어의 형태를 변화시킬 수 있음)

> 네 바이올린 레슨이 끝나면 같이 축구하자. (**be**, your violin lesson, when, over)

→ _____, let's play soccer together.

Unit 02 현재완료

과거의 일을 현재와 연관하여 말할 때 현재완료형으로 표현합니다.

A 긍정형, 부정형, 의문형

have[has]+과거분사(p.p.)

• I **have finished** the work.
• I **have not finished** the work.
• **Have** you **finished** the work?
— Yes, I **have**. / — No, I **haven't**.

긍정형

부정형: have[has]+not[never]+p.p.

의문형: Have[Has]+주어+p.p. ~?

B 네 가지 의미

계속, 경험, 결과, [1] _____

의미		함께 잘 쓰이는 어구
계속	(지금까지) 쭉 ~이다[하다] (과거에 시작된 일이 현재까지 계속)	always, for(~ 동안), (ever) since(~ 이래), how long 등
경험	(지금까지) ~한 적이 있다	ever, never, once, twice, three times, many times, before, often, sometimes, rarely[seldom], so far 등
결과	~했다 (그래서 지금 …이다) (과거에 일어난 일로 인한 '현재'의 결과)	
완료	막[이미] ~했다[해놓았다] (이제 막[이미] 끝낸 최근의 행동)	just(방금, 막), already(이미), now, recently, lately (최근에), still(아직), yet(부정문: 아직, 의문문: 벌써 ~했니?) 등

• We**'ve been** friends *since* we were 10. — 계속
• James **has worked** in the company *for* two years. — 계속
• **Have** you *ever* **met** him? — 경험
• I **have** *never* **been** to Brazil. — 경험
• I **have lost** my watch. (시계를 잃어버렸다. 그래서 지금 가지고 있지 않다.) — 결과
• He **has gone** to Paris. (그는 파리에 갔다. 그래서 지금 여기에 없다.) — 결과
• They **have** *just* **arrived** at the hotel. — 완료
• **Have** you **finished** your homework *yet*? — 완료
— Yes, I **have** (*already* **finished** it).
— No, I **haven't** (**finished** it *yet*).

> **More** have been(경험)과 have gone(결과)의 의미 차이
> I **have been** to L.A. (경험: ~에 가본 적이 있다, ~에 갔다 왔다)
> She **has gone** to L.A. (결과: ~에 갔다. 그래서 지금 여기에 없다)
> I have gone ~, You have gone ~은 '내가[당신이] ~에 가서 지금 여기에 없다'는 뜻이므로 같은 공간에 있는 상대방에게는 할 수 없는 말이 된답니다.
> I[You] **have gone** to New York. (×)

C 현재완료와
과거시제의
차이

과거시제: 과거에 이미 끝난 일 / 현재완료: 과거 일이 현재까지 계속되거나 영향을 줌

현재완료는 과거에 일어난 일이 '현재'의 의미를 어느 정도 포함하고 있으므로 명백한 2_____ 시점을 나타
내는 표현(yesterday, 「last+시간」, 「기간+ago」, 「in+(과거) 연도」, just now(조금 전), When ~? 등)과 같이
쓸 수 없어요.

* Eric **was** a teacher *in 2018*. (Eric may not be a teacher now.)
* Sandy **has been** a nurse *for 5 years*. She likes to help others.
 (Sandy is a nurse now.)

D 현재완료
진행형

have[has] been+-ing: ~해 오고 있다, ~하고 있는 중이다

과거에 시작한 동작이 3_____까지 계속 진행되고 있음을 뜻합니다. have, has는 줄여서 -'ve, -'s로 나타내
기도 해요.

* We **have been discussing** the matter all evening.	긍정형
* It **has not been raining** since last Saturday.	부정형
* How long **have** you **been waiting** for him?	의문형
— I**'ve been waiting** for him for 5 hours.	I have = I've

E 현재완료와
현재완료
진행형

❶ 동사가 '계속'의 의미를 담고 있을 때는 의미 차이 없음
* It**'s been raining** since last Saturday.
 = It**'s rained** since last Saturday.

❷ 현재완료 진행형을 쓰면 '계속'의 의미가 강조됨
* I **have studied** English for ten years.
* I **have been studying** English for ten years.

PRACTICE

STEP 1 굵은 글씨로 된 현재완료의 의미를 〈보기〉에서 골라 그 기호를 쓰세요.

> 〈보기〉 ⓐ 계속: 지금까지 쭉 ~이다[하다]
>
> ⓑ 경험: (지금까지) ~한 적이 있다
>
> ⓒ 결과: ~했다 (그래서 지금 …이다)
>
> ⓓ 완료: 막[이미] ~했다[해놓았다]

1 The last bus **has** just **left**.

2 She **has gone** to London.

3 We **have** already **finished** dinner.

4 I**'ve studied** Chinese for five years.

5 He **has been** ill since last week.

6 I **have eaten** durian before.

7 Peter **has lost** some weight and now looks better than ever.

8 **Have** you ever **lived** in a cave house?

9 How long **have** you **stayed** in China?

10 I **have** already **sent** you an e-mail this morning. Did you get it?

11 It **has been** a long time since we last met.

12 I **have** never **met** a famous movie star.

STEP 2 괄호 안에서 문맥과 어법에 맞는 것을 고르세요.

1 I knew Tim when he was a child, but I [didn't see / haven't seen] him for many years.

2 Last January, I [have seen / saw] snow for the first time in my life.

3 Since Korea manufactured its first car in 1955, it [grew / has grown] to be one of the most advanced automobile-producing countries in the world.

4 I have been waiting for Jane since noon, but she still [didn't show / hasn't shown] up.

5 Anton [played / has played] the violin with the London Symphony for seven years now. When he was ten, he [played / has played] Beethoven's Violin Concerto for the first time in his life.

STEP 3 다음 문장에서 밑줄 친 부분을 어법에 맞게 고치세요.

1 Rebecca enjoys writing since she wrote her first book.

2 I've been to Busan three times, but Jisu has never been being there.

3 Today is the day I was in Seoul for exactly two years.

4 Marie has been to a theater to see a play, so she is not here now.

5 Jim first has gone bungee jumping when he was 20.

6 He is a good tennis player. He played tennis since he was seven.

STEP 4 현재완료 진행형을 이용하여 주어진 두 문장을 한 문장으로 바꿔 쓰세요.

1 She started doing yoga two hours ago.
She is still doing yoga now.
→ She _____.

2 They started talking on the phone almost an hour ago.
They are still talking on the phone now.
→ They _____.

3 It started raining five hours ago.
It is still raining now.
→ It _____.

4 Suho started learning ballet ten years ago.
He is still learning ballet now.
→ Suho _____.

STEP 5

다음 대화 중 어법과 문맥상 바르지 <u>않은</u> 것은?

① A: Did you watch the soccer game last night?
B: Sure! It was the best game I've ever seen.

② A: I'll introduce you to my brother at the party tonight.
B: You don't need to. I have already met him.

③ A: Go back to sleep. It's only six o'clock in the morning.
B: I have already slept for eight hours. I'm going to get up.

④ A: It's midnight. Aren't you going to bed?
B: I'll go to bed now. I have just finished my homework.

⑤ A: Have you seen Jenny lately? I haven't seen her for months.
B: Didn't she tell you? She's been to Busan to start a new job.

STEP 6

우리말과 뜻이 같도록 괄호 안의 단어를 이용하여 문장을 완성하세요. (단, 동사 형태를 변화시킬 수 있음)

1 너는 여기 온 후에 얼마나 많은 사람들을 만났니? (meet, since, come here)

→ How many people _____?

2 우리는 10년 동안 친구로 지내왔다. (be, friends, for ten years)

→ We _____.

3 그는 최근에 소설 한 권을 쓰겠다는 계약에 서명했다. (recently, sign, a contract)

→ He _____ to write a novel.

4 그는 그 가방을 지금 갖고 있지 않다. 그는 그것을 Tim에게 선물로 주었다. (give, to Tim)

→ He doesn't have the bag now. He _____
as a gift.

5 아빠가 4시부터 저녁식사를 만들고 있는 중이다. (cook, dinner)

→ My dad _____.

6 그녀는 이전에 해외로 여행한 적이 전혀 없어서, 여름 휴가를 호주에서 보낸다는 것에 신이 나 있다.
(travel, abroad, before)

→ She _____, so she's excited to
spend her summer vacation in Australia.

Unit 02

내신 적중

Point

Point 01 빈칸에 들어갈 알맞은 말 찾기
현재완료와 현재완료 진행형은 과거에 한 일이 현재까지 이어질 때 씁니다.

Point 02 그림의 상황에 맞게 문장 완성하기
그림이 나타내는 시간의 흐름에 따라 시제를 판단하세요.

Point 01

● 빈칸 (A)와 (B)에 들어갈 말로 바르게 짝지어진 것은?

> • It _____(A)_____ since the day before yesterday.
> • Jack _____(B)_____ to New Zealand. I miss him.

	(A)		(B)
①	has rained	······	has been
②	rained	······	has been
③	is raining	······	has gone
④	has been raining	······	has gone
⑤	rains	······	went

Point 02

서술형 ▶

● 그림을 보고 괄호 안에 주어진 표현을 사용하여 문장을 완성하세요.
(단, 동사 형태를 변화시킬 수 있음)

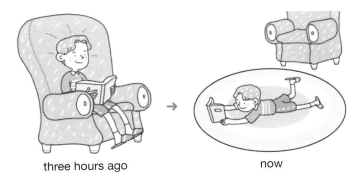

three hours ago → now

(read, a book, for)

→ Eric _____.

Unit 03 과거완료

과거에 일어난 어떤 일을 기준으로 그 전에 일어난 일을 나타낼 때 씁니다.

A 긍정형, 부정형, 의문형

1 _____+과거분사(p.p.)
had는 줄여서 -'d로 나타내기도 해요. had 다음에 p.p.가 아닌 다른 형태를 쓰지 않도록 주의하세요.

• When I arrived, the plane **had left**. 　　　　　긍정형

• He **had never played** basketball before he was 　　부정형: had+not[never]+p.p.
twelve.

• **Had** she **been** there a day or a week? 　　　　의문형: Had+주어+p.p. ~?

B 네 가지 의미

계속, 경험, 결과, 완료

과거의 어떤 때까지, 어떤 일의 그 이전부터의 계속, 경험, 완료, 결과를 나타내요. 현재완료와 마찬가지로 for(~ 동안), since(~ 이래), ever, never, already, just, until then 등의 표현과 자주 쓰이죠.

의미	
계속	(과거의 어떤 때까지, 과거의 어느 기간 동안) 쭉 ~였다[하고 있었다]
경험	(과거의 어떤 때까지) ~한 적이 있었다
결과	~했다 (그래서 과거의 어떤 때에 …였다)
완료	(과거의 어떤 때에) 막[이미] ~했다[해놓았었다]

• The trees **had grown** *since* I last saw them. 　　　계속

• When I met her, she **had been** on a diet *for* five months. 　계속

• He **had** never **been** abroad *before* he entered university. 　경험

• He **had lost** some weight but looked healthy. 　　결과

• I told her that I **had** *just* **finished** my homework. 　완료

C 과거 일보다 더 과거의 일

먼저 일어난 일(대과거)임을 확실히 알려줌

• John **went** to bed *when the phone rang*.

• John **had gone** to bed *when the phone rang*.

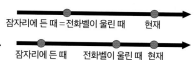

잠자리에 든 때＝전화벨이 울린 때　　현재

잠자리에 든 때　전화벨이 울린 때　현재

> **More** 먼저 일어난 일을 그냥 과거시제로 표현하는 경우
>
> I woke up early and went for a walk. 같은 문장에서는 woke up이 went for a walk보다 먼저 일어난 것이 확실하므로 굳이 had woken up로 표현하지 않아요. 또한 before, **2 _____** 등이 있어 시간 순서를 명확히 알 수 있을 때에도 그냥 과거시제로 표현하는 경우가 많습니다.
>
> He **went** shopping at the local market *after* he **visited** the museum. (○)

PRACTICE

STEP 1

굵은 글씨로 된 과거완료의 의미로 알맞은 것을 〈보기〉에서 골라 그 기호를 쓰세요.

〈보기〉 ⓐ 계속: (~ 때까지) 쭉 ~였다[하고 있었다] ⓑ 경험: (~ 때까지) ~한 적이 있었다

ⓒ 결과: ~했다 (그래서 ~때 ...였다) ⓓ 완료: (~ 때) 막[이미] ~했다[해놓았었다]

1 The last train **had** just **left** when we got out of the taxi.

2 Before Amy won the writing contest, she **had** never **won** any kind of contest.

3 I thought that he **had slept** until then.

4 Suji arrived home safely but found that she **had lost** her key.

5 Jason offered to introduce me to Professor Kim, but it wasn't necessary. I **had met** her before.

6 I handed Betty the newspaper, but she said that she **had** already **read** it at breakfast.

7 By the time Lisa unlocked the door and got into her apartment, the phone **had stopped** ringing.

STEP 2

괄호 안에 주어진 단어를 빈칸에 알맞은 형태로 바꿔 쓰세요.

1 She lost the necklace that I _____ (give) her last year as a birthday gift.

2 He couldn't buy a new car because he _____ (spend) all his money on gambling.

3 Dinosaurs _____ (go) extinct when humans first appeared.

4 They had lived in the house for nearly ten years when their son _____ (be) born.

5 A: How was Nicky? She _____ (be) ill for a week when I last _____ (meet) her.

 B: Oh, she is fine now.

STEP 3 다음 물음에 알맞은 답을 고르세요.

1 다음 중 밑줄 친 부분이 어법상 바른 문장은?

① He still remembered that I have broken his window.

② She has been ill for three weeks before I came back.

③ I had been with my company for six years today.

④ We rushed to the station, but the train had already left.

⑤ She has been reading for three hours when I got to her place yesterday.

2 주어진 문장과 밑줄 친 부분의 쓰임이 같은 것은?

> The girl said that she hadn't seen a tiger before.

① The ship had just left when we arrived at the port.

② I had never heard of the rumor until then.

③ My uncle had gone to Tokyo, so I didn't meet him.

④ I had stayed at the hotel for a week by the time you arrived.

⑤ Mr. Park was no longer there. He had moved to his hometown.

STEP 4 우리말과 뜻이 같도록 괄호 안의 단어를 이용하여 문장을 완성하세요. (단, 동사 형태를 변화시킬 수 있음)

1 나는 잠을 충분히 잤기 때문에 어제 피곤하지 않았다. (sleep, enough)

→ I didn't feel tired yesterday because I _____.

2 그녀는 친구가 오기 전에 가게 주인과 잠시 이야기했었다. (talk with, a shopkeeper, for a while)

→ She _____ before her friend came.

3 어제 너랑 이 영화를 보았을 때 나는 그것을 세 번째 보는 거였어. (watch, this movie, three times)

→ I _____ when I saw it with you yesterday.

4 Anna와 David는 지난달에 결혼한 지 30년이 되었다. (be married, for thirty years)

→ Anna and David _____ last month.

내신 적중 Point

Point 01 단락에서 어법에 맞는 것들 찾기

과거의 두 가지 일 중 과거나 과거완료로 써야 하는 것이 있는지 확인해요.

Point 02 틀린 부분 고쳐서 문장 다시 쓰기

after, before 등이 쓰인 절의 시제를 확인해요.

정답 및 해설 p.3

Point 01

● (A), (B), (C)의 각 네모 안에서 어법에 맞는 것끼리 짝지어진 것은?

> I got back to Daejeon very late at night. When I finally (A) got / had gotten home, everybody except Mom had already gone to bed. I gave Mom the box my friend's mother (B) gave / had given to me. When she (C) opened / has opened it, she was surprised to see that it was full of cookies. How kind!

	(A)		(B)		(C)
①	got	gave	opened
②	got	had given	opened
③	got	gave	has opened
④	had gotten	had given	opened
⑤	had gotten	gave	has opened

Point 02

서술형 ▶

● 다음 우리말과 뜻이 같도록 어법상 틀린 부분을 고쳐서 문장을 다시 쓰세요.

> 그들은 파티가 시작된 후에 도착했다.
> They arrived after the party has begun.

→ _____

Overall Exercises 01

[1-4] 다음 중 빈칸에 알맞은 것을 고르세요.

1
> I started to play the drums in the school band three years ago. I _____ the drums for three years.

① plays　　　　　② played
③ was playing　　④ have played
⑤ had played

2
> My dad _____ dinner when we came home.

① prepares　　　　② is preparing
③ was preparing　④ will prepare
⑤ will be preparing

3
> When I _____, I will be an animal doctor and take care of all kinds of animals.

① grow up　　　　② grew up
③ will grow up　　④ have grown up
⑤ am growing up

4
> I _____ such a beautiful beach before I went to Bali.

① see　　　　　　② don't see
③ will see　　　　④ had never seen
⑤ have never seen

[5-7] 다음 대화의 빈칸에 알맞은 것을 고르세요.

5
> A: Do you have the key? I can't find it.
> B: I don't have it. I _____ it to you yesterday!

① give　　　　　　② am giving
③ gave　　　　　　④ have given
⑤ have been giving

6
> A: I'm so sorry. I forgot to bring the book I _____ from you.
> B: That's okay. I don't need it now.

① borrow　　　　　② borrowed
③ will borrow　　　④ have borrowed
⑤ had borrowed

7
> A: Why don't you call your sister and ask her to join us?
> B: Not now! She _____ on the phone for almost an hour!

① is　　　　　　　② was
③ will be　　　　　④ has been
⑤ had been

8 다음 문장에서 어법상 틀린 곳을 찾아 바르게 고치세요.

> If it will snow, we will go skiing.

_____ → _____

[9-11] 다음 중 밑줄 친 부분이 어법과 문맥상 바른 문장을 고르세요.

9
① My sister has already gone with my shoes on before I woke up.
② If my team will win this game, we can reach the final.
③ I am leaving now. See you tomorrow.
④ I have called her before I left.
⑤ Eric seems happy today. He was smiling all the time.

10
① Get your healthy meal before the soccer match will start.
② I have never been to N Seoul Tower before I was sixteen.
③ I have been waiting for his reply since last week.
④ We have played baseball a few hours ago.
⑤ Every time a traffic light will turn red, you should stop.

11
① It is often said that time flew like an arrow.
② While we are eating, George stopped by to visit us.
③ He is watching the news when he heard the doorbell ring.
④ When I arrived in the city center, I found it crowded with people.
⑤ As soon as the phone rang last night, Matt had run out of his room.

[12-13] 다음 빈칸 (A)와 (B)에 들어갈 말로 바르게 짝지어진 것을 고르세요.

12
A: I feel terrible. I _____(A)_____ a cold for two weeks.
B: It's May! No one catches a cold in May!
A: I _____(B)_____ to Spain two weeks ago. I think I caught it on the plane.

	(A)		(B)
①	had	have gone
②	had	go
③	have	had gone
④	have had	have gone
⑤	have had	went

13
• As I _____(A)_____ yesterday, you have a terrific talent for writing.
• He _____(B)_____ for seven years when his first child was born.

	(A)		(B)
①	said	has been married
②	said	had been married
③	had said	has been married
④	have said	had been married
⑤	have said	has been married

14 **밑줄 친 부분을 바르게 고쳐 쓰세요.**

A: Have you ever saw round roofs that look like big doughnuts?
B: Yes. In a city in southern China.

→ _____

[15-16] 다음 밑줄 친 부분 중 어법상 틀린 것을 고르세요.

15

A: ① Did you play a musical instrument when you ② were young?
B: Yes, I ③ played the piano for ten years now. But I ④ am not good at it.
A: I hope I can ⑤ hear you play the piano someday.

16

A: I ① can't stand Patricia. She always ② messed up my room.
B: That's a problem. You ③ should talk to her about that.
A: I ④ have told her several times, but she ⑤ doesn't listen to me.

17 어법상 바른 문장을 모두 고른 것은?

ⓐ I have bought a new cell phone a week ago.
ⓑ My aunt has been in London for 10 years.
ⓒ His mother said he was sleeping in his room.
ⓓ Early Egyptians believed that the sun rose in the east.

① ⓐ, ⓑ ② ⓑ, ⓒ ③ ⓒ, ⓓ
④ ⓐ, ⓓ ⑤ ⓑ, ⓒ, ⓓ

[18-19] 다음 대화를 읽고 물음에 답하세요.

A: Good morning, Sally. Are you ready for your surgery?
B: Yes, Dr. Jang, I ⓐ haven't had anything to eat or drink since last night.
A: Good girl. Now, is there anything you would like to ask me?
B: Yes, I'm a little scared. What if there is a lot of pain after the surgery?
A: You should tell me or one of the nurses if it _____ⓑ_____, and we'll give you a painkiller right away.

*painkiller: 진통제

18 위 대화의 밑줄 친 ⓐ와 쓰임이 같은 것은?

① They have already had dinner.
② I have lost my wallet on the bus.
③ I have eaten an ostrich egg before.
④ Since then, we have been best friends.
⑤ I have never seen such a long bridge.

19 위 대화의 빈칸 ⓑ에 들어갈 말로 알맞은 것은?

① hurt very badly
② hurts very badly
③ will hurt very badly
④ has hurt very badly
⑤ never hurt very badly

20 다음 두 문장을 한 문장으로 바꿔 쓸 때 빈칸에 알맞은 말을 쓰세요.

• Suji started to learn Chinese seven months ago.
• She is still learning Chinese these days.

→ Suji _____
Chinese for seven months.

Writing Exercises

1 다음 우리말과 같은 뜻이 되도록 괄호 안의 단어를 이용하여 문장을 완성하세요.

(1)
우리는 해가 지기 전에 집에 도착했다. (reach)

→ We _____
 before the sun set.

(2)
나는 내 개인 블로그를 3년째 업데이트해 오고 있다.
(update, my personal blog)

→ I _____

_____ .

2 다음 우리말과 같은 뜻이 되도록 괄호 안의 단어를 바르게 배열하세요. (필요한 경우, 동사의 형태를 바꿀 것)

(1)
너는 긍정적 사고의 힘에 대해 들어본 적이 있니?
(you, hear, have, ever, the power of, positive thinking, of)

→ _____

(2)
내가 어제 그를 만났을 때 그는 이미 그 책을 읽었다.
(have, already, read, when, I, yesterday, meet, him, the book)

→ He _____

_____ .

3 다음 그림의 내용과 일치하도록 문장을 완성하세요.

→ The article said that _____

_____ .

4 다음 문장에서 어법상 틀린 부분을 고쳐 문장을 다시 쓰세요.

Tim was late for the meeting because he has missed the train.

→ _____

5 다음 우리말과 같은 뜻이 되도록 〈조건〉에 맞게 문장을 쓰세요.

〈조건〉
• sleep, all afternoon을 포함하되 필요하면 단어를 변형할 것
• 총 7단어로 쓸 것

나의 형은 오후 내내 자고 있는 중이다.

→ _____

CHAPTER

02

수동태

| 기본 개념 & 용어 Review |

주어는 보통 동작을 직접 한다고 알고 있지만, 주어가 동작을 당하는 것일 때가 있어요.

I **opened** the door. 나는 문을 **열었다**.

The door **was opened** by me. 문이 나에 의해 **열렸다**.

이러한 경우 수동태를 사용하는데, 형태는 시제와 문장 형식에 따라 달라진답니다.

수동태의 의미와 형태

주어가 동작을 직접 하는 것이 아니라 누군가에게 동작을 당하는 것일 때는 동사 형태가 달라져요.

A 능동태와 수동태

주어가 동사의 동작을 하면 능동태, 동작을 당하면 [1]_____

* My mother **made** this bag. 능동태: 엄마가 만드심
* This bag **was made** by my mother. 수동태: 가방은 만들어진 것

> **More** 수동태를 쓰는 경우
> • 동작을 하는 쪽보다 받는 쪽을 더 강조하여 주어로 하고 싶을 때
> My father made *this desk*. → *This desk* **was made** by my father.
> • 동작을 하는 쪽이 불분명하거나 굳이 언급할 필요가 없을 때
> The book **is written** in Chinese.
> Her books **are sold** in many countries.

B 수동태 문장 만들기

❶ be동사+과거분사(p.p.) (+by ~)

• 능동태의 [2]_____ → 수동태의 주어 • 동사는 「be동사+p.p.」로 변화 • be동사는 수동태의 주어에 인칭과 수를 맞춘다. • 능동태의 주어 → 수동태의 by ~ (생략 가능)	She painted the picture. The picture **was painted** by her.
• not은 수동태의 be동사 뒤에 둔다.	The picture **was not painted** by her.

❷ 의문문: (의문사+) be동사+주어+p.p. [조동사+주어+be+p.p.] (+by ~)?

* **Is** the class **taught** by him?
* **Will** the class **be taught** by him?
* **When is** the class **taught** by him?

❸ 혼동하기 쉬운 과거분사형

* His wallet was **found** in the waste basket in the street. find(~을 발견하다)의 과거분사
* My school was **founded** in 1985. found(~을 설립하다)의 과거분사

C 시제에 따른
수동태

미래를 나타내는 조동사나 표현으로 나타냄

		능동태	수동태
현재		They **paint** the house.	The house **is painted** by them.
과거		They **painted** the house.	The house **was painted** by them.
미래		They **will paint** the house.	The house **will be painted** by them.
진행형		They **are painting** the house. They **were painting** the house.	The house **is being painted** by them. The house **was being painted** by them.
완료형		They **have painted** the house. They **had painted** the house.	The house **has been painted** by them. The house **had been painted** by them.

D 수동태를
만들 수 없는
동사

❶ 자동사: ³＿＿＿＿＿를 가질 수 없기 때문
 • The accident **happened** yesterday. (○)
 • The accident **was happened** yesterday. (×)
 • The sun **rises** in the east. (○)
 • The sun **is risen** in the east. (×)

 > **More** 주요 자동사
 >
 > Errors can **occur**. The train will **arrive**.
 > She suddenly **appeared**. My wallet **disappeared**.
 > Everyone **dies** in the end. They **remained** calm.
 > My cat always **lies** on my chest.

❷ 수동태로 표현했을 때 어색한 동사
 have, want, need, belong (to), possess, resemble, seem, exist 등 상태를 나타내는 동사는 행위자의
 의지와 상관없이 그런 상태에 놓인 것이므로 수동태 표현이 어울리지 않아요.

 • I **want** bacon and eggs sunny-side up for breakfast.
 → Bacon and eggs sunny-side up **are wanted** by me for breakfast. (×)

E 조동사가
쓰인 수동태

조동사+be+p.p.
 • They **can paint** the house.
 → The house **can be painted** by them.
 • The prince **had to solve** the problem.
 → The problem **had to be solved** by the prince.

PRACTICE

STEP

1

다음 문장을 수동태로 바꿔 쓰세요.

1 Beethoven composed the *Moonlight Sonata*.

→ The *Moonlight Sonata* _____ .

2 Farmers usually plant crops in spring.

→ _____ in spring.

3 Jeff Bezos established Amazon.com in 1994.

→ Amazon.com _____ .

4 Nowadays, young men read fashion magazines too.

→ Nowadays, _____ .

5 You need to wait while they are checking your luggage.

→ You need to wait while _____ .

6 The hotel has canceled my reservation as I didn't pay for the room.

→ _____ as I didn't pay for the room.

7 We will invite the previous prize winners to the IF Prize Award Ceremony 2020.

→ _____ to the IF Prize Award Ceremony 2020.

8 These days, we can use cell phones as cameras and music players.

→ These days, _____ as cameras and music players.

9 They were satisfied that Mr. Kim was teaching their children.

→ They were satisfied that _____ .

10 You don't need to visit a station because they are selling train tickets on the Internet.

→ You don't need to visit a station because _____ .

11 Do you upgrade your computer every year?

→ _____

STEP 2 괄호 안에서 문맥과 어법에 맞는 것을 고르세요.

1 My dog suddenly [was disappeared / disappeared] while we were taking a walk.

2 This jacket [belongs / is belonged] to me.

3 For more than a year, the Korean won has been [rising / risen] in value.

4 Accidents [happen / are happened] when we don't pay attention to what we are doing.

5 Judging from the style, it [seems / is seemed] that all the pieces were painted by the same artist.

6 Looking down from the helicopter, they discovered that the river [has polluted / has been polluted] by the factory waste.

7 Why has so much money [spent / been spent] on advertising by companies?

STEP 3 밑줄 친 부분을 어법에 맞게 고치세요.

1 When was her first novel publish?

2 More than 200 guests have invited to the wedding.

3 This issue has not agreed to by all of us.

4 Many of the rainforests are being destroying to provide wood for construction.

5 Many workers have exposed to toxic chemicals.

6 The pool locates on the top floor of the hotel.

7 I hope the elevator will repair by this afternoon.

8 We are needed to do some extra work to prepare for the event.

STEP 4

다음 물음에 알맞은 답을 고르세요.

1 다음과 같이 문장을 전환할 때 빈칸에 알맞은 것은?

> He should take care of two babies.
> → Two babies _____ by him.

① take care of　　　　　　② are taken care of
③ were taken care of　　　　④ should be taking care of
⑤ should be taken care of

2 다음 중 어법상 <u>틀린</u> 문장은?

① He resembles his brother a lot.
② Suddenly, a dark cloud appeared on the horizon.
③ We were totally lost because there was no sign.
④ All of us were surprised to hear that he had died.
⑤ Did a large number of buildings destroyed in the earthquake?

STEP 5

우리말과 뜻이 같도록 괄호 안의 단어를 알맞게 배열하여 문장을 완성하세요. (단, 동사의 형태를 변화시킬 수 있음)

1 계속 노력하면, 나쁜 습관은 고쳐질 수 있다. (can, bad habits, fix)

→ If you continue trying, _____.

2 파일이 다운로드되고 있는 중에는 차분히 기다려라. (the files, download)

→ Please be patient while _____.

3 작년에 여기에 왔을 때 건물이 하나 지어지고 있었다. (a building, build)

→ When I came here last year, _____.

4 너의 스트레스는 다른 사람들과의 좋지 못한 관계에서 비롯된 거니? (your stress, cause)

→ _____ by poor relationships with other people?

5 그의 생일 파티는 오후 6시에 열릴 것이다. (birthday party, hold)

→ _____ at 6 p.m.

Point 01 문맥 속에서 어법상 틀린 것 찾기
글의 흐름상 주어가 동작을 받는 상황이면 수동태로 표현해야 해요.

Point 02 어법상 빈칸에 들어갈 알맞은 말 찾기
문장 안에서 시제를 판단할 수 있는 표현들에 유의하세요.

Point 03 올바른 형태로 바꿔 쓰기
주어와 동사의 관계가 능동인지 수동인지 판단하세요.

정답 및 해설 p.5

Point 01

● 다음 글의 밑줄 친 ①~⑤ 중 어법상 틀린 것은?

Last summer, my family ① experienced a hurricane for the first time. The old tree in our backyard ② uprooted and thrown onto the roof of our house. It made a large hole, and the rain ③ poured in through it. Our living room was flooded by the water, and it ④ rose to a height of three feet. Next time, when a hurricane ⑤ comes, I'm sure our family will be the first to leave.

*uproot: 뿌리째 뽑다

Point 02

● 빈칸에 들어갈 말로 알맞은 것은?

My computer _____, so I'm not able to upload the photos to my blog.

① is repairing ② can be repaired ③ was repaired
④ is being repaired ⑤ has been repairing

서술형 ▶

Point 03

● 다음 우리말을 영어로 옮긴 문장에서 어법상 틀린 곳을 고쳐 문장을 다시 쓰세요.

나는 그 같은 사람은 지도자로 불릴 만하지 않다고 생각해.
I don't think a person like him can call a leader.

→ _____

Unit 05 주의해야 할 수동태

수동태로 표현할 때 어떤 점에 주의해야 하는지 알아보기로 해요.

A 「구동사 +목적어」인 문장

구동사 전체를 하나의 ¹_____로 생각해서 수동태로 바꿈

동사와 함께 구동사를 이루는 with, of, at 등을 생략하지 않도록 주의해야 해요.

* The matters **were dealt with** immediately (by them). deal with: ~을 다루다
 (← They **dealt with** the matters immediately.)
* The baby **was taken care of** by him. take care of: ~을 돌보다
* My teacher **was looked up to** by me. look up to: ~을 존경하다

> **More** 주요 구동사
>
> | look at(~을 보다) | look after(~을 돌보다) | run over((차량 등이) ~을 치다) |
> | take away(~을 치우다) | call off(취소하다) | catch up with(~을 (따라)잡다), |
> | pay attention to(~에 주목하다) | turn off(~을 끄다) | speak well of(~에 대해 좋게 말하다) |
> | laugh at(~을 비웃다) | look forward to(~을 고대하다) | get rid of(~을 없애다) |
> | put off(연기하다) | carry out(수행하다) | pick up(~을 차에 태우다) |

B 목적어가 두 개인 문장

❶ 두 가지 수동태가 가능한 경우

직접목적어를 주어로 할 경우, 간접목적어였던 것의 앞에는 적절한 ²_____를 넣어야 해요.

* He **gave** me a pen. → *I* **was given** a pen by him.
 → *A pen* **was given to** me by him.

> **More** 동사에 따라 다르게 쓰는 전치사
>
> * **to**: give, send, teach, tell, bring, lend, write, offer
> * **for**: buy, make, cook * **of**: ask

❷ 한 가지 수동태만 가능한 경우

간접목적어를 주어로 한 수동태의 의미가 어색하면 수동태로 표현하지 않아요.

* He **bought** me a car. → *A car* **was bought for** me by him. (○)
 → *I* **was bought** a car by him. (×)

C 목적격보어가 있는 문장

목적어만 수동태의 주어로 가능

목적격보어는 명사일 때도 수동태의 주어가 될 수 없고 과거분사 뒤에 그대로 남겨 두어요.

* We **call** the dog Roxy.
 → The dog **is called** Roxy. (○)
 → Roxy **is called** the dog by us. (×)

PRACTICE

STEP 1

우리말과 뜻이 같도록 〈보기〉에서 알맞은 구동사를 골라서 문장을 완성하세요. (단, 동사의 형태를 변화시킬 수 있음)

〈보기〉 call off catch up with look up to

 laugh at take care of

1 그는 곧 경찰에게 붙잡혔다.

→ He _____ soon.

2 태어나면서부터 대부분의 포유류는 그들의 어미에 의해 돌보아진다.

→ Most mammals have _____ from birth.

3 존경할 만한 태도로 행동하면, 다른 사람들에게 존경받을 것이다.

→ Act in a respectable manner, and you will _____.

4 어제 비 때문에 그 경기가 취소되었다.

→ The game _____ because of the rain yesterday.

5 그 형제들은 마을 사람들에게 비웃음을 당했다.

→ The brothers _____ in the village.

STEP 2

다음 문장을 수동태로 바꿔 쓰세요.

1 My parents taught me honesty and kindness.

→ I _____ by my parents.

2 The teacher gave them a chance to take the test again.

→ A chance to take the test again _____.

3 In an interview, the interviewers ask each candidate the same questions.

→ In an interview, the same questions _____.

4 Her parents made her a very responsible person.

→ She _____.

5 People call Vincent van Gogh the best artist in the world.

→ Vincent van Gogh _____.

STEP 3

문장전환이 바른 것은 ○표를 하고, <u>틀린</u> 것은 바르게 고치세요.

1 My friends laughed at me for the way I dressed.

→ I was laughed at my friends for the way I dressed.

2 They will finish the project by the end of the year.

→ The project will be finished by them by the end of the year.

3 Asian people grow and consume most of the world's rice.

→ Most of the world's rice is grown and consumed by Asian people.

4 My mom bought me a new backpack.

→ A new backpack was bought me by my mom.

5 People have called him "Father of the Homeless."

→ "Father of the Homeless" has been called by him. *the homeless: 노숙자들

6 His grandmother has looked after him since he was little.

→ He has been looked after by his grandmother since he was little.

STEP 4

빈칸 (A)와 (B)에 들어갈 말이 알맞게 짝지어진 것은?

> • She was taken care ____(A)____ by one of her friends.
>
> • A lot of homework was given ____(B)____ us by Mr. Park.

	(A)		(B)
①	to	for
②	of	to
③	for	with
④	by	of
⑤	with	by

**내신
적중
Point**

Point 01 어법상 틀린 것 찾기

능동태 문장을 수동태로 바꿀 때 주의해야 할 점들을 확인하세요. 구동사가 있는 문장은
전치사를 빼먹지 않도록 주의하세요.

Point 02 문장 전환하기

목적어가 두 개인 문장을 수동태로 바꿀 때는 간접목적어였던 것 앞의 전치사에 주의
하세요.

정답 및 해설 p.5

**Point
01**

● **다음과 같이 문장을 바꿀 때 어법상 틀린 것은?**

① The singer called off the concert for no reason.

→ The concert was called off by the singer for no reason.

② Her father bought her a new computer.

→ She was bought a new computer by her father.

③ My parents taught me some valuable lessons.

→ Some valuable lessons were taught to me by my parents.

④ I looked up to my grandfather.

→ My grandfather was looked up to by me.

⑤ People called the pot sinseollo.

→ The pot was called sinseollo.

**Point
02**

서술형 ▶

● **주어진 문장을 다음과 같이 바꿔 쓸 때 빈칸에 알맞은 말을 쓰세요.**

> They will buy the kids more books.

→ More books _____ the kids by them.

Unit 06 다양한 수동태 표현들

by 이외의 다른 전치사를 쓰는 것은 숙어처럼 알아두면 좋아요.

A be covered with[by] 등

숙어처럼 알아두어야 할 표현들

* The mountain **is covered with[by]** snow. ~으로 덮여 있다
* The meeting room **is filled with** people. ~으로 가득 차 있다
* The team **is composed of** eleven players. ~로 구성되다
* I **am interested in** math. ~에 흥미가 있다
* The band **is known to** many people. ~에게 알려져 있다
* The city **is known for** its beautiful beach. ~로 알려지다
* That vase **is made of** glass. ~으로 만들어지다
* Cheese **is made from** milk. ~으로 만들어지다 (다른 성질)

B be surprised at[by] 등

감정을 나타내는 수동태

우리말로는 '놀라다', '실망하다' 등으로 마치 능동태를 해석한 것 같지만 영어로는 수동태로 표현해요. 감정을 일으키는 것 앞에는 1 _____ 대신 다른 전치사를 쓰는 경우가 더 많답니다.

* I **was surprised at[by]** the sound.
 ← The sound **surprised** me.
* She **is satisfied with** her grades. ~에 만족하다
* We **are pleased with[at]** our success. ~에 기뻐하다
* Everybody **was delighted at[by/with]** the news. ~을 기뻐하다
* We **were disappointed with[by/at/in]** his decision. ~에 실망하다
* Emily **was amazed at[by]** the news. ~에 놀라다
* He **was excited at[about, by]** the game. ~에 신이 나다
* My brother **is worried about** the exam. ~에 대해 걱정하다
* I **was confused by[at/about]** his answer. ~에 혼란스러워 하다

단, 누군가에게 감정을 일으키는 것이 주어가 되면 2 _____ 로 표현해야 해요.

* The game was **exciting**.
* The news was **surprising**.

PRACTICE

STEP 1

괄호 안에서 어법에 맞는 것을 고르세요.

1 The large table was covered [in / with] every kind of food for her birthday party.

2 When he revisited Korea, he said he was surprised [about / at] how fast it was changing.

3 I was pleased [at /on] her coming back.

4 If you are not satisfied [of / with] our product, just tell us and we will refund your payment.

5 Her eyes were filled [by / with] tears.

6 The village is known [to / with] the world as Twins' Village.

7 My little sister is interested [at / in] classical music.

8 We were very excited [about / for] the news that my high school soccer team is going to the finals.

STEP 2

다음 문장을 수동태로 바꿔 쓰세요.

1 The news surprised us.

→ We _____ the news.

2 Flowers almost covered the trees.

→ The trees _____ .

3 The news will delight his fans all over the world.

→ His fans all over the world _____ .

4 Ice and snow cover the lake in the winter.

→ The lake _____ .

STEP 3

다음 밑줄 친 부분을 어법에 맞게 고치세요.

1 They <u>were surprised for</u> the snake.

2 Kate's heart <u>was filled of</u> pride and confidence.

3 The toy <u>makes of</u> plastic.

4 My hometown <u>is known by</u> its beautiful landscapes.

5 Many people <u>are worried to</u> losing their jobs.

6 The result of the poll is a little <u>disappointed</u>.

7 He <u>is so bored</u> that I don't want to sit with him.

8 Amy <u>is exciting</u> at the thought of going skiing tomorrow.

STEP 4

우리말과 뜻이 같도록 괄호 안의 단어를 이용하여 문장을 완성하세요. (단, 동사 형태를 변화시킬 수 있음)

1 우리는 당신의 좋은 서비스에 만족한다. (satisfy)

→ We _____ your good services.

2 그들은 그녀가 제시한 숫자에 놀랐다. (surprise, the number)

→ They _____ that she had suggested.

3 나는 멸종위기 동물들을 돕는 것에 관심을 갖고 있었다. (interest, help)

→ I _____ endangered animals.

4 이 도시는 따뜻한 기후와 아름다운 해변으로 알려져 있다.
(know, its, warm climate, beautiful beaches)

→ This city _____.

Point 01 빈칸에 공통으로 들어갈 단어 찾기
수동태에서 by 이외의 전치사를 쓰는 표현들을 잘 익혀 두세요.

Point 02 문장 전환하기
감정 동사와 주어의 의미 관계에 따라 올바른 형태인지를 판단하세요.

Point 03 조건에 맞게 문장 쓰기
동사 형태와 전치사의 사용에 모두 주의하세요.

정답 및 해설 p.6

Point 01

● 빈칸에 공통으로 들어갈 말로 알맞은 것은?

- My room is filled _____ all kinds of books.
- You should be satisfied _____ what you have now.
- He was pleased _____ his new car that we bought him.

① at ② by ③ for ④ to ⑤ with

Point 02

● 다음 중 바꾼 문장이 바른 것은?

① My picture surprised my teacher.
 → My teacher was surprising at my picture.
② The exam worries me.
 → I am worried from the exam.
③ Everybody in the village knows him.
 → He is known by everybody in the village.
④ Thick fine dust covered South Korea's sky last Sunday.
 → South Korea's sky was covered with thick fine dust last Sunday.
⑤ The result disappointed my parents.
 → My parents were disappointing with the result.

Point 03

서술형 ▶

● 다음 우리말과 뜻이 같도록 〈조건〉에 맞게 문장을 완성하세요.

〈조건〉 • singer, not, many를 포함할 것 • 모두 8단어로 쓸 것

그 가수는 많은 사람들에게 알려져 있지 않다.

→ _____

Overall Exercises 02

[1-4] 다음 중 빈칸에 알맞은 것을 고르세요.

1

> When you buy a product on our site, a text message will _____ to you.

① send ② be sent
③ be sending ④ have sent
⑤ have been sent

2

> She _____ as "Teacher of the Year" three times.

① recognizes
② recognized
③ has recognized
④ was recognizing
⑤ has been recognized

3

> Anything spilled on a carpet should _____ immediately with warm water and soap.

① be cleaning ② clean
③ have cleaned ④ be cleaned
⑤ have been cleaning

4

> The game they _____ last night is a board game called Monopoly.

① play ② playing
③ has been played ④ were playing
⑤ were played

[5-7] 다음 중 빈칸에 들어갈 말이 알맞게 짝지어진 것을 고르세요.

5

> • I was surprised _____ the news that she has gotten married.
> • I am totally satisfied _____ the gift I was given by her.
> • This bag was bought _____ my daughter several years ago.

① in by to
② with at by
③ at with for
④ at by to
⑤ in at by

6

> • A cheerful greeting is _____ to everyone.
> • We are so _____ to see you here.

① pleasing pleased
② pleased pleasing
③ pleased pleased
④ pleasing pleasing
⑤ please pleased

7

> • Her new novel will _____ in Spanish.
> • The riddle can't _____.

① write solve
② be written solve
③ be written be solved
④ be written be being solved
⑤ write to be solved

[8-9] 다음 문장에서 어법상 **틀린** 곳을 찾아 바르게 고치세요.

8
> Sunflowers grow best when they plant in early spring in wet soil.

→ _____

9
> Many questions were asked for the lecturer by the audience.

→ _____

10 주어진 문장을 수동태로 바꿀 때, 빈칸 (A), (B)에 가장 알맞은 것은?

> He made his sister a birthday cake.
> → _____(A)_____ was made _____(B)_____ by him.

	(A)		(B)
①	His sister	·····	a birthday cake
②	His sister	·····	for a birthday cake
③	A birthday cake	·····	to his sister
④	A birthday cake	·····	for his sister
⑤	A birthday cake	·····	of his sister

11 다음 중 어법상 바른 문장은?

① She was bought for a carpet as a house-warming gift.
② Their wedding party will be held at 5 p.m.
③ According to Korean history, *Gojoseon* was found in 2333 B.C.
④ The Arctic is covered of ice and snow for most of the year.
⑤ The actress asked a lot of questions by the reporter yesterday.

[12-13] 다음 중 바꾼 문장이 어법상 **틀린** 것을 고르세요.

12
① We elected her team leader.
 → She was elected team leader.
② I resemble my grandmother.
 → My grandmother is resembled by me.
③ Some people consider the number thirteen unlucky.
 → The number thirteen is considered unlucky by some people.
④ The beautiful park attracted him.
 → He was attracted by the beautiful park.
⑤ She wrote me a letter of apology.
 → A letter of apology was written to me by her.

13
① Watching good movies delighted him.
 → He was delighted by watching good movies.
② We should respect the individual's privacy.
 → The individual's privacy should be respected.
③ Her friends looked up to her as a good adviser.
 → She was looked up to as a good adviser by her friends.
④ On a clear night, we can see thousands of stars in the sky.
 → On a clear night, thousands of stars can be seen in the sky.
⑤ My mom made me a world traveler.
 → A world traveler was made me by my mom.

[14-15] 다음 글을 읽고 물음에 답하세요.

The crocodiles at the zoo look like statues. They ____(A)____ perfectly still for hours at a time. They have no need to move because they don't have to hunt for their food. They ____(B)____ (feed) regularly by the zookeepers.

14 윗글의 빈칸 (A)에 들어갈 말로 알맞은 것은?

① lie
② was lying
③ lay
④ are lain
⑤ have been lain

15 윗글의 빈칸 (B)에 괄호 속 단어의 알맞은 형태를 쓰세요.

→ _____

16 어법상 바른 문장을 모두 고른 것은?

ⓐ No one was home at that time, and no one was injured.
ⓑ One of the buildings in the town destroyed by fire.
ⓒ He wants to be a professor who is looked up to by every student.
ⓓ The game called off because of the heavy rain.
ⓔ The buildings are being renovated and preserved.

① ⓐ, ⓑ
② ⓐ, ⓒ, ⓔ
③ ⓑ, ⓓ
④ ⓑ, ⓓ, ⓔ
⑤ ⓒ, ⓓ, ⓔ

17 밑줄 친 부분을 어법에 맞게 고치세요.

Olive oil has used in many different dishes for generations.

→ _____

18 밑줄 친 부분이 어법상 틀린 것은?

① We are pleased with our success.
② I am worried about my future.
③ He is so boring that I don't want to talk with him.
④ The result of the exam is a little disappointed.
⑤ I was confused about this subject.

[19-20] 다음 대화를 읽고 물음에 답하세요.

A: Jin said he is acting in a play. Do you know when?
B: It will ____(A)____ at 7 p.m. at the Arts Center. Are you going to go?
A: I'd like to, but I can't. I have too much to do tonight.
B: So do I. What should we do, then?
A: I've already done something for him. A flower basket will ____(B)____ to him backstage.
B: Good idea! (C) 그는 정말 놀라겠지.

19 위 대화의 빈칸 (A), (B)에 알맞은 말로 짝지은 것은?

	(A)		(B)
①	hold	deliver
②	be held	deliver
③	be held	be delivering
④	be held	be delivered
⑤	hold	be delivered

20 위 대화의 밑줄 친 (C)의 우리말과 같도록 괄호 속 단어를 활용하여 문장을 완성하세요.

(really, surprise)

→ He will _____ .

서술형 만점 Writing Exercises

1 다음 우리말과 같은 뜻이 되도록 괄호 안의 단어를 이용하여 문장을 완성하세요.

(1)
> Bach는 음악의 아버지라고 불린다.
> (call, "the Father of Music")

→ Bach _____ .

(2)
> 그녀는 그 계획에 만족하지 못했다.
> (satisfy, the plan)

→ She _____ .

(3)
> 그 왕은 그의 학식과 올바른 판단으로 알려져 있었다.
> (know, his knowledge, good judgment)

→ The king _____

_____ .

2 다음 우리말과 뜻이 같도록 주어진 단어를 바르게 배열하세요. (필요한 경우, 동사의 형태를 바꿀 것)

(1)
> 멸종 위기에 처한 동물들은 보호되어야 한다.
> (endangered animals, protect, should)

→ _____

(2)
> 동물들은 사람의 언어를 배울 수 없다.
> (animals, teach, cannot, human language)

→ _____

3 주어진 단어를 알맞게 바꾸어 빈칸에 넣어서 다음 책을 설명하는 글을 완성하세요.

J.K. Rowling
HARRY POTTER

write	publish	know

Harry Potter _____ _____ by J. K. Rowling. It _____ first _____ in 1997 after many rejections from other publishers. Now it _____ _____ _____ every child in the world.

4 다음 문장에서 어법상 틀린 부분을 고쳐 문장을 다시 쓰세요.

> A chance to become an actor was given for me by the director.

→ _____

5 주어진 문장을 다음과 같이 바꿔 쓸 때 빈칸에 알맞은 말을 넣으세요.

> My father bought me my first electric guitar as a birthday present.

→ My first electric guitar _____

_____ .

CHAPTER

03

조동사

| 기본 개념 & 용어 Review |

조동사는 동사를 돕는 역할을 하는데 크게 두 가지로 종류를 나눌 수 있어요.

① **be, have, do** : 문법적으로 역할을 하여 시제, 수동태, 의문, 부정 등을 나타냄으로써
동사 의미를 변화시켜요.

② **will, can, may, must** 등: 주로 말하는 사람의 판단, 의무, 확신, 능력, 허가 등
동사에 의미를 더해주는 역할을 해요.

이 챕터에서는 동사에 의미를 더해주는 조동사들의 의미와 형태에 대해 알아봅시다.

can, may, will

can, may, will의 과거형인 could, might, would는 반드시 '과거'를 뜻하는 것은 아니고 좀 더 부드럽고 정중한 느낌으로 쓰이는 경우가 많아요.

A can, could

❶ 능력: ~할 수 있다

- I **can** *run* fast. (= am able to) 현재: ~할 수 있다
- **Can** you *cook*? 현재: ~할 수 있니?
 — Yes, I **can**. / — No, I **can't**.
- I **could** *run* fast. (= was able to) 과거: ~할 수 있었다
- I **cannot[can't]** *run* fast. (= am not able to) 현재: ~할 수 없다
- I **couldn't[could not]** *run* fast. 과거: ~할 수 없었다
 (= was not able to)

> **More** 미래의 능력: **will be able to** (~할 수 있을 것이다)
> 조동사는 두 개를 연달아 쓸 수 없기 때문에 will can으로 쓰지 않아요.
> I **will be able to** run fast. (○)
> I **will can** run fast. (×)

❷ 허가: ~해도 좋다

- You **can** *get* some rest now. 허가: ~해도 좋다
- You **cannot[can't]** *use* this machine. 금지: ~하면 안 된다

❸ 가능성, 1_____ : ~할[일] 수 있다

- An earthquake **can[could]** *happen* at any time.
- **Can[Could]** it *be* true? 의심: 과연 ~일까?
- He **cannot[can't]** *be* there. 부정적 추측: ~일 리가 없다

B Can [Could] ~?

2_____ , 허가 구하기, 도움 제안

- **Can[Could] you** *do* me a favor? 요청: ~해 줄래[주시겠어요]?
 — Sure[OK]. What is it?
 — Sorry, but I can't.
- **Can[Could] I** *use* your computer? 허가: ~해도 되니[되나요]?
 — Yes, you can.
 — No, you can't[cannot].
- **Can[Could] I** carry your luggage? 제안: ~해 줄까[드릴까요]?
 — Oh, thanks.
 — No, it's all right, thanks.

C **may, might**

❶ 허가: ~해도 좋다

• You **may** *go* inside now. ~해도 좋다
• **May I** *turn* up the volume? (= Can I ~?) ~해도 되나요?
 — Yes, you **may[can]**. 허가
 — No, you **may not[can't]**. 금지
 — No, you **must not**. 강한 금지

❷ 가능성, 약한 추측: 어쩌면 ~일지도 모른다

• She **may[might]** *be* at home. 어쩌면 ~일지도 모른다
• She **may[might] not** *be* aware of the danger. ~이 아닐지도 모른다

❸ 바람, 기원: ~하기를

• **May you** always be happy! ~하기를

D **will, would**

❶ 단순 미래: ~이 될 것이다

시간이 지나면 자연히 그렇게 되는 미래를 의미해요.

• I **will** *be* seventeen next year. ~이 될 것이다
• I told him it **would** be fine soon. 주절 과거시제+종속절 would

❷ 주어의 ³_____: (반드시) ~하겠다

• I **will** *stop* smoking. (반드시) ~하겠다
• I **will** *do* my best.

> **More** be동사+going to+동사원형
> 미리 마음먹고 있거나 가까운 미래에 하려고 하는 일은 「be동사+going to+동사원형」으로 나타내요.
> **I'm going to** *visit* my friend who had a traffic accident.

❸ 정중한 요청: ~해 주시겠어요?

• **Would[Will] you** *do* this for me? ~해 주시겠어요?
 (= **Could[Can] you** *do* this for me?)

❹ ~하려 하다, ~하곤 했다(would)

• He **will** *do* as he likes in everything. 고집: ~하려 한다
• Whenever I visited her, I **would** *buy* her a 과거의 습관: ~하곤 했다
present.

PRACTICE

STEP 1 다음 밑줄 친 부분의 뜻으로 알맞은 것을 〈보기〉에서 골라 그 기호를 쓰세요.

〈보기〉
ⓐ 능력: ~할 수 있다[없다]

ⓑ 허가: ~해도 좋다, ~해도 되니[되나요]?

ⓒ 요청, 부탁: ~해 주시겠어요?

ⓓ 가능성, 추측: ~일 수 있다, 어쩌면 ~일지도 모른다

ⓔ 주어의 의지: (반드시) ~하겠다

ⓕ 금지: ~하면 안 된다

ⓖ 과거의 습관: ~하곤 했다

1 You <u>can</u> make it. You are strong.

2 I'm sorry, but Tim <u>can't</u> speak to you now. He has someone with him.

3 <u>May</u> I borrow your book?

4 Noise <u>can</u> be a problem when you're living in an apartment.

5 She <u>might</u> be over thirty.

6 We <u>would</u> have lunch together when we were students.

7 I <u>will</u> try to join the soccer club this year.

8 I'm not ready to go. You <u>can</u> leave if you're in a hurry.

9 My brother knows a lot about computers. He <u>can</u> help you fix your broken computer.

10 A: <u>Could</u> you drive me home this evening?
　　　B: I'd like to, but I can't. I have an appointment.

11 You <u>cannot</u> smoke here.

12 Today is Friday. There <u>may</u> be a lot of traffic this afternoon. Let's not drive.

13 <u>May</u> I have your attention, please? We're landing in a few minutes. Please fasten your seat belts.

14 <u>Would</u> you please give me a ride to school?

STEP 2

문맥상 빈칸에 알맞은 말을 <u>모두</u> 고르세요.

1

You _____ have the book if you want to read it.

① can　　　　　② may　　　　　③ would

2

When my parents went out on weekends, I _____ take care of my younger brother.

① can　　　　　② would　　　　　③ might

3

A: Excuse me, could you tell me which bus I should take to get to City Hall?
B: Bus number 63 _____ go there. But you'd better ask the driver.

① could　　　　　② is able to　　　　　③ may

4

A: Shall I wash the dishes?
B: No, please leave them there. I _____ do them later.

① will　　　　　② may　　　　　③ am not going to

5

A: I need to go to the supermarket.
B: I _____ drive you there. I'll get my car keys.

① will　　　　　② can　　　　　③ may

6

_____ I go home early today? I have a headache.

① Can　　　　　② May　　　　　③ Would

PRACTICE

정답 및 해설 p.7

STEP 3

다음 물음에 알맞은 답을 고르세요.

1 다음 중 어법상 바른 문장은?

① Will you getting up early tomorrow morning?
② I have been able ride a bicycle since I was three.
③ When I was a child, I would watch Disney movies every weekend.
④ I wondered if you will lend me some money.
⑤ Your brother may helps you with your math homework.

2 주어진 문장과 밑줄 친 부분의 의미가 같은 것은?

On holidays, I would do chores to help my mom.

① Would you open the window, please?
② My friend promised that he would get up early.
③ Would you mind waiting outside for a few minutes?
④ He would often go hiking when he was young.
⑤ I should go. Jina said that she would wait for me.

STEP 4

우리말과 뜻이 같도록 괄호 안의 단어를 이용하여 문장을 완성하세요. (단, 동사의 형태를 변화시킬 수 있음)

1 당신은 제시간에 거기에 갈 수 있나요?
(able, there, on time, get)

→ Will _____ ?

2 나는 다음날 오전 11시에 그곳에 있겠다고 말했다.
(be, there)

→ I said _____ the next day.

3 제가 이 박스를 가지고 들어오는 동안 문 좀 잡아주실래요?
(hold, the door)

→ _____ while I bring this box in?

Point 01 짝지어진 문장의 의미가 다른 것 찾기
문장에서 조동사의 의미를 각각 확인하세요.

Point 02 의미가 같은 것 찾기
조동사가 가지고 있는 다양한 의미 중에서 전체 문맥상 어울리는 것을 찾으세요.

정답 및 해설 p.7

Point 01

● 다음 중 짝지어진 문장의 뜻이 서로 <u>다른</u> 것은?

① You may use my phone.

= You can use my phone.

② You can't vote this year because you're only 18.

= You aren't able to vote this year because you're only 18.

③ I don't know how to get there. Would you come with me?

= I don't know how to get there. Could you come with me?

④ You will be able to make it if you try again.

= You may make it if you try again.

⑤ Sorry I'm late. I couldn't find a parking space.

= Sorry I'm late. I was not able to find a parking space.

Point 02

● 다음 대화의 밑줄 친 부분과 의미가 같은 것은?

A: I'm thinking of reading a book about planting flowers.
B: Well, I have the perfect book for you. You <u>can</u> borrow it if you want.

① <u>Can</u> this be true?

② How <u>can</u> I get to City Hall?

③ <u>Can</u> you please pass me the salt?

④ I <u>can</u> speak Spanish and Chinese.

⑤ Children <u>can</u> have anything they want on the table.

Unit 08 must, should

조동사 must나 should를 써서 의무나 추측, 충고 등을 나타낼 수 있어요.

A must, have to

❶ 1_____, 필요: ~해야 한다
- You **must** *go* home now. (= have to)
- I **had to** *leave* work early yesterday.
- We **will have to** *be* in the classroom before nine.
- You **don't have to** *go* home now.
 = You **don't need to** *go* home now.
 = You **need not** *go* home now.
cf. You **must not** *go* home now.

현재: ~해야 한다
과거: ~해야 했다
미래: ~해야 할 것이다

~할 필요가 없다

금지: ~하면 안 된다

❷ 강한 긍정적 추측: ~임에 틀림없다
- Jerry didn't eat anything this morning.
 He **must** be hungry.
 (= **It is certain that** he is hungry.)
cf. Jerry just had lunch. He **can't** *be* hungry.

강한 긍정적 추측: ~임에 틀림없다

부정적 추측: ~일 리가 없다

B shall, should

제안, 의무, 2_____, 추측
- **Shall we** *dance*?
- **Shall I** *open* the door?
- You **should** *obey* the rules.
- You don't look well, so you **should** *go* to bed early.
- You **shouldn't** *hurt* your friends.
- I believe him. His story **should** *be* true.

제안: 우리 ~할까요?
제안: 제가 ~할까요?
의무: ~해야 한다, ~하는 것이 당연하다
충고: ~하는 것이 좋겠다
금지: ~하지 말아야 한다
추측: ~일 것이다

C must [should] have+p.p.

❶ must have+p.p.: 과거에 대한 강한 긍정적 추측
- He isn't here. He **must have gone** home.
 (= **It is certain that** he went home.)

~했음에 틀림없다

❷ should have+p.p.: 과거의 일에 대한 후회나 비난
- It was fantastic! You **should have come** with us.
 (= **I'm sorry** you **didn't** come with us.)

~했어야 했는데

PRACTICE

STEP
1

다음 밑줄 친 부분의 뜻으로 알맞은 것을 〈보기〉에서 골라 그 기호를 쓰세요.

〈보기〉 ⓐ 의무, 필요: ~해야 한다

ⓑ 금지: ~하면 안 된다

ⓒ 불필요: ~할 필요가 없다

ⓓ 현재에 대한 강한 추측: ~임에 틀림없다

ⓔ 과거에 대한 강한 추측: ~했음에 틀림없다

ⓕ 충고: ~하는 것이 좋겠다

ⓖ 과거에 대한 후회, 비난: ~했어야 했는데

1 It's very late. We really <u>should</u> go home.

2 I <u>must</u> read several books for my literature class.

3 You <u>must</u> be tired after such a long flight.

4 Children over five <u>must</u> pay full price for the ticket.

5 You <u>must not</u> talk during the film, or other people will get angry.

6 Mr. Park can remember the names of almost all his students. He <u>must</u> have a good memory.

7 In English, every sentence <u>should</u> start with a capital letter. *capital letter: 대문자

8 If you use this phone number, you <u>don't have to</u> pay for the phone call.

9 You <u>shouldn't have made</u> promises you couldn't keep.

10 A: Why hasn't Molly come? I need her to help with the baking.
B: She <u>must have gone</u> to buy flour. We ran out of it.

11 You <u>should not</u> put off till tomorrow what you can do today.

12 When you want to get a part-time job, you <u>should</u> make a list of your favorite jobs.

STEP
2 괄호 안에 주어진 동사를 〈보기〉를 참조해 가장 적절한 형태로 바꿔 빈칸에 쓰세요.

〈보기〉 should have+p.p. must have+p.p. must+동사원형

1 We _____(leave) an hour ago. We'll be late for the concert.

2 I can't make the new camera work. I _____(do) something wrong.

3 A: Sejin knows that we are planning to go on a vacation together.
B: How does he know about that? He _____(hear) our conversation!

4 A: Brian has been coughing all day.
B: That's a pity. He _____(have) a cold.

5 A: I bought a cell phone at a high price last month. But its price has come down.
B: You _____(wait) for a while.

6 A: Look over there. There are so many people waiting in line to get into the restaurant.
B: It _____(be) a famous restaurant. Why don't we get in line?

7 A: Something smells really good.
B: Mom _____(bake) some potatoes before we got home.

STEP
3 다음 중 짝지어진 문장의 뜻이 서로 다른 것은?

① You should have seen the concert. It was fantastic.
= I'm sorry that you didn't see the concert. It was fantastic.
② Suji won first prize. Her parents must be proud of her.
= Suji won first prize. It is certain that her parents are proud of her.
③ It isn't very late. We don't have to hurry yet.
= It isn't very late. We don't need to hurry yet.
④ Those who can't swim must not go into deep water.
= Those who can't swim need not go into deep water.
⑤ The roads are wet. It must have rained.
= The roads are wet. It is certain that it rained.

Point 01 빈칸에 알맞은 말 찾기
문맥을 통해 적절한 조동사를 판단하세요.

Point 02 어법상 틀린 것 찾기
조동사를 쓴 문장의 시제가 나타내는 의미에 유의하세요.

Point 03 주어진 단어를 활용하여 영작하기
주어진 우리말을 잘 표현할 수 있는 적절한 조동사를 사용하세요.

정답 및 해설 p.8

Point 01

● 빈칸 (A)와 (B)에 들어갈 말로 바르게 짝지어진 것은?

> • I ____(A)____ have exercised more. I am overweight!
> • Jim traveled all day long to get to his grandmother's place.
> He ____(B)____ have been tired when he arrived.

	(A)		(B)		(A)		(B)
①	should	······	cannot	②	cannot	······	must
③	must	······	cannot	④	should	······	must
⑤	must	······	should				

Point 02

● 다음 중 어법상 틀린 것은?

① I must have lost my wallet on the bus on my way home.
② I was late. I should have taken the subway.
③ I don't have to go see a doctor. I'm feeling much better.
④ We had to wait almost an hour to buy movie tickets yesterday.
⑤ If you want to be a good swimmer, you should have enjoyed yourself.

Point 03

서술형 ▶

● 우리말과 뜻이 같도록 괄호 안의 단어를 이용하여 문장을 완성하세요.
(단, 동사 형태를 변화시킬 수 있음)

> 그는 다른 누군가와 나를 혼동하는 것이 분명하다. 나를 틀린 이름으로 부른다.
> (me, confuse)

→ He _____ with someone else. He calls me by
the wrong name.

Unit 09
used to, ought to, had better, need

used to, ought to, had better, need 등의 조동사를 사용한 표현의 <u>의미</u>와 <u>형태</u>를 구분하는 것이 중요해요.

A used to

❶ ~하곤 했다 (과거의 습관)

전에는 ~했는데 지금은 아니라는 뜻이에요.

* I **used to** *go* fishing with my father on weekends, but I don't anymore.
* I didn't **use to** *drink* coffee, but now I drink at least two cups a day.

> **More** be[get] used to+-ing/명사: ~에 익숙하다, 익숙해지다
> 이때의 to는 전치사이므로 뒤에는 반드시 명사 역할을 할 수 있는 어구가 와야 합니다.
> I **am used to** *getting* up early in the morning.
> You'll **get used to** *the noise* in the city.
> *cf.* be used to+동사원형(use의 수동태: ~하는 데 사용되다)
> English **is used to** *communicate* with foreigners.

❷ used to와 would

모두 <u>1 </u>의 습관을 뜻하지만, used to는 '동작'과 '상태', would는 '동작'만 표현할 수 있어요.

* There **used to** *be* a big tree on the hill when I was young. (○)
* There **would** *be* a big tree on the hill when I was young. (×)
* He **used to[would]** *visit* his grandparents on Sundays, but not recently. (○)

B ought to, had better, need

❶ ought to: ~해야 한다, ~하는 것이 당연하다 (= should)

* You **ought to** *obey* the rules. 도덕적 의무, 당연함
* You **ought not to** *play* with knives. 금지: ~하면 안 된다

❷ had better: ~하는 편이 낫다

should나 ought to보다 더 강한 권고예요. 부정형은 2<u> </u>, 줄임말은 -'d better입니다.

* You **had better** *go* there by taxi, or you will be late. 강한 권고: ~하는 편이 낫다
* You **had better not** *eat* too much.

❸ need: ~할 필요가 있다

부정문과 의문문에서는 조동사, 긍정문에서는 일반동사로 쓰여요.

* **Need** I *do* this again? ~할 필요가 있다
* You **need not** *do* it again. (= don't need[have] to) ~할 필요가 없다
* *cf.* She **needs** *to do* the job. 일반동사

PRACTICE

STEP 1

다음 밑줄 친 부분의 알맞은 뜻을 〈보기〉에서 골라 그 기호를 쓰세요.

〈보기〉 ⓐ ~하곤 했다 ⓑ ~해야 한다
　　　　ⓒ ~할 필요가 있다[없다] ⓓ ~하는 편이 낫다
　　　　ⓔ ~하는 데 익숙하다

1 People <u>used to</u> believe that the world was flat.

2 A: <u>Need</u> I fill in a form to attend the class?
　　B: Yes, you must.

3 You <u>ought to</u> wear a life-saving vest when you ride a boat.

4 You <u>had better</u> keep your passport safe. Otherwise, you will waste money and time making a new one.

5 They <u>were used to</u> working together.

6 You <u>need not</u> go to school if you don't feel well.

7 When I was a child, I <u>used to</u> go to the public library.

STEP 2

다음 중 주어진 문장과 의미가 가장 가까운 문장을 고르세요.

1 │ You had better not stay home all day long. │

① You should not stay home all day long.
② You should not have stayed home all day long.
③ You must stay home all day long.

2 │ I used to be shy in my elementary school days. │

① I was shy in my elementary school days and I am still shy now.
② I was not shy in my elementary school days but I am very shy now.
③ I was shy in my elementary school days but I am not shy anymore.

STEP 3 괄호 안에서 어법에 맞는 것을 고르세요.

1 Yumi [needs not / need not] worry about the result of the test. She did well on it.

2 We [had better not / had not better] go to the zoo on Children's Day. It will be too crowded there.

3 You [ought to not / ought not to] eat that soup. It looks bad.

4 At first I didn't recognize Jason! He [used to / was used to] be a little heavy. Now he's quite thin.

5 Minju woke up at five every morning for work. After a year of doing this, she is used to [get up / getting up] early, even on weekends.

6 You need not [do / to do] the dishes. I've already done them.

7 My grandfather used to [eat / eating] spicy food with no problem. But now he can't eat anything spicy.

8 A: Can I have some ice cream?
B: You'd better not [have / to have] any. It's nearly dinner time.

STEP 4 우리말과 뜻이 같도록 괄호 안의 단어를 이용하여 문장을 완성하세요. (단, 동사 형태를 변화시킬 수 있음)

1 어렸을 때 나는 사탕을 좋아했는데, 이제는 좋아하지 않는다. (like, candies)

→ I _____ when I was a kid, but now I don't like them.

2 그는 바다에서 거의 익사할 뻔했는데, 왜냐하면 파도가 높은 곳에서 수영하는 데 익숙하지 않았기 때문이다. (swim)

→ He almost drowned at sea because he _____ in the big waves.

3 너는 열이 있구나. 오늘은 학교에 가지 않는 게 좋겠다. (go to school)

→ You have a fever. You _____ today.

내신 적중 Point

Point 01 빈칸에 가장 적절한 말 찾기
문맥의 흐름에 알맞은 조동사를 선택하세요.

Point 02 그림의 상황에 맞게 문장 완성하기
충고나 금지 등을 나타내는 조동사를 써야 할 경우가 많아요.

Point 03 단어 배열하여 문장 만들기
had better, used to와 같은 조동사구는 구 전체가 하나의 조동사처럼 쓰여요.

정답 및 해설 p.8

Point 01

● 빈칸에 가장 적절한 것은?

He _____ go to school by bicycle, but now he goes to school by subway.

① ought to ② used to ③ should not
④ had better ⑤ need not

Point 02

서술형 ▶

● 괄호 안에 주어진 단어를 사용하여 그림 속 사람이 할 말을 완성하세요.

(wear, a helmet, for your safety, had better)

→ You _____.

Point 03

서술형 ▶

● 다음 우리말과 뜻이 같도록 괄호 안의 단어를 배열하여 문장을 완성하세요.

벌써 늦었다. 나는 이제 자러 가는 게 좋겠어.
(I, better, go, bed, now, had, to)

→ It's late already. _____

[1-4] 다음 중 빈칸에 알맞은 것을 고르세요.

1

You _____ hand in the essay by Friday.

① might
② have to
③ would
④ used to
⑤ must have

2

My camera is gone! Someone _____ it while I was in the restroom.

① can steal
② might steal
③ must have stolen
④ had to steal
⑤ should have stolen

3

A: I'll call the restaurant to make a reservation for tonight.
B: You _____ call them. You can do it online.

① can't
② must
③ had better
④ may
⑤ don't have to

4

A: I had a stomachache last night.
B: I told you! You _____ so much ice cream.

① cannot eat
② must eat
③ need not eat
④ might not eat
⑤ shouldn't have eaten

5 **다음 중 밑줄 친 부분과 바꾸어 쓸 수 있는 것은?**

Jack had an accident last week, so he is not able to use his right hand right now.

① can
② couldn't
③ need not
④ cannot
⑤ may

6 **다음 중 밑줄 친 부분과 바꾸어 쓸 수 <u>없는</u> 것은?**

You shouldn't go out after midnight. It's dangerous.

① must not
② cannot
③ had better not
④ ought not to
⑤ don't have to

7 **빈칸에 공통으로 들어가기에 알맞은 것은?**

• I _____ like cartoons, but now I don't.
• Eric has lived in Korea for five years. He is _____ eating Korean food.
• Milk is _____ make cheese and yogurt.

① would
② have to
③ used to
④ ought to
⑤ able to

8 다음 중 의미하는 바가 나머지 넷과 <u>다른</u> 하나는?

① You ought to go home and rest.
② You'd better go home and rest.
③ I think you should go home and rest.
④ I advise you to go home and rest.
⑤ Let's go home and rest.

9 다음 중 어법상 바른 문장은?

① You ought to not take a shower for a day after having a flu shot.
② Her grandfather used to teaching her life lessons when she was young.
③ They told him that he needed not answer.
④ Will you be able to buy some eggs on your way home?
⑤ I don't know where I am. I should print out the map before I left the office.

10 다음 대화 중 어법상 <u>틀린</u> 것은?

① A: What are you going to do after school?
 B: I'll may play soccer with my friends.
② A: Mom, I think I have a fever.
 B: You'd better not go to school today.
③ A: I'm so sorry. I forgot to bring your book.
 B: That's okay. I don't need it now.
④ A: I watched TV until 2 a.m., so I'm a bit tired.
 B: You should go to bed before midnight for your health.
⑤ A: I almost had a car accident yesterday.
 B: Are you OK? You should have driven carefully.

11 대화의 흐름과 어법상 빈칸 (A)와 (B)에 들어갈 말로 알맞은 것은?

> A: I ____(A)____ get on the flight to Paris. I left my passport at home.
> B: You ____(B)____ that you had your passport before you left.

	(A)		(B)
①	can	have checked
②	won't	should check
③	couldn't	should have checked
④	would	must have checked
⑤	might	would check

[12-13] 다음 중 어법상 <u>틀린</u> 문장을 고르세요.

12 ① We had better not park here.
② You don't have to shout. I can hear you.
③ You must not give up your dream too easily.
④ Minho is waiting for me. I must go now.
⑤ He must been married. He wears a wedding ring.

13 ① May I have a glass of water, please?
② My father won't give me any money.
③ You ought to not send the text message to him.
④ You should not bring your pets here.
⑤ I lost my book yesterday, and I couldn't find it.

14 다음 우리말과 뜻이 같도록 괄호 속 단어를 이용하여 문장을 완성하세요.

> Nick은 《어벤져스》를 여러 번 보았음에 틀림없다. 그는 거의 모든 세부 내용을 기억한다.

→ Nick _____ (see) *The Avengers* several times. He remembers almost all the details.

[15-16] 다음 대화를 읽고 물음에 답하세요.

> A: This e-mail has a file attachment.
> B: Oh, yeah? What kind of file is it?
> A: It says "iloveyou.exe."
> B: _____(A)_____ It ___(B)___ damage the computer.
> A: But I trust the person who sent it.
> B: That doesn't make it safe. Don't risk it.

15 위 대화의 흐름상 빈칸 (A)에 들어갈 말로 가장 적절한 것은?

① You ought to open it.
② You are able to open it.
③ You must have opened it.
④ You should have opened it.
⑤ You had better not open it.

16 위 대화의 빈칸 (B)에 들어갈 말로 알맞은 것은?

① could ② cannot
③ has to ④ needs to
⑤ used to

17 밑줄 친 부분 중 문맥상 알맞지 않은 것을 모두 고른 것은?

> A: I ⓐcan stand Patricia. She always ⓑmesses up my room and never ⓒcleans up.
> B: That's a problem. You ⓓshould not talk to her about that.
> A: I ⓔhave told her several times, but she doesn't listen to me.

① ⓐ, ⓑ ② ⓐ, ⓓ ③ ⓑ, ⓓ
④ ⓒ, ⓓ ⑤ ⓓ, ⓔ

18 밑줄 친 부분의 의미가 주어진 문장과 다른 것은?

> We must put off the meeting.

① You must be quiet in the library.
② That girl must be Mr. Carter's daughter.
③ We must learn how to forgive.
④ We must hurry if we want to get good seats.
⑤ In order to succeed, we must believe that we can do it.

19 다음 대화의 밑줄 친 부분과 의미가 같은 것은?

> A: What are you doing this afternoon?
> B: I have to do my science homework. But all the books I need are already checked out.
> A: Well, I've finished mine. You can borrow my books if you want.
> B: Sure. Thank you.

① Pandas can sleep upside down.
② Can you write a good story?
③ Good things can happen anytime.
④ You can turn right here.
⑤ Can you please tell me one more time?

20 다음 밑줄 친 부분 대신 쓸 수 있는 말을 두 가지 쓰세요.

> You need not go abroad to learn English.

→ _____

→ _____

Writing Exercises

1 다음 우리말과 뜻이 같도록 괄호 안의 단어를 이용하여 문장을 완성하세요.

(1)
> 너는 이 수수께끼를 풀 수 있니?
> (answer, this riddle)

→ Are you _____?

(2)
> 그는 개를 데리고 산책을 하곤 했다. (take a walk)

→ He _____ with his dog.

(3)
> 네가 시간이 되면 언제든지 와도 좋아. (come)

→ You _____ whenever you have time.

2 다음 대화의 밑줄 친 우리말과 같은 뜻이 되도록 괄호 안의 단어를 활용하여 문장을 완성하세요.

> A: Is something wrong?
> B: I have a stomachache. <u>나는 점심을 너무 많이 먹지 말았어야 했는데.</u>
> A: Why don't you go for a walk?
> B: O.K. I'll give it a try.

(eat, so much, for lunch)
→ I _____.

3 다음 표지판을 보고 주어진 단어를 활용하여 문장을 완성하세요.

drive	must	over

→ You _____ 25 miles per hour in school zones.

4 주어진 문장에서 어법상 틀린 부분을 고쳐 다시 쓴 문장을 완성하세요.

> Amy was used to play chess with her grandfather when she was little.

→ Amy _____
_____.

5 다음 대화의 빈칸에 어울리는 말을 완성하세요.

> A: We are late. The movie starts at 5:20 and it's 5:10 now.
> B: See? We should have taken the subway.
> A: I'm sorry I didn't listen to you. We _____ the bus.

→ _____

CHAPTER 04

부정사

| 기본 개념 & 용어 Review |

부정사(不定詞)의 '부정(不定)'은 '정해져 있지 않다'는 뜻으로, to부정사는 그 역할이 하나로 제한되어 있지 않아요.

명사적 역할 주어 · 목적어 · 보어
형용사적 역할 (대)명사 수식 / be+to부정사
부사적 역할 목적 · 원인 · 결과 · 판단의 근거 / 형용사+to부정사 / 문장 전체 수식

to부정사의 형태와 명사적 역할

부정사는 동사의 성질을 가지고 있지만 문장에서 명사처럼 주어, 목적어, 보어 역할을 해요.

A to부정사의 형태

to+동사원형 / not[never]+to+동사원형

• I want **to stay** here.

• She pretended **not to be** sad.

• He promised **never to tell** a lie again.

긍정형: to+동사원형

부정형: not+to+동사원형

부정형: never+to+동사원형

B 주어 역할

it(가주어) ~ to부정사(구)(진주어): ~하는 것은, ~하기는

to부정사(구)가 주어일 때는 보통 가주어 1_____을 쓰고 to부정사(구)는 뒤에 둡니다.

이때의 it은 형식적인 것이므로 '그것은'이라고 해석하지 않아요.

• <u>**To talk** with my grandfather</u> <u>is</u> fun.
　　　주어　　　　　　　　　　동사

→ ***It*** is fun <u>**to talk** with my grandfather</u>. (할아버지와 이야기를 나누는 것은 즐겁다.)
　 가주어　　　　　　　진주어

> **More** it의 여러 가지 역할 구별
> • **It** is difficult *to write an English essay*. (가주어: It 자리에 진주어를 대입하면 의미 성립)
> • Can you answer *the riddle*? **It** is difficult. (지시대명사: '그것은')
> • **It**'s going to snow tomorrow. (비인칭주어: '그것은'으로 해석하면 의미 어색)

대화에서 to부정사를 문장의 주어로 하여 사용하는 경우는 거의 없고 글에서는 가끔 볼 수 있어요.

• **To see** is to believe.

C 목적어 역할

❶ **want, hope, decide 등+to부정사(구): ~하는 것을, ~하기를**

• I don't *want* **to miss** the last train for Busan.
　　　　　동사　　　　　　목적어

• I *decided* **to exercise** every morning.

> **More** to부정사를 목적어로 취하는 동사들
> 주로 to부정사가 미래의 일로 해석되는 동사들이 해당된다.
>
> | afford *to do* | agree *to do* | ask *to do* | choose *to do* |
> | decide *to do* | expect *to do* | hope *to do* | learn *to do* |
> | manage *to do* | need *to do* | offer *to do* | plan *to do* |
> | promise *to do* | refuse *to do* | want *to do* | wish *to do* |

❷ **make[find, think, consider 등]+it(가목적어)+형용사+to부정사(구)(진목적어)**

to부정사(구)가 5형식 문장의 목적어로 쓰일 경우, 그 자리에 ²_____ it을 쓰고 진목적어인 to부정사(구)는 문장 뒤로 보내요. 가목적어 it도 '그것을'이라고 따로 해석하지 않아요.

* I found ***it*** difficult **to take** pictures of the rainbow.
 　　　　가목적어　　　　　　　　진목적어

D 보어 역할

주격보어와 목적격보어

* *My dream* is **to become** a fashion designer.　　주격보어: 주어 의미
 　　　　　　 =　　　　　　　　　　　　　　　　　= to부정사구

* They *expect* me **to get** a good grade on the test.　목적격보어: to부정사

* Would you *let* me **introduce** myself to your guests?　목적격보어: 원형부정사

* His neighbor *helped* him **(to) carry** the heavy boxes.　목적격보어: to부정사,
 　　　　　　　　　　　　　　　　　　　　　　　　　　　원형부정사

> **More** 원형부정사를 목적격보어로 취하는 동사들
> * A에게 ~시키다(사역동사): make A do, have A do, let A do
> * A가 ~하는 것을 보다 등(지각동사): see A do, hear A do, feel A do, watch A do 등

E 의문사+to 부정사

「**의문사+to부정사**」 = 「**의문사+주어+should[can]+동사원형**」

* **What to do** next is the question.　　　　주어 = What we should do next

* *It* depends on him **when to leave**　　　진주어 = when he should leave the office
 the office.

* We decided **where to go** for dinner.　　목적어 = where we should go for dinner

* I chose **which university to enter**.　　　목적어 = which university I should enter

* This is **how to take notes** effectively.　보어 = how you can take notes effectively

F to부정사의 의미상 주어

의미상 주어의 여러 표현

to부정사의 동작을 하는 주어를 to부정사의 의미상 주어라고 해요. 문장의 주어, 목적어, 일반인이 의미상 주어가 되는 경우에는 따로 명시하지 않지만, 그 외에는 「for+목적격」을 쓰고, 일부 형용사 뒤에만 「³_____+목적격」을 써요.

* ***I*** went *to see* a musical.　　　　　　　　　　문장의 주어

* Mom told ***me*** *not to stay* up late.　　　　　　문장의 목적어

* It is difficult *to learn* how to ski.　　　　　　　일반인: 표시하지 않음

* It is difficult **for me** *to learn* how to ski.　　　for+목적격

* It was *nice* **of you** *to give* me a birthday present.　of+목적격

> **More** 의미상 주어로 「of+목적격」을 쓰는 형용사: 감정이나 성격을 나타내는 것
> kind, nice, polite, foolish, careful, careless, stupid 등

PRACTICE

STEP 1

문맥상 빈칸에 가장 적절한 말을 〈보기〉에서 골라 알맞은 형태로 쓰세요.

〈보기〉	complete	enter	make	lend	follow	have

1 He didn't want ＿＿＿＿＿＿＿ his bike to me.

2 It is difficult for me ＿＿＿＿＿＿＿ my homework in time.

3 I asked her not ＿＿＿＿＿＿＿ a noise.

4 There are so many dishes on the menu. It's hard to choose what ＿＿＿＿＿＿＿.

5 It is rude ＿＿＿＿＿＿＿ someone's room without knocking.

6 My parents expect me ＿＿＿＿＿＿＿ their good example.

STEP 2

밑줄 친 to부정사의 역할을 〈보기〉에서 골라 그 기호를 쓰세요.

〈보기〉	ⓐ 주어	ⓑ 목적어	ⓒ 주격보어	ⓓ 목적격보어

1 <u>To give</u> is better than to receive.

2 I want <u>to buy a new smartphone.</u>

3 In my city, it's common for people <u>to walk along the river.</u>

4 I met a girl whose dream is <u>to be the president.</u>

5 Jimin is planning <u>to visit her uncle in Canada this summer.</u>

6 I told my brother <u>to clean up his room.</u>

7 I found it possible <u>to inspire people with music.</u>

8 It is useless <u>to cry over spilt milk.</u>

9 The first and greatest victory is <u>to conquer yourself.</u>

10 She asked me <u>to take a picture of her in front of the statue.</u>

STEP 3

to부정사와 의미상 주어를 이용하여 바꿔 쓴 문장을 완성하세요.

1 You should learn how to use this new software.

= It is necessary _____ how to use this new software.

2 Thank you for helping me carry my bags. You are so kind.

= It is so kind _____ me carry my bags.

3 She was so foolish. She believed his lies again.

= It was so foolish _____ his lies again.

4 We should be aware of the danger of a fire.

= It is necessary _____ the danger of a fire.

5 My brother could easily solve the problem.

= It was easy _____ the problem.

6 I think that we should call the police right now.

= I think it necessary _____ the police right now.

STEP 4

밑줄 친 부분을 어법과 문맥에 맞게 고치세요.

1 My teacher made me to write an English essay.

2 I don't know when to swim because I never learned to swim.

3 It's difficult of me to get up at six every morning.

4 It is hard to making true friends when you lie.

5 I felt my desk to shake! There must have been an earthquake.

6 A: Do you know what to drink during a marathon?

B: You should drink fluids every 15 to 30 minutes.

7 A: Can you tell me how get to the National Museum?

B: It's quite far from here. You'd better take a taxi.

STEP **5** 다음 중 어법상 맞는 문장을 고르세요.

1 ① We found this impossible to fix the machine.

② It is important of you to arrive on time.

③ My parents want me being a doctor, but I don't.

④ Mom told me to not watch TV before dinner.

⑤ Minju asked her teacher how to solve the problem.

2 ① It is nice for him to care for his sister.

② They consider impolite to sneeze without covering one's mouth.

③ I can help you prepare breakfast.

④ Elle heard a dog to bark loudly.

⑤ That is wise of him to avoid a definite answer.

STEP **6** 다음 우리말과 뜻이 같도록 괄호 안의 단어를 배열하여 문장을 완성하세요.

1 성인이 다른 언어를 배우는 것은 매우 어렵다.

(another language, for, learn, to, very difficult, adults)

→ It is _____ .

2 당신이 광고의 모든 말을 믿는 것은 어리석은 일이다.

(stupid, is, you, to, of, believe, it)

→ _____ every word in an ad.

3 나는 이 문제를 푸는 방법을 모르겠다.

(know, to, how, don't, this problem, solve)

→ I _____ .

4 우리는 절대로 그를 잊지 않겠다고 약속했다.

(never, promised, forget, to, him)

→ We _____ .

5 인터넷은 우리가 정보를 얻는 것을 쉽게 만들어준다.

(get, easy, for us, it, to, makes, information)

→ The Internet _____ .

Point 01 쓰임이 같은 것 찾기

명사적 용법으로 쓰인 to부정사는 문장에서 주어, 보어, 목적어 역할을 해요.

Point 02 조건에 맞게 영작하기

「의문사+to부정사」, 「It ~ to부정사」 등 to부정사를 이용하는 표현들을 정확하게 알아두세요.

정답 및 해설 p.10

Point 01

● **밑줄 친 부분의 쓰임이 주어진 문장과 같은 것은?**

We decided to buy a new house.

① His dream is to be a professional gamer.

② It is easy to make ice cream.

③ To study English will help you to study other subjects well.

④ They did not expect to see their teacher at the cinema.

⑤ If your only goal is to become rich, you will never achieve it.

Point 02

서술형 ▶

● **다음 우리말과 뜻이 같도록 〈조건〉에 맞게 문장을 완성하세요.**

(1)

내게 컴퓨터로 사진을 편집하는 방법을 알려주세요.

〈조건〉 •다음 단어를 사용할 것: pictures, how, edit, tell, me
•필요하면 단어를 변형하거나 추가할 것

→ Please _____ on my computer.

(2)

당신이 저녁식사에 나를 초대하다니 친절하군요.

〈조건〉 •다음 단어를 사용할 것: kind, invite, to dinner, you, me
•필요하면 단어를 변형하거나 추가할 것
•It으로 시작할 것

→ _____

Unit 11 to부정사의 형용사적 · 부사적 역할

to부정사는 형용사처럼 명사를 꾸며 주거나, 부사처럼 동사·형용사·부사 또는 문장 전체를 꾸며요.

A to부정사의 형용사적 용법

❶ 앞의 (대)명사를 수식: '~하는, ~할'

- Would you like *something* **to drink**? 마실 것
- I have *a plan* **to travel** all around the world. 여행할 계획
- It's *time* for us **to go** home. 갈 시간

> **More** to부정사+전치사
> to부정사가 꾸며 주는 명사가 전치사의 목적어이면 부정사 뒤에 1_____를 써야 해요.
> We live **in** the house. (We live the house. (×))
> This is *the house* for us **to live in**. (This is *the house* for us **to live**. (×))

❷ be동사+to부정사: 예정, 의무, 의도, 가능

- They **are to eat out** this weekend. 예정: ~할 것이다
- You **are to finish** your report by Tuesday. 의무: ~해야 한다
- If you **are to succeed**, you should use your time wisely. 의도: ~하려면
- The fire alarm **is to be heard** throughout the building. 가능: ~할 수 있다

B to부정사의 부사적 용법

❶ 목적 · 원인 · 2_____ · 판단의 근거

- I arrived early (in order) **to get** a good seat. 목적: ~하기 위해
- Dad was *glad* **to learn** that I passed the exam. 감정의 원인: ~해서, ~하게 되어
- She *grew up* **to be** a famous scientist. 결과: (결국) ~하다, ~되다
- He must be a genius **to solve** that problem. 판단의 근거: ~하다니

❷ 형용사+to부정사

- This bed is *comfortable* **to sleep** in. 한정: ~하기에 (···한)
 = **It** is *comfortable* **to sleep** in this bed. It+be동사+형용사+to부정사
- She will be *happy* **to hear** that. ~해서 ···하다
- He is *silly* **to believe** such a thing. ~하다니 ···하다
 = **It** is *silly* of him **to believe** such a thing. It+be동사+성격 형용사+of+목적격+to부정사

❸ 문장 전체를 꾸미는 독립부정사

- **Strange to say**, Linda thinks she saw a ghost. 이상한 이야기지만
- **To be honest**, I don't like his hairstyle. 솔직히 말해서
- **To tell the truth**, I didn't read the book at all. 사실을 말하자면
- **To make matters worse**, she lost her purse. 설상가상으로

PRACTICE

STEP 1

밑줄 친 부분의 역할을 〈보기〉에서 골라 그 기호를 쓰세요.

〈보기〉　ⓐ 명사 수식　　　　　　　　ⓑ 예정: ~할 예정이다
　　　　ⓒ 의무: ~해야 한다　　　　　ⓓ 의도: ~하려면

1 Is there a way to make hair grow faster?

2 You are to wash your hands after you return home.

3 The 2026 World Cup is to be held in the United States, Canada, and Mexico.

4 We are to save endangered animals for the future of our planet.

5 If you are to sleep well, you'd better not exercise too late at night.

6 My teacher gave me a novel for high school students to read.

7 My class is to go on a field trip this Friday. I'm so excited about it.

8 I got a chance to see the northern lights last summer.

STEP 2

밑줄 친 부분의 역할을 〈보기〉에서 골라 그 기호를 쓰세요.

〈보기〉　ⓐ 목적: ~하기 위해　　　　　ⓑ 감정의 원인: ~해서, ~하게 되어
　　　　ⓒ 판단의 근거: ~하다니　　　 ⓓ 결과: (결국) ~하다, ~되다

1 The girl was very happy to get the movie star's autograph.

2 We climbed the mountain at dawn to see the sunrise.

3 He is very generous to buy new computers for our school.

4 He grew up to be the leader of the United Nations.

5 We are really pleased to announce the results of the study.

6 To join the club, you need at least a year's experience as a volunteer.

PRACTICE

STEP 3

〈보기〉에서 문맥상 빈칸에 가장 적절한 것을 골라 알맞은 형태로 쓰세요.

| 〈보기〉 | live in | take care of | put on | listen to | depend on |

1 These shoes are too small for me _____.

2 He has two younger sisters _____.

3 I got a new job in London. I'm looking for a place _____.

4 Everyone needs someone _____ at one time or another in his life.

5 Would you recommend some good songs for me _____?

STEP 4

다음 우리말과 뜻이 같도록 괄호 안의 단어를 배열하여 문장을 완성하세요.

1 나는 너를 만나서 행복하다. (meet, to, happy, you)

→ I'm _____.

2 그가 그런 무례한 행동을 하다니 매우 어리석다. (very, to, him, foolish, do, of)

→ It is _____ such a rude thing.

3 그녀는 책을 몇 권 빌리려고 도서관에 갔다. (to, borrow, the library, to, went)

→ She _____ some books.

4 그는 자신이 얼마나 많은 돈을 썼는지 알게 되어 놀랐다. (to, surprised, was, learn)

→ He _____ how much money he had spent.

5 그곳은 영화에 나온 이후로 가 봐야 할 세계적으로 유명한 곳이 되었다.
(has become, to, a world-famous place, visit)

→ It _____ since it appeared in a movie.

6 학생들은 새로운 환경에 적응해야 한다. (to, are, adjust, to, a new environment)

→ Students _____.

Unit 11

내신 적중 Point

Point 01 밑줄 친 부분의 역할이 다른 것 찾기
to부정사가 부사와 같은 역할을 하는지 명사를 꾸미는 형용사 역할을 하는지 확인하세요.

Point 02 그림이 나타내는 상황 표현하기
행동의 목적이나 감정의 원인, 판단의 근거 등을 알 수 있는 그림이 제시되는 경우가 많아요.

정답 및 해설 p.10

Point 01

● 다음 중 밑줄 친 부분의 역할이 나머지 넷과 다른 하나는?

① Andy ran fast to catch the train.
② You are foolish to repeat the same mistake.
③ She was satisfied to eat an apple pie for dessert after lunch.
④ I need a piece of paper to make a note on.
⑤ To be honest, this food tastes awful.

Point 02

서술형 ▶

● 괄호 안에 주어진 단어를 이용하여 사진의 상황을 나타내는 문장을 완성하세요.
(필요한 경우, 동사의 형태를 바꿀 것)

(make, pasta)

→ She is waiting for the water to boil _____ .

Unit 12 많이 쓰이는 to부정사 구문

의미와 어순에 주의하고 <u>that절</u>로 바꾸는 법을 알아두세요.

A too+ 형용사[부사]+ to부정사

너무 ~해서 …할 수 없다 = 「so+형용사/부사+that+S+cannot+동사원형」

- I was **too tired to go** on working. 너무 피곤해서 일을 계속할 수 없었다
 = I was **so tired that I couldn't go** on working.

to부정사의 의미상 주어가 있을 때는 의미상 주어의 주격 형태가 that절의 1_____가 됩니다.

- This water is **too hot** *for me* **to drink**. 내가 마시기에 너무 뜨겁다
 = This water is **so hot that *I* can't drink it**.

B 형용사[부사] +enough+ to부정사

~하기에 충분히 …하다 = 「so+형용사/부사+that+S+can+동사원형」

- She is **rich enough to buy** the island. 살만큼 충분히 부유하다
 = She is **so rich that she can buy** the island.
- The house was **big enough for the two families to share**. 두 가족이 함께 쓰기에 충분히 컸다
 = The house was **so big that the two families could share it**.

C in order [so as]+ to부정사

~하기 위하여 = 「so[in order] 2_____+S+may[will, can]+동사원형」

- You have to study hard **in order to catch up with** them. 따라잡기 위하여
 = You have to study hard **so[in order] that you may catch up with** them.
- They stopped talking **in order not to scare** the birds. 부정: 놀라게 하지 않으려고
 = They stopped talking **so (that) they would not scare** the birds.

D seem [appear]+ to부정사

~인 것 같다 = 「It seems[appears] that+S+동사의 현재형[will+동사원형]」

- She **seems to know** a lot about classical music. 아는 것 같다
 = *It* seems that *she* **knows** a lot about classical music.
- He **seemed to be** an honest man. ~이었던 것 같았다
 = *It* seemed that *he* **was** an honest man.

E It takes ~ to부정사

…하는 데 ~의 시간이 걸리다

- **It takes** *twenty minutes* for me **to walk** to school. 걸어가는 데 20분 걸린다
 = **It takes** me *twenty minutes* **to walk** to school.

PRACTICE

정답 및 해설 p.10

STEP 1

두 문장이 같은 뜻이 되도록 빈칸을 완성하세요.

1 He is tall enough to reach the shelf.

= He is _____ tall _____ _____ _____ reach the shelf.

2 The book is too difficult for me to understand.

= The book is _____ difficult _____ _____ _____ understand it.

3 Larry seems to know him.

= It seems that _____ _____ him.

4 Is your sister strong enough to win first place?

= Is your sister _____ strong _____ _____ _____ win first place?

5 I was so sleepy that I couldn't finish my homework last night.

= I was _____ sleepy _____ _____ my homework last night.

6 It seemed that he was very popular among young people.

= He seemed _____ _____ very popular among young people.

7 She was so careless that she broke a plate.

= She was careless _____ _____ _____ a plate.

8 It seems that you won't make a foolish decision.

= You seem _____ _____ _____ a foolish decision.

9 Make notes in order to remember such detailed data.

= Make notes so that _____ _____ _____ such detailed data.

10 The man was so rich that he could have his own private plane.

= The man was rich _____ _____ _____ his own private plane.

STEP 2

다음 짝지어진 두 문장의 의미가 <u>다른</u> 것을 고르세요.

1
① You have to study hard in order to become a doctor.
= You have to study hard to become a doctor.
② They appear to have little knowledge about the robbery.
= It appears that they had little knowledge about the robbery.
③ She ran too fast for us to follow.
= She ran so fast that we couldn't follow her.
④ It seemed that he wanted to share his umbrella with me.
= He seemed to want to share his umbrella with me.
⑤ I was too busy to attend the meeting yesterday.
= I was so busy that I couldn't attend the meeting yesterday.

2
① I was so sleepy that I couldn't concentrate on my class.
= I was too sleepy to concentrate on my class.
② Please speak loudly in order for me to hear you well.
= Please speak loudly so that I can hear you well.
③ Alan is too smart to make that kind of mistake.
= Alan is so smart that he can't make that kind of mistake.
④ She needed some money in order to pay the bill.
= She needed some money so that she couldn't pay the bill.
⑤ It takes a long time for him to fall asleep.
= It takes him a long time to fall asleep.

STEP 3

다음 우리말과 뜻이 같도록 괄호 안의 단어를 이용하여 문장을 완성하세요. (단, 동사의 형태를 바꿀 수 있음)

1 통증이 너무 심해서 그는 목을 움직일 수 없었다. (sharp, move, his neck)
→ The pain was too _____ .
→ The pain was so _____ .

2 그는 그것에 관해 모든 것을 알고 있는 것 같다. (seem, know, everything)
→ He _____ about it.
→ It _____ about it.

Unit 12

내신
적중

Point

Point 01 **어법상 틀린 문장 찾기**
to부정사와 함께 쓰이는 too ~ to ...와 ~ enough to ... 등의 표현은 어순에 주의하세요.

Point 02 **의미가 다른 문장 찾기**
자주 쓰이는 to부정사 구문의 의미를 정확하게 알아두세요.

Point 03 **문장 전환하기**
to부정사 구문의 의미를 나타낼 수 있는 다른 표현들을 익혀 두세요.

정답 및 해설 p.11

Point
01

● 다음 중 어법상 **틀린** 문장은?

① This watch seems to be expensive.
② I was too busy to give you much time.
③ I wash my hands often so as not to catch a cold.
④ I was so embarrassed that I couldn't say a word.
⑤ The computer is enough cheap for me to buy.

Point
02

● 다음 중 의미가 나머지 넷과 **다른** 하나는?

① This shirt was too small for me to wear.
② This shirt was so small that I couldn't wear it.
③ I couldn't wear this shirt because it was very small.
④ This shirt was small enough for me to wear.
⑤ This shirt was very small, so I couldn't wear it.

서술형 ▶

Point
03

● 두 문장의 뜻이 같도록 문장을 완성하세요.

Jane was so tall that she could wear men's clothes.

= Jane was tall _____.

[1-5] 다음 밑줄 친 부분의 쓰임이 나머지 넷과 다른 하나를 고르세요.

1 ① <u>To listen</u> well is as powerful as to talk well.
② My dream is <u>to go</u> abroad.
③ Job fairs are good opportunities <u>to find</u> a job.
④ <u>To follow</u> traffic rules is our duty.
⑤ They are preparing <u>to open</u> a business.

2 ① What is the best way <u>to prevent</u> spam?
② I'd like something <u>to drink</u>.
③ The right <u>to vote</u> is a basic right of citizens.
④ Can you recommend a good place <u>to visit</u> on vacation?
⑤ I have to change my eating habits <u>to stay</u> healthy.

3 ① You are foolish <u>to believe</u> his lies.
② She's planning <u>to move</u> to another country.
③ We were surprised <u>to hear</u> about your marriage.
④ Plants need certain conditions <u>to grow</u>.
⑤ These bikes are safe for children <u>to ride</u>.

4 ① My duty is <u>to keep</u> you safe.
② I thought it strange <u>to see</u> snow in April.
③ I decided <u>to work</u> part-time during the vacation.
④ Do you have something cold <u>to drink</u>?
⑤ <u>To have</u> balanced meals is important for your health.

5 ① This is the best time <u>to start</u>.
② Puppies and dogs are <u>to be</u> vaccinated.
③ Is she the only student <u>to make</u> a speech tonight?
④ This dirt is difficult <u>to remove</u>.
⑤ He is <u>to arrive</u> here this afternoon.

6 **빈칸에 들어갈 말이 나머지와 다른 하나는?**

① It's hard _____ me to accept his apology.
② Has it been easy _____ you to learn French?
③ It's kind _____ her to invite us to dinner.
④ It's important _____ family members to talk to each other.
⑤ It's impossible _____ him to ask for help.

7 **다음 빈칸에 들어갈 수 없는 것은?**

> Amy _____ me to help her with her homework.

① asked ② wanted
③ had ④ expected
⑤ ordered

[8-9] 밑줄 친 부분의 쓰임이 주어진 문장과 같은 것을 고르세요.

8

> Is there a place for you to exercise near your house?

① They are happy to win the game.
② I hope to travel all around the world.
③ She brought some cookies to have with coffee.
④ I found it easy to sing along to the song.
⑤ I set an alarm to wake up early tomorrow.

9

> This software makes it easy to edit pictures.

① It was pleasant to talk with you.
② Don't touch the inside of the oven. It's still hot.
③ It took us three hours to finish the task.
④ It is more expensive to eat out than to eat at home.
⑤ My parents consider it important to have a good education.

10 다음 중 어법상 틀린 것은?

① It took a long time for me to read this book.
② It's impossible of her to forget him.
③ His lecture was too difficult for me to understand.
④ He was rude not to apologize to you.
⑤ I asked my father to send me some money.

[11-12] 다음 중 어법상 바른 문장을 고르세요.

11 ① The book festival is to take place in October.
② Why did you decide becoming an architect?
③ This map will help her traveling more easily.
④ It was difficult for they to attend an early morning meeting.
⑤ It is necessary of visitors to wear a mask in the factory.

12 ① Is this water enough clean to drink?
② She told him to not turn off the radio.
③ It was really nice of them to welcome me.
④ This course offers a good opportunity for children learn history.
⑤ He found uncomfortable to take part in the meeting.

13 두 문장의 의미가 같도록 바꾼 문장이 어법상 틀린 것은?

① She seems to know Mike well.
= It seems that she knows Mike well.
② This bed is hard to sleep in.
= It is hard to sleep in this bed.
③ We couldn't easily choose the best idea.
= It was not easy for us to choose the best idea.
④ It was boring enough to make me fall asleep.
= It was so boring that it made me fall asleep.
⑤ The stage is too small for us to perform the show.
= The stage is so small that we can perform the show.

[14-15] 빈칸 (A)와 (B)에 들어갈 말로 알맞은 것을 고르세요.

14
• What is the best hotel to _____(A)_____ in Madrid?
• May I have a pen and something to _____(B)_____ ?

 (A) (B)
① stay ····· write
② stay ····· write on
③ stay at ····· write on
④ stay at ····· write
⑤ stay for ····· write of

15
• It seemed that he _____(A)_____ too much time to spare.
• She seems _____(B)_____ detective stories well.

 (A) (B)
① has ····· write
② has ····· to write
③ had ····· write
④ had ····· to write
⑤ have ····· be written

16 다음 중 밑줄 친 부분이 바르지 <u>않은</u> 것은?

① He told me <u>where to buy</u> cheap wine.
② She taught me <u>what to make</u> green curry.
③ I don't know <u>how to thank</u> you for all of this.
④ Tell me <u>when to open</u> my eyes.
⑤ I haven't decided <u>which club to join</u>.

[17-18] 다음 글을 읽고 물음에 답하세요.

After her return from London, Jenny couldn't find her luggage in the airport. She went to the lost luggage office (A) <u>to ask</u> for help. She told the man there that her bags hadn't shown up. He smiled and told her that there was nothing _____(B)_____ because the baggage handlers were trained professionals.

17 윗글의 밑줄 친 (A)와 쓰임이 같은 것은?

① I want <u>to raise</u> a dog.
② Can you bring me a pen <u>to write</u> with?
③ I'm going to the park <u>to take</u> a walk.
④ I'm so thirsty. I need something <u>to drink</u>.
⑤ I like <u>to draw</u> pictures on weekends.

18 윗글의 빈칸 (B)에 들어갈 말로 알맞은 것은?

① worry ② to worry
③ worrying ④ not to worry
⑤ to worry about

[19-20] 다음 문장에서 어법상 틀린 곳을 찾아 바르게 고치세요.

19
Please recommend some good songs for us to listen.

_____ → _____

20
He left home early to not be late for the meeting.

_____ → _____

서술형 만점 ▸ Writing Exercises

1 다음 우리말과 뜻이 같도록 괄호 안의 단어를 활용하여 문장을 완성하세요.

(1)
> 우리는 그 소식을 듣고 기뻤다.
> (happy, hear, the news)

→ We were _____ .

(2)
> 인사동은 관광객들이 전통적인 한국을 경험할 수 있는 가장 좋은 장소 중의 하나이다.
> (tourists, experience)

→ Insa-dong is one of the best places _____ traditional Korea.

(3)
> 그는 너무 키가 작아서 농구 선수가 될 수 없었다.
> (short, too, a basketball player)

→ He was _____
_____ .

2 다음 우리말과 뜻이 같도록 각각 주어진 조건에 맞게 두 문장을 완성하세요.

> 그 방은 아이들이 잠자기에 충분히 따뜻하다.
> (1) enough를 사용할 것
> (2) so ~ that을 사용할 것

(1) The room is _____ to sleep in.

(2) The room is _____ .

3 다음 사진 속 상황에 맞게 괄호 안에 주어진 단어를 이용하여 문장을 완성하세요.

(the airport, pick up)

→ She went _____ her friend.

4 다음 두 개의 상자에서 하나씩 고른 단어를 이용하여 대화문을 완성하세요.

how when who where what	come put join play swim

(1) A: Could you tell me _____ these bags?
 B: Just leave them on the table.

(2) A: Why should you learn _____ ?
 B: Swimming keeps my heart and lungs healthy.

5 두 문장이 같은 뜻이 되도록 문장을 완성하세요.

> It seemed that he lived a full life.

= He _____ .

CHAPTER

05

동명사

| 기본 개념 & 용어 Review |

동명사(-ing)는 동사의 성질을 가지면서 문장 내에서 주어, 목적어, 보어 역할을 해요.

> **동명사** ① 주어(~하는 것은)
> ② 목적어(~하는 것을, ~하기를)
> ③ 보어(~하는 것(이다), ~하기(이다))

목적어로 동명사나, to부정사 중 하나 또는 둘 다를 취할 수 있는 동사가 있는데
각각에 어떤 동사가 있는지 이 챕터에서 학습해 봅시다.

동명사의 쓰임

동사의 -ing 형태인 동명사는 동사의 성질을 가지고 있지만 문장에서 명사처럼 주어, 목적어, 보어 역할을 해요.

A 동명사의 형태와 역할

❶ 긍정형: 동사원형(v)-ing / 부정형: not[never]+v-ing
 * **Playing** badminton is a great pleasure. play +ing = playing
 * **Not having** breakfast can be bad for your health. not+v-ing

❷ 주어 역할: 동명사 주어+단수 동사
to부정사가 주어인 경우는 대부분 1_____ it으로 대체하지만, 동명사가 주어일 때는 그대로 쓰는 경우가 더 많아요. 동명사 주어는 단수 동사로 받아요.
 * **Having** a pet *is* good for your mental health.

❸ 동사의 목적어 역할: enjoy, keep, finish 등+동명사 목적어
동명사나 to부정사, 또는 둘 다 목적어로 취하는 동사가 있어요. (⇨ Unit 14 동명사와 to부정사)
 * Most people *enjoy* **traveling** to different parts of the world. enjoy+동명사
 * I *like* **relaxing** on the beach. like+동명사/to부정사
 = I *like* **to relax** on the beach.

❹ 전치사의 목적어 역할: 전치사+동명사
전치사 뒤에 나오는 말을 전치사의 2_____ 라고 해요.
 * The skill *of* **writing** takes time to develop.
 * Brush your teeth *before* **going** to bed.

❺ 보어 역할: 보통 be동사와 함께 주격보어로 쓰임
 * The most important skill in ballet *is* **keeping** your balance. (= to keep)

B 동명사의 시제

❶ v-ing: 동명사가 문장 동사의 시제와 같거나 미래의 일일 때
 * She *is* proud of **having** three children. 주절의 시제 = 동명사구의 시제
 = She *is* proud that she **has** three children.
 * I *am* sure of **winning** the game. 동명사: 미래의 의미
 = I *am* sure that I'**ll win** the game.

❷ having+p.p.: 문장 동사의 시제보다 한 시제 앞서거나 그 시점에 완료된 일일 때
 * She *is* proud of **having been** on the national handball team. 주절은 현재, 동명사구는 과거
 = She *is* proud that she **was[has been]** on the national handball team.

C 의미상 주어

소유격[목적격(구어체)]+동명사

동명사의 동작이나 상태를 실제로 행하는 이를 3_____라고 해요. 대개 문장의 주어나 목적어 등이 의미상 주어가 되는데, 그렇지 않을 때는 동명사 앞에 따로 써 줍니다.

- I can't understand **her being** angry at me.
 = I can't understand that **she is** angry at me.
- I wouldn't mind **his**[**him**] **staying** here.
 = I wouldn't mind if **he stayed** here.

D 많이 쓰이는 동명사 구문

go v-ing	~하러 가다
be busy v-ing	~하느라 바쁘다
on v-ing = as soon as	~하자마자
cannot help v-ing = cannot but+동사원형	~하지 않을 수 없다
look forward to v-ing = (gladly) expect to-v	~하기를 고대하다
be worth v-ing	~할 가치가 있다
prevent ~ (from) v-ing = keep ~ from v-ing	~가 …하지 못하게 하다
feel like v-ing	~하고 싶은 생각이 들다
spend + 시간[돈] + (on) v-ing	~하느라 시간[돈]을 쓰다
be used to v-ing	~에 익숙하다

- Let's **go skiing** this weekend.
- Dr. Brown **is** very **busy examining** her patients.
- **On checking** her watch, she went out of the classroom.
 = *As soon as* she checked her watch, ~.
- I **cannot help crying**.
 = I *cannot but* cry.
- I **look forward to working** with you.
 = I (*gladly*) *expect to* work with you.
- Life **is worth living**.
- The heavy snow **prevented** the plane (**from**) **departing** on time.
 = The heavy snow **kept** the plane **from departing** on time.
- I don't **feel like sleeping** now.
- I **spent** too much money (**on**) **buying** things that I didn't need.
- They **were used to eating** smaller dinners like eggs and toast.

PRACTICE

STEP 1

괄호 안에서 어법에 맞는 것을 <u>모두</u> 고르세요.

1 I enjoy [spend / spending] time with my friends.

2 Their project is [building / to build] a big shopping mall in two years.

3 I'm so sorry for [being / to be] late for your party.

4 He was afraid of [getting / to get] a poor test result.

5 Following the instructions [is / are] easy.

6 His biggest concern is [used / using] green products.

7 I'm looking forward to [see / seeing] you soon.

8 I'm getting tired of [eat / eating] instant food.

9 What to do next is [mixing / to mix] all the ingredients in a bowl.

10 They spent three hours [having / to have] dinner.

11 [Buying / To buy] clothes on the Internet [require / requires] careful consideration.

STEP 2

두 문장이 같은 뜻이 되도록 괄호 안에서 알맞은 것을 고르세요.

1 I am sure that I am ready for a marathon.

 = I am sure of [be / being] ready for a marathon.

2 I'm sorry that I don't have time to help you.

 = I'm sorry for [not having / having not] time to help you.

3 Minji is ashamed that she did such a thing.

 = Minji is ashamed of [doing / having done] such a thing.

4 I'm sorry that I didn't answer your call yesterday.

 = I'm sorry for [not answering / not having answered] your call yesterday.

5 My sister was disappointed that he was not there.

 = My sister was disappointed about [he / his] not being there.

STEP 3

두 문장이 같은 뜻이 되도록 빈칸에 알맞은 말을 쓰세요.

1 I'm proud that I am your son.

= I'm proud _____ _____ your son.

2 I gladly expect to get an immediate reply from you.

= I look forward _____ _____ an immediate reply from you.

3 I'm sure that she will come on time.

= I'm sure of _____ _____ on time.

4 My mom kept me from eating in the middle of the night.

= My mom prevented me _____ _____ in the middle of the night.

5 As soon as he opened the door, his children ran to greet him.

= On _____ _____ the door, his children ran to greet him.

STEP 4

문맥상 빈칸에 가장 적절한 말을 〈보기〉에서 골라 알맞은 형태로 쓰세요.

〈보기〉	look	eat	come	hear	go	make	start

1 We are really looking forward to _____ on a vacation.

2 He spent two hours _____ for the cat.

3 Are you used to _____ spicy food?

4 On _____ the news, he broke down in tears.

5 I don't like her _____ to the farewell party.

6 The heavy rain prevented us _____ in the morning.

7 She apologized for _____ _____ a wrong decision.

STEP 5

다음 물음에 답하세요.

1 다음 중 어법상 <u>틀린</u> 문장은?

① She enjoys going shopping.
② I'm interested in watching horror movies.
③ Teaching students are interesting.
④ I'm proud of her having won a prize.
⑤ My job is helping people find a job.

2 다음 중 어법과 문맥상 맞는 문장은?

① He blamed me for keeping not the promise.
② To fastening your seat belt is very important.
③ He is scared of to swim in the lake.
④ I'm sure of he passing the driving test.
⑤ He admitted having cheated on the exam.

STEP 6

다음 우리말과 뜻이 같도록 괄호 안의 단어를 이용하여 문장을 완성하세요. (단, 동사의 형태를 바꿀 수 있음)

1 가족을 보자마자 그는 울기 시작했다. (on, see)

→ _____ his family, he began to cry.

2 네가 날 도와주지 않으면 나는 약속을 깰 수밖에 없다. (cannot, break, help)

→ I _____ the promise if you don't help me.

3 그 축제는 참가할 가치가 있다. (worth, take part in)

→ The festival _____.

4 나의 어머니는 당신을 만나길 고대하고 계신다. (look forward, meet)

→ My mother is _____ you.

5 사람들은 가끔 일상생활에서 달아나고 싶어 한다. (feel, like, run)

→ People sometimes _____ away from everyday life.

내신 적중 Point

Point 01 **바르게 영작한 것 찾기**
동명사는 문장에서 명사처럼 주어, 보어, 목적어 역할을 해요.

Point 02 **빈칸에 공통으로 들어갈 말 찾기**
자주 쓰이는 동명사 구문들의 의미와 형태를 알아두세요.

Point 03 **어법상 틀린 부분 바르게 고치기**
동명사의 시제, 의미상 주어, 부정형 등의 형태를 정확하게 익혀 두세요.

정답 및 해설 p.12

Point 01

● **다음 우리말을 영어로 바르게 옮긴 것은?**

> 그는 붉은 셔츠를 입는 것을 싫어한다.

① He doesn't like wear red shirts.
② He doesn't like to wearing red shirts.
③ He doesn't like wearing red shirts.
④ He likes not to wear red shirts.
⑤ He doesn't like having worn red shirts.

Point 02

● **다음 빈칸에 공통으로 들어갈 말은?**

> • I'm really looking forward _____ on holiday.
> • He was used _____ fishing with his father.

① to go ② going ③ having gone
④ to going ⑤ from going

서술형 ▶

Point 03

● **다음 우리말을 영어로 옮긴 문장에서 어법상 틀린 부분을 바르게 고치세요.**

> 그들은 자신들의 시간을 낭비하지 않은 것에 대해 당신에게 감사할 것이다.
> → They'll thank you for wasting not their time.

_____ → _____

Unit 14 동명사와 to부정사

동사 중에는 목적어로 <u>동명사</u>나 <u>to부정사</u>, 또는 둘 다를 목적어로 취할 수 있는 것들이 있어요.

A 동사+동명사

enjoy, finish, keep, mind 등+1_____ : ~하는 것을 …하다

동명사 목적어는 대개 이미 진행 중이거나 과거의 일을 나타내요.

* Most people *enjoy* **watching** comedy movies.
* When you *finish* **reading** the book, please let me know.
* He *kept* **asking** me the same question over and over again.
* Would you *mind* **looking** after my cat for a while?
* When we met last time, Jack *avoided* **looking** at me.
* She finally *gave up* **finding** a new publisher.

> **More** 동명사와 to부정사를 각각 목적어로 취하는 동사
>
동명사를 목적어로 취하는 동사			to부정사를 목적어로 취하는 동사		
> | imagine v-ing | deny v-ing | consider v-ing | want to-v | expect to-v | hope to-v |
> | discuss v-ing | postpone v-ing | quit v-ing | decide to-v | learn to-v | plan to-v |
> | put off v-ing | admit v-ing | | promise to-v | offer to-v | choose to-v |

B 동사+ 동명사/ to부정사

❶ 동명사와 to부정사의 의미 차이가 거의 없는 동사

like, love, hate, start, begin, continue, prefer, intend 등 감정이나 시작 등의 의미가 있어요.

* I love **watching[to watch]** cartoons with my cousin.
* They started **building[to build]** the highest building in Asia.
* It began **raining[to rain]** while I was waiting for the bus.

❷ 의미 차이가 있는 동사

remember, forget, try, regret 등의 동사일 때 주로 to부정사 목적어는 미래에 할 일, 2_____ 목적어는 진행 중이거나 과거에 했던 일을 의미해요.

Do you **remember receiving** the letter from Nick? **Remember to send** this letter tomorrow.	(과거에) ~했던 것을 기억하다 (미래에) ~할 것을 기억하다
If you are bored, **try cleaning** the house. I **tried to find out** the truth for myself.	시험 삼아 ~해보다 ~하려 애쓰다
I **regret telling** him my secret. I **regret to say** I can't attend the meeting.	(과거에) ~한 것을 후회하다 ~하게 되어 유감이다
My computer suddenly **stopped working**. The taxi **stopped to pick up** a passenger.	~하는 것을 멈추다 ~하기 위해 멈추다 (이때 to부정사는 목적을 나타내는 부사적 용법)

PRACTICE

STEP 1 괄호 안에서 어법과 문맥상 알맞은 것을 고르세요.

1 The dog kept [barking / to bark] at the stranger.

2 The kids continued [play / playing] outside until late.

3 Let's start [discuss / to discuss] the new topic.

4 Did you finish [talking / to talk] on the phone?

5 Would you mind [opening / to open] the window?

6 We can't imagine [living / to live] without electricity.

7 The restaurant manager tried to avoid [meeting / to meet] the angry customer.

8 A: Mom, what is that smell? Something is burning in the oven!
 B: Oh, I forgot [turning / to turn] it off!

9 She regrets [saying / to say] things about herself that weren't true.

10 He remembered [talking / to talk] about his future with me last month.

11 Sam is very nice to stop [picking / to pick] up trash on the street.

12 When I fell into the water, I desperately tried [breathing / to breathe].

STEP 2 밑줄 친 부분이 어법에 맞으면 ○표를 하고, 틀리면 바르게 고치세요.

1 I will consider to take part in the project.

2 Sera continued studying Mexican art.

3 Why does she keep look at the clock?

4 I'll finish to write the essay in an hour.

5 She gave up persuading her brother.

PRACTICE

정답 및 해설 p.13

STEP 3

우리말과 뜻이 같도록 〈보기〉에서 적절한 단어를 골라 알맞은 형태로 빈칸에 쓰세요.

| 〈보기〉 | water | buy | pull | listen | leave |

1 나는 시험 삼아 그 줄을 가볍게 당겨 보았다.

→ I tried _____ the rope lightly.

2 나는 화분에 있는 식물에 물을 줬다는 사실을 종종 잊어버려서, 계속 물을 주곤 한다.

→ I often forget _____ the potted plant, so I do it again and again.

3 제 인생에서 매우 중요한 부분이었던 이 회사를 떠나게 되어 유감입니다.

→ I regret _____ this company that has been such an important part of my life.

4 James는 집에 가는 길에 빵을 사기 위해 멈춰 섰다.

→ James stopped _____ some bread on the way home.

5 그 가수는 그녀의 노래를 들었던 것을 기억했다.

→ The singer remembered _____ to her song.

STEP 4

다음 우리말과 뜻이 같도록 괄호 안의 단어를 이용하여 문장을 완성하세요. (단, 동사의 형태를 바꿀 수 있음)

1 나는 시험 삼아 일주일 동안 아침, 점심, 저녁으로 패스트푸드를 먹어 보았다. (fast food, eat, try)

→ I _____ for breakfast, lunch, and dinner for a week.

2 나는 전화를 받으려고 길에서 걸음을 멈추었다. (my phone, answer, stop)

→ I _____ on the street.

3 오늘 오후에 민주와 도서관에서 만나기로 한 것을 잊지 마. (forget, don't, meet)

→ _____ Minju at the library this afternoon.

4 나는 어젯밤 내 커피머신을 고쳐 보려고 노력했다. (try, my, repair, coffee machine)

→ I _____ last night.

5 당신은 공부할 때 시끄러운 음악을 듣는 것을 그만두어야 한다. (music, stop, listen to, loud)

→ You should _____ when you study.

내신 적중 Point

Point 01 빈칸에 알맞은 말 찾기

목적어로 동명사를 취하거나 to부정사를 취하는 동사, 또는 둘 다 취할 수 있는 동사를 구분할 수 있어야 해요.

Point 02 그림이 나타내는 상황 표현하기

그림 속 인물의 행위나 상황을 나타내는 동사가 어떤 형태의 목적어를 취할 수 있는지 생각하세요.

정답 및 해설 p.13

Point 01

● 빈칸에 들어갈 수 <u>없는</u> 말은?

> Jason _____ talking about the girl he met at the party.

① started ② wanted ③ continued
④ stopped ⑤ began

Point 02

서술형 ▶

● 괄호 안에 주어진 단어를 이용하여 사진의 상황에서 두 사람이 나눌 수 있는 대화를 완성하세요. (필요한 경우, 동사의 형태를 바꿀 것)

(finish, read, put off, clean)

Dad: Why don't you clean your room, Eric?

Eric: I'm sorry, but I want _____ this book today. I'll clean my room tomorrow.

Dad: It's not a good idea to _____ your room until tomorrow.

Overall Exercises 05

[1-2] 빈칸에 들어갈 말이 바르게 짝지어진 것을 고르세요.

1
> • Do you mind _____ the window?
> • I almost forgot _____ the medicine.
> • I tried _____ my lost wallet, but I couldn't.

① open ······ to take ······ to find
② to open ······ taking ······ finding
③ opening ······ to take ······ to find
④ to open ······ taking ······ to find
⑤ opening ······ taking ······ finding

2
> • Remember _____ out when you finish online banking.
> • Could you stop _____ that loud noise? I can't sleep.
> • You can save money by _____ energy more efficiently.

① log ······ to make ······ use
② logging ······ making ······ using
③ logging ······ to make ······ using
④ to log ······ making ······ using
⑤ to log ······ to make ······ to use

3 다음 문장에서 어법상 틀린 것을 바르게 고치세요.

> He was ashamed of being not brave.

_____ → _____

[4-7] 다음 중 어법상 바른 문장을 고르세요.

4
① Reading classical novels are good for your writing.
② Would you mind keeping an eye on my luggage?
③ She enjoyed to sing and dance.
④ How about to take a break for a while?
⑤ Don't interrupt until I finish to speak.

5
① He couldn't help cry.
② Let's go skated today.
③ This book is worth to read.
④ Thank you for having been my teacher.
⑤ She doesn't mind he attending the meeting.

6
① Spending time with friends are always fun.
② He wanted me believing his story.
③ We can't afford buying that sports car.
④ It's hard for me to imagine win the gold medal.
⑤ He began looking for available flights around Christmas.

7
① Tim is busy to study for the test.
② I enjoy writing essays and short stories.
③ He kept to practice his cello for four hours each day.
④ On notice the difference, he came to ask about it.
⑤ She is looking forward to visit her relatives in Paris.

8 우리말을 영어로 옮긴 문장 중 틀린 것은?

① 여기에 상자를 묻은 것을 기억하니?
 → Do you remember burying the box here?
② 그는 저녁식사 후 그 책을 계속 읽었다.
 → He kept reading the book after dinner.
③ 저를 집에 데려다 주실 수 있나요?
 → Do you mind taking me home?
④ 나는 그녀한테 돈을 좀 빌린 것을 잊었다.
 → I forgot to borrow some money from her.
⑤ 그런 훌륭한 건축가와 함께 일하는 것은 굉장하다.
 → It is amazing to work with such a great architect.

[9-11] 다음 중 어법상 틀린 문장을 고르세요.

9 ① I gave up learning Japanese.
 ② She wanted to be a lawyer.
 ③ Tim decided to go fishing next weekend.
 ④ I'll finish reading the novel by tomorrow.
 ⑤ Would you mind to smoke outside?

10 ① You forgot telling me your address.
 ② Did you enjoy riding a horse?
 ③ I didn't intend to hurt you.
 ④ She chose having some ice cream.
 ⑤ My father doesn't like to wear neckties.

11 ① I regret to buy this bag yesterday.
 ② We stopped to wait for the green light.
 ③ He couldn't avoid serving in the army.
 ④ He was used to walking his dogs.
 ⑤ I look forward to seeing it on the big screen.

12 짝지어진 두 문장의 뜻이 같지 않은 것은?

① I'm sorry for not having called you.
 = I'm sorry that I didn't call you.
② I'm sure of her having committed the crime.
 = I'm sure that she committed the crime.
③ He is afraid of missing the last train.
 = He is afraid that he missed the last train.
④ She is very proud that she was a nurse.
 = She is very proud of having been a nurse.
⑤ She complained of the room being very hot.
 = She complained that the room was very hot.

13 다음 중 어법상 바른 문장을 모두 고른 것은?

ⓐ Her baby began to cry at the noise.
ⓑ He is scared of to swim in the lake.
ⓒ The police officer gave up to chase the thief.
ⓓ I won't forget to call you tomorrow.
ⓔ I decided going on a diet.

① ⓐ, ⓒ 　　　　② ⓐ, ⓓ
③ ⓑ, ⓓ 　　　　④ ⓑ, ⓔ
⑤ ⓒ, ⓔ

14 다음 우리말과 뜻이 같도록 주어진 단어를 이용하여 문장을 완성하세요.

나한테 문자 보내는 거 잊지 마.
(forget, send)

→ Don't _____ a text message to me.

[15-17] 다음 대화를 읽고 물음에 답하세요.

> A: How was your trip to Beijing?
> B: It was really great. (A) I especially remember to visit Wangfujing Street.
> A: What did you do there?
> B: While I was busy ___(B)___ different street foods, my sister was admiring a wide variety of shops.
> A: Wow, sounds like you had a wonderful time.
> B: I did. (C) 베이징은 방문할 가치가 있다고 생각해.

15 위 대화의 밑줄 친 (A)에서 어법상 틀린 곳을 찾아 바르게 고치세요.

_____ → _____

16 위 대화의 빈칸 (B)에 들어갈 말로 어법에 맞는 것은?

① eat
② eats
③ eating
④ to eat
⑤ having eaten

17 위 대화의 밑줄 친 (C)의 우리말과 뜻이 같도록 주어진 단어를 활용하여 문장을 완성하세요.

| worth visit |

→ I think that Beijing _____.

18 다음 대화의 빈칸에 들어갈 말로 알맞은 것은?

> A: I'm sorry, but I won't be able to go camping with you this weekend.
> B: Come on! I was really looking forward _____ camping with you.

① go ② to go
③ going ④ to going
⑤ to having gone

19 다음 빈칸 (A)와 (B)에 들어갈 말로 알맞게 짝지어진 것은?

> • The zoo keeps people from ___(A)___ the animals.
> • I am not good at ___(B)___ to strangers.

	(A)		(B)
①	feed	talk
②	feeding	talking
③	to feed	to talk
④	feeding	have talked
⑤	feed	talking

20 우리말과 뜻이 같도록 괄호 안에 주어진 단어의 알맞은 형태를 빈칸에 쓰세요.

| Tom은 시끄러운 거리에서 사는 데 익숙하다. |

→ Tom is used to _____ (live) on a noisy street.

서술형 만점 Writing Exercises

1 다음 우리말과 뜻이 같도록 괄호 안의 단어를 이용하여 문장을 완성하세요. (단, 동사의 형태를 바꿀 수 있음)

(1)
> Ben은 늘 문을 잠그는 것을 잊어버린다.
> (the door, forget, lock)

→ Ben always _____ .

(2)
> 나는 그녀의 어머니에게 인사하기 위해 멈춰 섰다.
> (stop, say hello to)

→ I _____ .

(3)
> 내가 여기 앉아도 될까요? (mind, sit)

→ Do you _____ ?

2 다음 우리말과 뜻이 같도록 괄호 안의 단어를 알맞게 배열하여 문장을 완성하세요.
(필요할 경우, 단어의 형태를 바꿀 것)

(1)
> 나는 그가 그렇게 늦는 것을 이해할 수가 없다.
> (can't, late, understand, be, he, so)

→ I _____ .

(2)
> 그녀는 일찍 일어나는 것에 익숙하지 않다.
> (not, used, early, be, get up, to)

→ She _____ .

3 다음 사진을 보고 괄호 안에 주어진 단어를 이용하여 대화의 빈칸에 들어갈 말을 완성하세요.

> A: I called you last night many times, but you didn't answer.
> B: Oh, I'm so sorry. I _____ in the laboratory.
> A: I see.

(busy, do, research)

→ _____

4 다음 우리말과 뜻이 같도록 주어진 문장을 바르게 고치세요.

> 나의 개는 밖으로 나가려고 애쓰고 있었다.
> My dog was trying go out.

→ _____

5 다음 문장과 뜻이 같도록 문장을 완성하세요.

> As soon as I came back home, I started to play the guitar.

= On _____ _____ _____ ,
I started _____ the guitar.

CHAPTER

06

분사

| 기본 개념 & 용어 Review |

분사에는 현재분사(v-ing)와 과거분사(p.p.)가 있어요.
분사는 문장 내에서 여러 역할을 해요.

① 명사 수식 분사 명사 분사구 ~

② 보어 *My mother* sat **knitting**. (주격보어)

 I heard *birds* **singing**. (목적격보어)

③ 감정을 나타내는 분사 The game was **exciting**. (감정을 느끼게 하는)

 Children were **excited**. (감정을 느끼는)

Unit 15 분사의 종류와 명사 수식 역할

분사는 현재분사(v-ing)와 과거분사(p.p.)가 있으며 명사를 수식하는 형용사 역할로 많이 쓰여요.

A 명사 수식 역할

❶ 현재분사 (v-ing): ~하는, ~하고 있는

- Write an **exciting** story about animals.
 a story which **excites** people 능동: ~하는

- Who is the **smiling** girl? 진행: ~하고 있는
 the girl who **is smiling**

> **More** 동명사와 현재분사
> 동명사가 명사 앞에서 ¹_____처럼 쓰일 때는 '~하기 위한'의 의미로서 그 명사의 용도, 목적을 나타내요.
> a **swimming** pool (동명사: **수영장**)
> *cf.* a **swimming** dog (현재분사: **수영하는 개**)

❷ 과거분사 (p.p.): ~된, ~한

- There were **broken** toys all over the room. 수동: ~된
 toys which **were broken**

- The **fallen** leaves are spread all over the street. 완료: ~한
 leaves which **have fallen**

> **More** 동사 역할을 하는 분사
> 분사는 명사를 수식하는 형용사 역할 외에도 동사로 쓰여 진행형, 완료형, 수동태를 만들어요.
> Kate **is crying** in her room. (진행형: be동사+v-ing)
> **Have** you ever **been** to Kyoto? (완료형: have[has]/had+p.p.)
> He **was arrested** in 2018. (수동태: be동사+p.p.)

B 분사의 위치

명사 뒤 또는 앞
분사 뒤에 딸린 어구가 없는 분사는 명사 ²_____에서 수식하고, 분사 뒤에 목적어, 보어, 부사(구) 등이 딸려 있을 때는 명사 뒤에서 수식해요.

- Scuba diving is a very **exciting** *sport*.

- The boat was full of **excited** *scuba divers*.

- I know *a customer* **wanting *to buy a home theater*** 분사+목적어
 system. (= *a customer* **who is wanting to buy ~**.)

- *People* **employed *by the government*** decided to go 분사+부사구
 (= *People* **who were employed by the government**)
 on strike.

PRACTICE

정답 및 해설 p.14

STEP 1

문맥상 빈칸에 적절한 말을 〈보기〉에서 골라 알맞은 형태로 쓰세요.

〈보기〉 finish want fall smile gain
 break call lose run cook

1 I enjoy the sound of _____ raindrops on the roof.

2 My daughter's _____ face always makes me happy.

3 It's better to eat _____ fish in summer.

4 I went to the luggage office to find my _____ bag.

5 Venus is sometimes _____ the evening star.

6 She is _____ weight these days.

7 I couldn't find out how to fix my son's _____ toys.

8 I love animals. I've always _____ to be an animal doctor.

9 This work is urgent. It should be _____ by tomorrow.

10 Wash the vegetables under _____ water for one minute.

STEP 2

주어진 두 문장을 합친 의미가 되도록 빈칸을 채우세요.

1 I know those three girls. They are sitting on the grass.
 → I know those three girls _____ on the grass.

2 My mother likes chocolates. They are made in Belgium.
 → My mother likes chocolates _____ in Belgium.

3 I have lived in a small town. It is located near the sea.
 → I have lived in a small town _____ near the sea.

4 Look at the dog. It is sleeping with the baby.
 → Look at the dog _____ with the baby.

STEP 3

괄호 안에서 어법에 맞는 것을 고르세요.

1 The [cry / crying] baby is my little sister Sara.

2 An iceberg is a large body of ice [floating / floated] in water.

3 Instead of finishing the race, Tony chose to stop and help an [injuring / injured] runner.

4 She found some errors in the magazine [publishing / published] last week.

5 My grandmother needs a [walking / walked] stick.

6 All those [participating / participated] in this trip will have the chance to see the northern lights.

7 When you eat fewer calories than you use, your body burns [storing / stored] calories.

8 A [growing / grown] child needs special care and attention from his or her parents.

STEP 4

밑줄 친 부분 중 어법상 틀린 것을 찾아 바르게 고치세요.

1 According to <u>recent</u> research, the newly <u>developed</u> medicine can <u>help</u> those
 ① ② ③
 <u>suffered</u> from depression.
 ④

2 A boy <u>leaving</u> in a <u>locked</u> room has been <u>rescued</u> <u>by</u> firefighters.
 ① ② ③ ④

3 There <u>are</u> 6,800 <u>known</u> languages <u>speaking</u> in the two <u>hundred</u> countries of the
 ① ② ③ ④
 world.

4 The project <u>leading</u> by Ken <u>included</u> <u>planting</u> trees and <u>reducing</u> plastic waste.
 ① ② ③ ④

5 The singer <u>was</u> under pressure because there <u>were</u> too <u>many</u> people <u>watched</u>
 ① ② ③ ④
 him.

Unit 15

내신 적중 Point

Point 01 **성격이 다른 것 찾기**
현재분사는 명사 앞이나 뒤에서 명사를 수식하고, 동명사는 문장에서 명사 역할을 해요.

Point 02 **그림이 나타내는 상황 표현하기**
그림 속 인물의 행동을 나타내기 위해 진행형이나 완료형을 사용하는 경우와 상황을 묘사하는 표현 등에 분사가 많이 쓰여요.

정답 및 해설 p.14

Point 01

● **밑줄 친 부분 중 나머지와 쓰임이 다른 하나는?**

① My dog likes playing with a ball.
② Vietnam is a developing country.
③ We thought he was taking a nap.
④ Who is the man sitting in the corner?
⑤ She is talking to her friend on the phone.

Point 02

서술형 ▶

● **괄호 안에 주어진 단어의 형태를 알맞게 바꾸어 다음 사진을 묘사하는 문장을 완성하세요.**

(repair, break)

→ A man is _____ his son's _____ bicycle.

Unit 16

분사의 보어 역할, 감정을 나타내는 분사

분사는 명사를 수식하는 역할 외에도 <u>주어나 목적어를 설명해 주는 보어 역할</u>을 할 수 있어요.

A 주격보어 역할

주어의 동작, 상태: **v-ing**(~하면서), **p.p.**(~된[~한] 채로)

* He sat **reading** a newspaper.
* The problem remained **unsolved**.

cf. My hobby is **making** short movies.

> 능동: ~하면서
> 수동: ~된 채로
> 동명사 보어 (~하는 것) = 주어

B 목적격보어 역할

목적어와 능동 관계는 **v-ing**, 수동 관계는 **p.p.**
지각동사(see, hear, ...), 사역 의미의 동사(have, get, ...), 상태동사(keep, leave, ...) 뒤에 쓰여요.

* I *heard* her **singing** a song loudly.
* We *had* a taxi **waiting** for us.
* He *got* the machine **repaired**.
* He *saw* the door **opened**.
* They *kept* me **waiting** so long.
* I *found* her **crying** on the bed.
* He *left* the work **unfinished**.

> hear: O가 ~하고 있는 것을 듣다
> have: O가 ~하게 하다
> get: O가 ~되도록 하다
> see: O가 ~된 것을 보다
> keep: O를 ~하는 상태로 두다
> find: O가 ~하고 있는 것을 발견하다
> leave: O가 ~된 채로 두다

C 감정을 나타내는 분사

감정을 느끼게 하는 현재분사, 감정을 느끼는 과거분사
주어가 누군가에게 어떤 감정을 느끼게 할 때는 1_____를, 주어가 어떤 감정을 느낄 때는 2_____를 써요.
분사가 명사를 수식하는 경우, 수식받는 명사가 다른 대상에게 감정을 느끼게 할 때는 현재분사를, 어떤 감정을 느낄 때는 과거분사를 써요.

* The news was very **surprising**. /
 surprising news
* People looked **surprised** at the news. /
 surprised people

> '놀라게 하는' 뉴스
> '놀란' 사람들

interesting (흥미를 갖게 하는)	interested (흥미를 가진)	exciting(신나게 하는)	excited(신이 난)
boring(지루하게 하는)	bored(지루해 하는)	amazing(놀라게 하는)	amazed(놀란)
satisfying(만족하게 하는)	satisfied(만족한)	frightening(무섭게 하는)	frightened(무서워하는)
exhausting(지치게 하는)	exhausted(지친)	depressing(우울하게 하는)	depressed(우울해하는)
embarrassing (당황하게 하는)	embarrassed(당황한)	confusing(혼란시키는)	confused (혼란스러워하는)
shocking(놀라게 하는)	shocked(놀란)	disappointing (실망시키는)	disappointed(실망한)
pleasing(즐겁게 하는)	pleased(즐거워하는)	annoying(짜증나게 하는)	annoyed(짜증난)

PRACTICE

STEP 1

괄호 안에서 어법에 맞는 것을 고르세요.

1 They sat [watch / watching] TV for a while.

2 She stood [looking / looked] at the picture on the wall.

3 I'm [pleasing / pleased] to hear you are feeling better.

4 That [annoying / annoyed] sound is coming from the speakers.

5 My heart beat fast when I heard my name [calling / called].

6 Success in one's work is a [satisfying / satisfied] experience.

7 Her new novel was [disappointing / disappointed]. I expected it to be much better.

8 We saw the sun [sinking / sunk] below the horizon.

9 I felt [embarrassing / embarrassed] when I fell hard on the floor.

10 You'd better keep your cell phone [turning / turned] off on a plane.

STEP 2

다음 문장에서 어법상 틀린 곳을 바르게 고치세요.

1 Where did you get your car to fix?

　　＿＿＿＿＿＿＿＿＿ → ＿＿＿＿＿＿＿＿＿

2 They felt satisfying with her answer.

　　＿＿＿＿＿＿＿＿＿ → ＿＿＿＿＿＿＿＿＿

3 He got depressing when he failed the exam.

　　＿＿＿＿＿＿＿＿＿ → ＿＿＿＿＿＿＿＿＿

4 She watched the thief stolen the jewelry.

　　＿＿＿＿＿＿＿＿＿ → ＿＿＿＿＿＿＿＿＿

5 Bob woke up when he heard the dog barked.

　　＿＿＿＿＿＿＿＿＿ → ＿＿＿＿＿＿＿＿＿

STEP 3

〈보기〉와 같이 주어진 단어의 알맞은 형태를 빈칸에 쓰세요.

> 〈보기〉 (surprise)
> a. Some of the scenes in the movie were quite <u>surprising</u>.
> b. They were pleasantly <u>surprised</u> at the news of having twins.

1 (bore)

a. I think that learning math is _____.

b. You never made me _____ with your story.

2 (excite)

a. _____ fans waited for the famous singer to show up.

b. That was really an _____ match.

3 (frighten)

a. He was _____ by his reflection in the mirror.

b. It is _____ for him to realize what is happening to him.

4 (depress)

a. Listening to the sad song made me _____.

b. Some memories of my childhood are _____.

STEP 4

다음 우리말과 뜻이 같도록 괄호 안의 단어를 배열하여 문장을 완성하세요.
(단, 굵은 글씨로 된 동사는 분사 형태로 바꿀 것)

1 그는 깨어났을 때, 자신이 해변에 누워 있는 것을 알았다. (himself, found, **lie**)

→ When he woke up, he _____ on the beach.

2 그 섬으로의 긴 여행은 매우 피곤했다. (**tire**, very, was)

→ The long journey to the island _____.

3 나는 내 여동생이 연극 대사를 암기하고 있는 것을 보았다. (saw, **memorize**, my sister)

→ I _____ her lines for the play.

내신 적중 Point

Point 01 어법상 틀린 문장 찾기

감정을 느끼게 할 때는 현재분사, 감정을 느낄 때는 과거분사를 쓰세요.

Point 02 단락을 읽고 어법에 맞는 표현 고르기

글의 흐름을 통해 능동을 뜻하는 말이 필요한지, 수동을 뜻하는 말이 필요한지 파악하세요.

정답 및 해설 p.15

Point 01

● 다음 중 어법상 틀린 문장은?

① Monday morning is usually boring.

② I saw the man arrested at the crime scene.

③ This music is very pleased to the ear.

④ It was the most exciting moment in my life.

⑤ I had my computer fixed today.

Point 02

● 다음 (A), (B), (C)의 각 네모 안에서 어법에 맞는 표현으로 가장 적절한 것은?

A British man, Howard Stapleton, invented an (A) interesting / interested device. The device (B) naming / named the Mosquito produces special sounds, which can be heard only by teenagers. Some shop owners found the device very useful. It could drive away teenagers (C) hanging / hanged out late around their shops.

	(A)		(B)		(C)
①	interesting	……	naming	……	hanging
②	interesting	……	named	……	hanging
③	interesting	……	naming	……	hanged
④	interested	……	named	……	hanged
⑤	interested	……	naming	……	hanged

Overall Exercises 06

[1-4] 빈칸에 들어갈 말로 알맞은 것을 고르세요.

1

I'm looking for some _____ topics to talk about with my friends.

① interest
② interests
③ interested
④ interesting
⑤ being interested

2

The police examined the fingerprints _____ from the crime scene.

① take
② took
③ taken
④ taking
⑤ to take

3

The information _____ in this booklet will help you better understand our school.

① provide
② provides
③ provided
④ providing
⑤ to provide

4

I found my brother _____ under the bed.

① hides
② hiding
③ to hide
④ hidden
⑤ being hidden

[5-6] 빈칸에 들어갈 말이 바르게 짝지어진 것을 고르세요.

5

• He is always _____ about meeting new people.
• I heard the song _____ in Italian.

① exciting singing
② excited singing
③ excited sung
④ exciting sung
⑤ excited sing

6

• He had some fish _____ in the oven.
• Most people who visit the exhibition will find his works _____.

① cooked to amaze
② cooked amazing
③ cooked amazed
④ cooking amazing
⑤ cooking amazed

7 **다음 문장에서 어법상 틀린 것을 바르게 고치세요.**

My brother was exciting to see the dolphin swimming and playing in the sea.

_____ → _____

[8-9] 다음 중 밑줄 친 부분의 쓰임이 다른 하나를 고르세요.

8
① Are you having a good time?
② Making new friends takes time.
③ Who is the boy standing at the gate?
④ They tried to escape from the burning building.
⑤ I'm reading the last chapter of this book.

9
① They enjoy meeting new people.
② Keeping a diary is not as easy as you think.
③ It is a confusing lesson for the students.
④ I find living in this city quite stressful.
⑤ Some animals are in danger of becoming extinct.

[10-12] 다음 밑줄 친 부분 중 어법상 틀린 것을 고르세요.

10
These days, more and more people want
① ②
to buy fresh vegetables grew by local
③ ④ ⑤
farms.

11
I am always afraid of speaking in front
① ②
of many people watched me.
③ ④ ⑤

12
The museum is designed like a spaceship
①
floating over the water with all its walls
② ③
making of glass.
④ ⑤

[13-14] 다음 중 어법에 맞는 문장을 고르세요.

13
① Asian art is really interested.
② He moved a huge rock blocked the road.
③ I finally got my computer to fix.
④ We saw a fisherman waving to us from his boat.
⑤ This list shows 100 popular books writing for teenagers.

14
① Look at the sun risen over the horizon.
② I felt something crawling up my leg.
③ He kept me waited for two hours.
④ Jack had the bottle filling with water.
⑤ It was an exhausted day. We were all tired.

15
다음 우리말과 뜻이 같도록 주어진 단어의 알맞은 형태를 빈칸에 쓰세요.

잠자는 아기를 깨우지 않도록 주의해라. (sleep)

→ Be careful not to wake up the _____ baby.

Overall Exercises

[16-17] 다음 글을 읽고 물음에 답하세요.

A police officer found a perfect (A) hiding / hidden place for watching for speeding drivers. One day, the officer was so (B) surprising / surprised to find everyone was under the speed limit. He searched the area and found the big problem. A little boy was standing on the side of the road with a huge sign (C) saying / said "Speed Trap Ahead." And about 200 meters beyond the speed trap, there was another boy with a sign reading "Tips" and a bucket full of change.

16 윗글의 (A), (B), (C)의 각 네모 안에서 어법에 맞는 표현으로 가장 적절한 것은?

	(A)	(B)	(C)
①	hiding	surprising	saying
②	hiding	surprising	said
③	hidden	surprising	saying
④	hidden	surprised	said
⑤	hiding	surprised	saying

17 윗글의 밑줄 친 watching과 쓰임이 같은 것은?

① I heard the band playing music.
② I heard the disappointing news this morning.
③ I saw Phillip running to school this morning.
④ He was embarrassed about making lots of mistakes.
⑤ The girl sitting next to him is his assistant, Jenny.

[18-19] 다음 중 밑줄 친 부분이 어법상 틀린 것을 고르세요.

18
① Henry, stay away from the boiling water!
② I love reading stories about unsolved mysteries.
③ This is a list of novels making into movies.
④ Car owners are worrying about rising oil prices.
⑤ Dried fruit has a longer storage life than fresh fruit.

19
① The expected event did not happen.
② The abandoned car was found by the police.
③ He took a photo of his son dancing on the stage.
④ Look at the mountaintop covering with white clouds.
⑤ She ran out of the room crying loudly.

20 우리말과 뜻이 같도록 괄호 안에 주어진 단어의 알맞은 형태를 빈칸에 쓰세요.

무료 세탁 서비스는 5박 이상 머무르는 손님에게 제공됩니다.

→ Free laundry service is provided to guests _____ (stay) five nights or more.

서술형 만점 Writing Exercises

1 다음 우리말과 뜻이 같도록 괄호 안의 단어를 이용하여 문장을 완성하세요. (단, 동사의 형태를 변화시킬 수 있음)

(1)
> 그는 다양한 물체 위로 떨어지는 빗방울 소리를 녹음했다.
> (raindrops, fall, the sound of)

→ He recorded _____
 on different objects.

(2)
> 차고 구석에 먼지를 뒤집어쓴 채 있는 자전거를 봐라. 그것은 네 거지?
> (the bike, with, cover, dust)

→ Look at _____ in
 the corner of the garage. Is it yours?

(3)
> 너는 너의 눈을 정기적으로 검사해야 한다.
> (have, examine, your eyes)

→ You should _____
 regularly.

2 다음 우리말을 주어진 〈조건〉에 맞게 영어로 옮기세요.

> 나는 Tim이 그의 친구들과 축구를 하고 있는 것을 보았다.
>
> 〈조건〉
> • 모두 8단어로 쓸 것
> • 분사를 사용할 것

→ _____

3 다음 사진을 보면서 두 사람이 하는 대화의 빈칸에 알맞은 말을 쓰세요. (단, 분사를 사용할 것)

> A: Who are the boys and girls in the picture? Are they your friends?
> B: No. They are my sister and her friends.
> A: Who is your sister?
> B: The girl _____ is my sister Sally. She has long hair.

→ _____

4 두 상자에서 어울리는 표현을 하나씩 찾아 동사를 적절한 형태로 바꾸어 문장을 완성하세요.

the T-shirt the koala the man	climb the tree sing a familiar song display in that shop

(1) I'd like to buy _____.

(2) Look at _____.
 It's really cute.

(3) When I walked through the alley, I heard _____.

CHAPTER

07

문장의 형식

| 기본 개념 & 용어 Review |

문장은 뒤에 따라 나오는 것들에 따라 크게 다섯 가지로 분류할 수 있어요.

① 주어 + 동사

② 주어 + 동사 + 주격보어
　　　└───── = ─────┘

③ 주어 + 동사 + 목적어
　　　└───── ≠ ─────┘

④ 주어 + 동사 + 간접목적어 + 직접목적어

　⇔ 주어 + 동사 + 목적어 + 전치사+(대)명사

⑤ 주어 + 동사 + 목적어 + 목적격보어
　　　　　　└── = ──┘

이 챕터에서는 각 문장 형식의 특징에 대해 알아보기로 해요.

Unit 17 주어+동사/주어+동사+주격보어

주어와 동사만으로 의미가 완전한 문장과, 의미가 불완전하여 <u>주어를 보충 설명하는 주격보어</u>가 필요한 문장이 있어요.

A 「주어+동사」 문장

주어(S)+동사(V)(+수식어구)

주어와 <u>1_____</u>만으로 의미가 완전한 문장을 만들어요. 수식어구가 같이 오는 경우가 많지만, 수식어구를 문장에서 없애도 문장을 이해할 수 있어요.

- <u>**My stomach**</u> <u>**ached**</u> *really badly*.
 S V

- *There* <u>**are**</u> <u>**many flowers**</u> *along the river*.
 V S

- <u>**The light**</u> *in my room* <u>**went**</u> off.
 S V

B 「주어+동사」 문장의 동사

❶ 주로 쓰이는 동사

주어 스스로 동작을 할 뿐 다른 대상에 동작을 가하는 것이 아니므로 주어만 있으면 문장의 의미를 완전하게 만들어요.

- They **appeared** in the afternoon. 나타나다
- I **fell** from the stairs. 떨어지다
- I **go** to school by bus. 가다
- We are **arriving** soon. 도착하다
- The sun **rises** in the east. 떠오르다

> **More** 「주어+동사」 문형으로 쓰이는 주요 동사
>
> **sleep** well(잠자다) **cough** loudly(기침하다) **disappear** suddenly(사라지다)
>
> really **matter**(중요하다) **occur** in Asia(발생하다) **stay** at home(머무르다)
>
> 구동사는 이 문형으로 쓰이는 경우가 많아요.
>
> **stand up**(일어서다) **sit down**(앉다) **run away**(도망치다)
>
> **wake up**(잠에서 깨다) **lie down**(눕다) **go out**(외출하다, (불이) 꺼지다)
>
> **walk away**(떠나다) **break down**(고장나다)

❷ 쓰임에 주의해야 할 동사

「주어+동사」 문형으로 쓰이는 동사라도 뜻이 약간 달라지면 <u>2_____</u>와 함께 쓸 수도 있어요.

- ⌐ The vase **broke** into pieces. 깨지다
- ⌐ I **broke** *the vase*. ~을 깨뜨리다
- ⌐ Your essay **reads** well. 읽히다
- ⌐ I **read** *your essay* all day long. ~을 읽다
- ⌐ His new book didn't **sell**. 팔리다
- ⌐ She **sold** her car for $20,000. ~을 팔다

C 「주어+동사
+주격보어」
문장

❶ 주격보어가 명사: 내용상 주어와 동격이며, 주어의 신분을 나타냄
He is **a new member of our organization**.
S └──=──┘ C

❷ 주격보어가 ³_____: 주어의 상태·성질을 나타냄
The game was **very exciting**.
 S └──=──┘ C

D 「주어+동사+
주격보어」
문장의 동사

❶ be(~이다) / remain, lie, stay, keep(~인 채로 있다)
• The cat **is** cute.
• They **remained** silent over the issue.
• Some books **lie** open on the table.
• I exercise regularly to **stay** healthy.
• She **kept** quiet for a while.

❷ seem, look, appear: ~처럼 보이다, ~인 것 같다
• He **seems** rich.
• David **looks** very tired.
• The apples **appear** rotten.

❸ become, get, grow, go, turn, fall, run, come: ~가 되다
• Katherine **became** a famous movie star.
• She will **get** better soon.
• He **grew** a little stronger.
• The engine **went** bad.
• Her face **turned** red.
• The girl **fell** asleep on the bus.
• Electricity **runs** short during hot summers.
• My dreams will **come** true.

❹ 감각동사 feel, smell, sound, taste
• I **feel** cold.　　　　　　　　　　~한 느낌이 들다
• The perfume **smells** good.　　　~한 냄새가 나다
• His music **sounds** pleasant.　　~하게 들리다
• They **taste** very sweet and delicious.　~한 맛이 나다

PRACTICE

괄호 안에서 어법과 문맥상 알맞은 것을 고르세요.

1 Spring [comes / makes] after winter.

2 The birds in the tree sing [beautiful / beautifully].

3 Two young men arrived [the party / at the party].

4 His baby girl is so [love / lovely].

5 Roses look beautiful and smell [sweet / sweetly].

6 The plane arrived [safe / safely] at the airport.

7 The most important thing in life is [happy / happily / happiness].

8 The library will remain [open / openly] at night.

9 The weather has turned [cold / coldly] these days.

10 That type of cloth can burn [easy / easily].

11 Several people stopped and looked at the cat [silent / silently].

12 The athlete runs very [fast / fastly].

문맥상 빈칸에 가장 적절한 말을 〈보기〉에서 골라 쓰세요.

| 〈보기〉 | sleepy | bad | gray | happy | calm |

1 In order to win an argument, you should stay _____.

2 The milk has gone _____. The "use by" date was last Monday.

3 I don't like reading. Every time I read a book, I get _____ in a minute.

4 In time, everyone's hair turns _____.

5 What's wrong with Jake? He doesn't seem _____ these days.

STEP 3

다음 중 어법상 <u>틀린</u> 문장을 고르세요.

1 ① The school bell is ringing now.
② There are lots of people in the bakery.
③ Amy coughed constantly because of a bad cold.
④ They are arriving Seoul soon.
⑤ I eat at home every day.

2 ① "Why not?" is a slogan for an interesting life.
② Charles looks greatly in his new suit.
③ Her face went red with anger.
④ I was happy when I got a birthday present from my dad.
⑤ Russia is one of the world's coldest countries.

STEP 4

다음 우리말과 뜻이 같도록 〈보기〉에서 고른 동사와 괄호 안의 단어를 이용하여 문장을 완성하세요.

〈보기〉 look keep feel taste go

1 그는 정신이 나가서 다른 사람들을 공격하려고 했다. (mad)

→ _____ and tried to attack the others.

2 솔직히 그 파스타는 맛이 별로였다. (good)

→ Honestly, the pasta _____.

3 그들은 공연하는 동안 침묵을 지켰다. (silent)

→ _____ during the performance.

4 나는 놀이공원에서 롤러코스터를 탄 후 현기증을 느꼈다. (dizzy)

→ _____ after riding a roller coaster at the amusement park.

5 그 환자의 얼굴이 매우 창백해 보인다. (very pale)

→ The patient's face _____.

주어＋동사＋목적어/
주어＋동사＋간접목적어＋직접목적어

대부분의 문장은 주어와 동사 외에 목적어가 있어야 의미가 완전해져요.
'~에게 …을 해 주다'라는 뜻의 수여동사는 두 개의 목적어를 필요로 해요.

A 「주어＋동사＋목적어」문장

목적어의 여러 종류

목적어로는 (대)명사 혹은 그런 역할을 하는 어구가 쓰일 수 있어요.

• We have **two computers**.	명사
• I love **you**.	대명사
• We enjoyed **ourselves** at the party.	재귀대명사
• I want **to visit Australia**.	to부정사구
• She likes **watching movies**.	동명사구
• I don't think **that the price is reasonable**.	명사절

More 주격보어와 목적어의 구별

주격보어(C)는 주어(S)를 설명하는 것이고, 목적어(O)는 동작의 대상을 나타내요.
She is **my music teacher**. (S＝C)
She is **angry**. (S의 상태＝C)
She likes **music**. (S≠O)

B 「주어＋동사＋목적어」문장의 동사

쓰임에 주의해야 할 동사

자연스런 우리말로 목적어가 '~을[를]'로 해석되지 않는 동사는 목적어 앞에 1_____가 필요한 것으로 착각하기 쉬우므로 주의해야 해요.

• He didn't **answer** ~~to~~ my question.	~에 대답하다
• A train is **approaching** ~~to~~ the station.	~에 다가가다
• Many tourists **attend** ~~at~~ the cooking class.	~에 참석하다
• Let's **discuss** ~~about~~ environmental problems.	~에 대해 논의하다
• We **entered** ~~into~~ the main lobby.	~으로 들어가다
• The police officer **explained** ~~about~~ the situation.	~에 대해 설명하다
• Over two million people **inhabit** ~~in~~ the island.	~에 거주하다
• Will you **marry** ~~with~~ me?	~와 결혼하다
• I don't want to **mention** ~~about~~ my childhood.	~에 대해 언급하다
• Every citizen should **obey** ~~to~~ the law.	~에 복종하다, 따르다
• The temperature **reached** ~~to~~ 40 degrees.	~에 이르다[닿다]
• Jane **resembles** ~~with~~ her mother very much.	~와 닮다
• She **survived** ~~from~~ the fire in the mall.	~에서 살아남다
• Will you **join** ~~with~~ us for lunch?	~와 함께 하다

C 「주어+동사+
간접목적어+
직접목적어」
문장

❶ 간접목적어(IO)와 직접목적어(DO)

'~에게 …을 해 주다'라는 의미의 동사 중에는 동사 뒤에 '~에게'에 해당하는 2 _____ 와 '~을'에 해당하는
직접목적어를 순서대로 써서 문장을 만들 수 있는 것이 있어요.

- Please **give** <u>me</u> <u>a call</u>.
 IO DO

~에게 …을 주다

- I will **teach** <u>you</u> <u>how to swim</u>.
 IO DO

~에게 …을 가르쳐주다

❷ 주로 쓰이는 동사

- She **told** me an interesting story. ~에게 …을 말하다
- I'll **show** you some pictures. ~에게 …을 보여주다
- She **sent** me a Christmas card. ~에게 …을 보내다
- I will **make** you some sandwiches. ~에게 …을 만들어주다
- Peter **bought** her a pair of earrings. ~에게 …을 사주다
- The police officer **asked** me a lot of questions. ~에게 …을 묻다

그밖에 알아두면 유용한 주요 수여동사			
bring us food	**pass** me the salt	**hand** me the report	**sell** me the book
write me a letter	**lend** me his car	**build** them houses	**promise** him a bike
get me a ticket	**choose** him a gift	**cook** her spaghetti	**find** me a pencil

D 「주어+동사+
목적어+
전치사+명사」
문장

「S+V+IO+DO」 ⇔ 「S+V+O+to/for/of+(대)명사」

간접목적어와 직접목적어는 순서를 바꿔 쓸 수도 있어요. 이때 간접목적어는 「3 _____ +(대)명사」 형태가
된답니다. 단, 동사에 따라 적절한 전치사를 써야 해요.

to	give, tell, show, send, teach, bring, write, sell, hand, pass, lend, offer, promise, read, sing 등
for	make, buy, get, cook, build, find 등
of	ask

- Please **give** a call *to* me. (← Please **give** me a call.)
- She **told** an interesting story *to* me.
- I'll **show** some pictures *to* you.
- She **sent** a Christmas card *to* me.

- I will **make** some sandwiches *for* you. (← I will **make** you some sandwiches.)
- Peter **bought** a pair of earrings *for* her.
- He **cooked** spaghetti *for* her.

- May I **ask** a favor *of* you?

PRACTICE

STEP 1

다음 문장에서 목적어, 간접목적어, 직접목적어를 찾아 밑줄을 긋고 각각 O, IO, DO로 표시하세요.

1 He changed his mind soon.

2 I don't want to go outside because it's raining now.

3 Rebecca chose him a good English grammar book.

4 He will join his wife this weekend.

5 Seho promised them that he would finish his homework on time.

6 A well-trained dog should obey its owner's orders.

7 Did anyone leave a message while I was out?

8 Her grandmother usually brings her home from the kindergarten.

9 The band sang their new song on the stage.

10 The organization built the local children a new playground.

11 I've read almost all of the author's novels.

12 This evidence shows us that he might have a connection to the crime.

STEP 2

괄호 안에서 어법에 맞는 것을 고르세요.

1 Dan [resembles / resembles with] his elder sister.

2 Her family [survived / survived from] the earthquake in Indonesia.

3 I told [my teacher / to my teacher] that I would not be late again.

4 My mother brought [us / to us] some gifts from her trip to India.

STEP 3

빈칸에 전치사 to, for, of 중 알맞은 것을 쓰세요.

1 She wrote a letter _____ him.

2 Could you hand this book _____ Mitchell?

3 I'll buy lunch _____ you today.

4 They sold their used furniture _____ their neighbor.

5 He gave a toy car _____ his baby son to stop his crying.

6 Would you send a reply _____ them as quickly as possible?

7 The teacher asked some questions _____ him, but he didn't answer.

8 They made a wooden house _____ their dog.

9 I don't want to tell the news _____ him. He must get upset.

10 Ms. Jeong taught Korean history _____ us last year.

STEP 4

두 문장의 뜻이 같도록 빈칸을 완성하세요.

1 She sang a happy song to all the guests.

 = She sang all the guests _____.

2 He built his children a tree house.

 = He built _____.

3 Would you hand me the book?

 = Would you _____?

4 Can you find me my lost wallet?

 = Can you _____?

5 May I ask you a favor?

 = _____ you?

Unit 19 주어+동사+목적어+목적격보어

목적어의 상태나 동작 등을 설명하는 말인 목적격보어로는 명사, 형용사, to부정사, 현재분사, 과거분사, 원형부정사 등이 올 수 있어요. 목적격보어(C)는 목적어(O)의 신분, 상태, 동작 등을 보충 설명해줍니다.

A 「주어+동사+목적어+목적격보어(명사, 형용사)」 문장

❶ 명사 목적격보어

이때는 목적어와 목적격보어가 ¹_____ 관계로서 목적어의 신분을 보충 설명해요.

• Will you please **call** *me Tony*? 　　　　　　　　　O = C	~을 …라고 부르다
• They **named** their dog *Apollo*.	~을 …라고 이름 짓다
• They **elected** her *president of their club*.	~을 …로 선출하다
• The teacher **appointed** him *leader*.	~을 …로 임명하다

> **More** 「동사+목적어+목적격보어」와 「동사+간접목적어+직접목적어」 문장
>
> 한 개의 목적어와 이를 보충 설명하는 목적격보어가 있는 문장과, 동작의 대상이 되는 목적어가 두 개인 문장을 구분할 수 있어야 해요.
>
> The song **made** her a big star. (~을 …으로 만들다: her = a big star)
> I **made** her a cake. (~에게 …을 만들어주다: her ≠ a cake)

❷ 형용사 목적격보어

목적격보어가 목적어의 성질, 상태 등을 나타내요.

• I **found** the book *helpful*.	~이 …라는 것을 알다
• My dog always **makes** me *happy*.	~을 …하게 만들다
• **Keep** the window *open*.	~을 …한 상태로 유지하다
• **Leave** the door *unlocked*.	~을 …한 상태로 두다
• They **consider** Matt *gentle*.	~을 …라고 여기다

B 「주어+동사+목적어+목적격보어(to부정사, 원형부정사, 현재분사)」 문장

❶ to부정사 목적격보어

주어와 ²_____의 관계처럼 목적격보어가 목적어의 동작, 상태를 나타내요. ask, expect, want, allow, require 등의 동사가 잘 쓰인답니다.

• He **asked** me *to stay* there.	~가 …하도록 요청하다
• She **expects** her son *to pass* the next exam.	~가 …하기를 기대하다
• I **want** him *to spend* more time with me.	~가 …하기를 원하다
• My parents **allowed** me *to go* to an amusement park.	~가 …하도록 허락하다
• The job **requires** me *to have* a lot of experience.	~가 …하도록 요구하다

그밖에 to부정사를 목적격보어로 쓰는 동사들	
tell me to exercise (~에게…하라고 말하다)	**order** them to obey (~가 …하도록 지시하다)
advise her to rest (~에게…하도록 충고하다)	**encourage** me to try (~가 …하도록 격려하다)
permit me to leave (~가 …하는 것을 허락하다)	**cause** them to worry (~가 …하게 하다)
get him to fix the car (~가 …하도록 시키다)	**force** me to give up (~가 …하도록 강요하다)
enable someone to succeed (~가 …하는 것을 가능하게 하다)	**persuade** him to change his mind (~가 …하도록 설득하다)

❷ 원형부정사 목적격보어

사역동사 let, make, have(~가 …하게 하다) 뒤에 쓰여 목적격보어가 목적어의 동작, 상태를 나타내요.
help는 목적격보어로 원형부정사와 ³_____를 모두 취할 수 있어요.

• **Let** me *try* once more.
• Nothing can **make** me *change* my mind.
• I'll **have** him *come* early tomorrow morning.
• This music can **help** you *(to) get* a good night's sleep.

> **More** get, cause+목적어+to부정사
>
> get, cause는 사역의 의미를 지녔지만 사역동사가 아니라 일반동사로 to부정사를 목적격보어로 취해요.
> Let's **get** her *to try* the new dish.
> What **caused** you *to change* your mind?

❸ 원형부정사/현재분사(-ing) 목적격보어

지각동사 hear, see, watch, feel, notice, listen to 등의 뒤에 쓰여 목적격보어가 목적어의 동작, 상태를
나타내요. 현재분사를 쓰면 진행의 의미가 강조돼요.

• I **saw** the police *chase* a robber.　　　　　경찰이 강도를 쫓는 것을 봄
• I **saw** the police *chasing* a robber.　　　　경찰이 강도를 쫓고 있는 것을 봄
• I could **hear** the girl *sing*[*singing*] in her room.
• I **felt** someone *tap*[*tapping*] my shoulder.
• Did you **watch** him *give* the statement yesterday?

> **More** 지각·사역동사+목적어+p.p.
>
> 지각동사나 사역동사의 목적어와 목적격보어가 수동 관계일 때는 목적격보어로 과거분사를 써요.
> I saw a robber **arrested** by the police.
> Yesterday, I had my hair **dyed**.

PRACTICE

다음 문장에서 보어를 찾아 밑줄로 표시하세요.

1 She always keeps her desk clean.

2 The boss appointed her head of the sales department.

3 The captain named the ship The Great Explorer.

4 He found the tool useful.

5 Peeling onions always makes me cry.

6 Hajun found the movie boring.

7 I've solved the question! You should call me "Little Einstein."

8 Tom is brilliant. I consider him a genius.

9 She felt someone touch her shoulder.

10 We saw the dog cross the street.

11 Do you want me to buy you a ticket for the concert?

12 Phillip allowed his son to study overseas.

다음 중 어법상 <u>틀린</u> 문장을 고르세요.

1 ① He left the door open again.

② The police found the man guilty.

③ Her classmates call her an angel.

④ The insistent calls kept me awake for twenty minutes.

⑤ My surprise visit made them happily.

2 ① A kind person brought me my lost wallet.

② He always invests his money safely.

③ They saw the river ice melting.

④ Let me just to tell you what I do all day.

⑤ I gave him a toy robot that transforms into a spaceship.

3 ① He wants his daughter to be a scientist.

② The music makes you feels good when you are sad.

③ We expect her not to be late this time.

④ The coach encouraged his players to cheer up.

⑤ I was sleepy, so I had my friend drive my car.

STEP 3 괄호 안에서 어법에 맞는 것을 <u>모두</u> 고르세요.

1 That experience made her more [confident / confidently].

2 I found her speech very [interesting / interest].

3 The doctor made the patient [stay / to stay] in bed.

4 I'm looking for an apartment which allows me [keep / to keep] pets.

5 I helped my cousin [pack / to pack] for his trip to Brazil.

6 Bill had the computer engineer [fix / to fix] his broken computer.

7 She got me [take / to take] her son to the science fair.

8 Her father didn't want her [be / to be] an actress.

9 I heard him [talk / talking] with someone on the phone.

10 The flight attendant asked passengers [fasten / to fasten] their seat belts.

11 Ms. Penn saw Brian [sweep / to sweep] the snow in front of her house.

PRACTICE

STEP 4

밑줄 친 부분이 어법에 맞으면 ○표를 하고, 틀리면 바르게 고치세요.

1 She made me <u>did</u> it again.

2 Did you watch him <u>make</u> the final goal?

3 The wet floor caused him <u>to falling</u> down.

4 My mother tells me <u>to exercise</u> regularly.

5 We saw the dog <u>crossed</u> the street.

6 I finally got her <u>agree</u> to see a doctor.

7 Why don't you ask her <u>to have</u> dinner with us?

8 You shouldn't let children <u>playing</u> with matches.

9 My mother had me <u>to clean</u> the whole house.

10 Do not force her <u>makes</u> a decision right now.

STEP 5

다음 우리말과 뜻이 같도록 괄호 안의 단어를 배열하여 문장을 완성하세요. (단, 동사의 형태를 변화시킬 수 있음)

1 그들은 자신들의 딸을 소진이라고 이름 지었다. (daughter, name, their, Sojin)

→ They _____ .

2 우리는 그를 우리 모임의 대표로 선출했다. (our, of, meeting, him, elect, leader)

→ We _____ .

3 이 열기는 잔디를 갈색으로 바꿀 것이다. (the grass, turn, will, brown)

→ This heat _____ .

4 이번에는 더 잘할 수 있어. 내게 한 번 더 기회를 줘. (have, me, chance, let, another)

→ This time, I can do better. _____

5 급했기 때문에, 그는 그녀에게 자신을 도와 달라고 요청했다. (him, help, he, her, ask, to)

→ Because he was in a hurry, _____ .

Point 01 **공통으로 들어갈 말 찾기**
목적격보어의 형태를 보고 문장에 쓰인 동사를 판단하세요.

Point 02 **같은 형태의 문장 찾기**
문장에서 목적격보어와 직접목적어를 혼동하지 않도록 주의하세요.

Point 03 **조건에 맞게 영작하기**
지각동사를 쓴 문장에서는 목적격보어로 원형부정사나 현재분사를 쓸 수 있어요.

정답 및 해설 p.17

Point 01

● **빈칸에 공통으로 알맞은 말은?**

> • The project manager _____ us meet at 10 a.m.
> • He _____ walked along the Olle Trail before he went swimming.

① got
② made
③ had
④ let
⑤ asked

Point 02

● **문장의 형식이 주어진 문장과 같은 것은?**

> I couldn't see anyone coming.

① Suddenly, I heard a scream.
② She wants to change her name.
③ This moisturizer made my skin softer.
④ Andy's dog brought him a slipper.
⑤ Her face turned red with anger.

Point 03

서술형 ▶

● **다음 우리말과 뜻이 같도록 〈조건〉에 맞게 문장을 쓰세요.**

> 그녀는 자신의 개가 낯선 사람에게 짖고 있는 것을 보았다.
>
> 〈조건〉 • 다음 단어를 사용할 것: see, bark, a stranger, at
> • 필요하면 단어를 변형하거나 추가할 것
> • 모두 8단어로 쓸 것

→ _____

Overall Exercises 07

[1-4] 다음 빈칸에 들어갈 수 <u>없는</u> 것을 고르세요.

1

The doctor _____ me to stay in bed for a few days.

① told ② made
③ asked ④ wanted
⑤ advised

2

The castle became _____.

① famous worldwide over the centuries
② a major tourist attraction in the area
③ very popularly in the 19th century
④ four hundred years old last year
⑤ the subject of many historical studies

3

I didn't know _____.

① the results of the election
② that he was suffering from cancer
③ you were at home
④ on a variety of science topics
⑤ the difference between tornadoes and hurricanes

4

I _____ him carry the luggage.

① had ② made
③ helped ④ watched
⑤ ordered

[5-6] 다음 빈칸에 들어갈 말이 바르게 짝지어진 것을 고르세요.

5

• I've seen thousands of people _____ down the streets. • The coach has his players _____ every day as part of practice.

① march to run
② march run
③ to march to run
④ to march run
⑤ marching to run

6

• That book will help him _____ his passion. • Let me _____ you to my favorite place.

① find to take
② finds taken
③ to find taking
④ find take
⑤ finding take

7 다음 문장에서 어법상 <u>틀린</u> 한 곳을 찾아 바르게 고치세요.

My grandfather has taught to me many life lessons since I was little.

_____ → _____

[8-9] 다음 밑줄 친 부분 중 문장에서의 역할이 <u>다른</u> 하나를 고르세요.

8
① This facial cream feels <u>really</u> smooth.
② Though deaf and blind, she became <u>a world-famous author</u>.
③ Milk contains <u>many essential vitamins</u>.
④ It is <u>the oldest church in town</u>.
⑤ The plants look <u>healthy</u>.

9
① She heard him <u>call her name</u>.
② The kid named the monkey <u>Coco</u>.
③ The wind made my hair <u>messy</u>.
④ He doesn't allow us <u>to play with our smartphones in class</u>.
⑤ Our college is offering <u>various courses in fashion</u>.

10 **다음 중 빈칸에 들어갈 말이 나머지 넷과 <u>다른</u> 하나는?**

① They want to show their new baby girl _____ all their friends.
② She teaches ballet _____ children aged from three to ten.
③ Last summer, my aunt made a silk dress _____ me.
④ You can send any reviews _____ our editors.
⑤ J.K. Rowling gives so much pleasure _____ readers through her books.

[11-12] 주어진 문장과 문장 형식이 같은 것을 고르세요.

11
He stayed awake all night.

① Dan turned his head to look at her.
② The river is running dry these days.
③ Will you hand me the key on your left?
④ We wrote letters to each other.
⑤ The actress appeared in a few hit movies.

12
Can I ask you a favor?

① I consider Felicia my best friend.
② The milk on the table turned sour.
③ We grow organic vegetables in the garden.
④ They called their new baby Boris.
⑤ He bought me this shirt for Christmas.

[13-14] 다음 중 어법에 맞는 문장을 고르세요.

13
① Keep your room neatly and tidy.
② Please enter to the room one by one.
③ They lay down on the sandy beach.
④ I won't let this chance going by.
⑤ We heard Mary to sing in the park.

14
① They soon reached the campsite.
② He expected his flight be on time.
③ Andrew is going to marry with Amy.
④ The incident made him very carefully about fire.
⑤ Can I ask a favor for you?

[15-16] 다음 글을 읽고 물음에 답하세요.

Very few people make their own bread, and it's not hard ⓐto know why. Making bread can't be hurried. It makes you ⓑslow down. After mixing the dough for 15 minutes, you have to allow it ⓒrest. For an hour or more, the dough ⓓrises until it doubles in size. You just have to wait ⓔpatiently. And (A)you still have lots of work to do after the dough is ready.

15 윗글의 밑줄 친 ⓐ~ⓔ 중 어법상 틀린 것은?

① ⓐ ② ⓑ ③ ⓒ ④ ⓓ ⑤ ⓔ

16 윗글의 밑줄 친 (A)와 문장 형식이 다른 것은?

① I get a dental checkup every year.
② How much sleep do you get each night?
③ We've got four new designs to choose from.
④ She got me to change a light bulb.
⑤ I sometimes get spam ads on my cell phone.

17 우리말과 뜻이 같도록 괄호 안의 단어를 배열하여 문장을 완성하세요.

네 덕분에 기분이 나아졌어.
(feel, me, made, better, you)

→ _____

[18-19] 다음 중 어법상 틀린 문장을 고르세요.

18 ① He felt someone push him gently.
② She resembles her mother a lot.
③ Stress causes blood pressure to increase.
④ The towels still feel softly.
⑤ The telephone rang loudly for several minutes.

19 ① The heavy rain kept them indoors all day long.
② I saw the spaceship landing on the moon on TV.
③ We had two students to join our club.
④ Wine tastes better in the proper glass.
⑤ He wants his teacher to explain it again.

20 다음 빈칸에 공통으로 들어갈 말을 쓰세요.

• Paul lent his hat _____ me.
• My mom gave this backpack _____ me for my birthday last year.
• The company offered a full-time job _____ them.

서술형 만점 Writing Exercises

1 다음 우리말과 뜻이 같도록 괄호 안의 단어를 이용하여 문장을 완성하세요.

(1)
> 그는 그 전쟁에서 살아남았다.
> (survive, the war)

→ _____

(2)
> 그는 형의 조언이 매우 도움이 된다는 것을 깨달았다.
> (find, his brother's advice, helpful, very)

→ _____

(3)
> 컨디셔너는 당신이 모발을 윤기 있고 매끄럽게 유지하는 것을 도와줄 수 있다.
> (help, keep, your hair, shiny and smooth)

→ Conditioners can _____
_____.

2 〈보기〉의 동사를 하나씩 활용하여 Sophie가 생일날 친구들에게 받은 것을 문장으로 쓰세요.

〈보기〉 write cook give

(1) (a letter from Finn)
→ Finn _____ to Sophie.

(2) (a book from Kate)
→ Kate _____.

(3) (a pizza from Emma)
→ Emma _____.

3 괄호 안에 주어진 단어를 이용하여 사진의 상황을 영어로 표현하세요.

(made, sit down)

→ The girl _____.

4 괄호 안에 주어진 단어를 이용하여 대화를 완성하세요.

(1) A: Where's Julie? She's not home.
B: I think she's in the park. I _____
_____ her dog there ten minutes ago. (see, walk)

(2) A: Does Sam have a cold?
B: Yes. I _____.
(hear, cough)

(3) A: Tomorrow is my mom's birthday. I want to make a cake for her.
B: That's a good idea. I'll _____
_____ the cake. (help, bake)

CHAPTER

08

품사

| 기본 개념 & 용어 Review |

수일치 주어로 쓰인 명사가 셀 수 있느냐 없느냐에 따라 동사의 '수'가 결정 되는데,
이를 '수일치'라고 해요.

부정대명사 정해지지 않은 불특정한 대상을 가리키며, 형용사처럼 많이 쓰여요.
반드시 앞에 나온 명사를 대신하는 것은 아니에요.

전치사 「전치사+(대)명사」 = 형용사 or 부사

명사와 수일치

명사는 셀 수 있는 명사와 셀 수 없는 명사가 있어요. 셀 수 있는 명사는 단수와 복수가 있고 그에 따라 동사의 형태를 다르게 쓰는데 이를 수일치라고 해요.

A 셀 수 있는 명사

❶ 단수형
문장에서 단독으로 못쓰고 반드시 a(n), the, my, this 등이 앞에 나와야 해요. 주어일 때는 동사도 단수형을 써서 주어와 ¹_____의 수를 일치시켜야 해요.

* *My **friend** **is*** a genius at mathematics.
* ***Friend** **is*** a genius at mathematics. (×)

❷ 복수형
문장에서 단독으로도 쓸 수 있고 some, any 등도 앞에 올 수 있어요. 주어로 쓰일 때는 동사도 복수형을 써서 주어와 동사의 수를 일치시켜야 해요.

Passwords *are* required to be at least eight characters long.

B 셀 수 없는 명사

❶ 단수형만 가능
셀 수 없는 것이므로 앞에 a(n)를 쓸 수 없고, 복수형도 없어요. 문장에서 the, some, any 등이 앞에 올 수 있으며 단독으로도 쓸 수 있어요. 주어로 쓰일 때 동사는 ²_____을 써야 해요.

* **Milk *is*** good for your health.
* *The* **water** in this bottle ***comes*** from a spring.
* Can I have *some* **water**, please?

> **More** 셀 수 없는 명사의 수량 표현: 명사의 모양이나 담는 그릇, 단위 이용
>
> | **a cup of** tea | **two pieces[slices] of** cake | **three pieces of** advice |
> | **a glass of** water | **a pound of** sugar | **a bag of** flour |
> | **a sheet of** paper | **a loaf[piece, slice] of** bread | **a slice[piece] of** ham |

❷ 셀 수 있는 명사처럼 쓰이는 경우
구체적인 제품이나 개체 등을 나타낼 때는 a(n)이 붙거나 복수형이 가능해요.

There is no **room** in the parking lot.	공간
The second floor has three **rooms** for the guests.	방
What kind of wood is **paper** made from?	종이
The **papers** are ready to publish.	문서, 보고서
It's **time** to say goodbye.	시간
I've watched the movie three **times**.	횟수, ~ 번

C 주의할 수일치 **❶** 「분수, half, most, all, percent 등+of+명사」

주어의 형태가 위와 같은 경우, 동사는 ³ _____ 뒤의 명사의 수에 일치시켜야 해요.

- *Two-thirds of* **our tickets *have*** already been sold.
- *Two-thirds of* **the pizza *has*** already been eaten.
- *Half of* **the houses** in the city ***were*** destroyed.
- *All of* **this money *is*** yours.
- *Almost 80 percent of* **students *want*** to go to college.
- *Only 10 percent of* **the information *was*** useful.

❷ 「There[Here]+동사 ~」

동사 뒤에 오는 명사에 동사의 수를 일치시켜야 해요.

- *There **is** a letter* for you on the desk. 단수명사
- *There **are** two people* in this photo. 복수명사
- *Here **comes** the bus*. 단수명사
- *Here **is** the latest news*. 셀 수 없는 명사

D 단수·복수
취급하는 명사

❶ 단수 취급
- **Mathematics *is*** difficult to learn. 학문, 학과명
- **The furniture *looks*** expensive. 셀 수 없는 명사
- **Your black and white striped shirt *looks*** good 동일한 물건
 on you.
- **Winning or losing *doesn't*** matter. or로 연결된 것
- **One** of my favorite places ***is*** Paradise Beach. one이 주어
- **Many a child *loves*** reading fairy tale stories. many a+단수명사
 cf. **Many of the children *love*** reading fairy tale many of+복수명사
 stories.
- **Twenty miles *is*** a long way to walk. 시간, 거리, 무게, 금액 등
- **Fish and chips *is*** a traditional British dish. 음식명: 하나의 개념

❷ 복수 취급
- **Tomatoes *need*** lots of sunshine. 복수명사
- **My father and mother *work*** for the same company. and로 연결된 명사
- **Your pants *look*** nice. 짝으로 이뤄진 물건
- **A number of students *are*** studying in the library 많은 ~
 now.
 cf. **The number of students** in this class ***is*** twenty. ~의 수: 단수 취급

PRACTICE

괄호 안에 주어진 단어를 빈칸에 알맞은 형태로 쓰세요.

1 The room is full of wooden _____(furniture).

2 The teacher handed out two sheets of _____(paper) to me.

3 Most of the _____(information) in this book is very useful to me.

4 A: Which high school do you want to go to?

 B: I haven't decided yet. I need some _____(advice) from my teacher.

5 Five _____(student) were absent from school because of the flu.

6 These days, many people share their _____(knowledge) through the Internet.

7 _____(happiness) is all around us and we only have to look for it.

8 She buys two loaves of _____(bread) from a bakery every morning.

9 Can I have three pieces of _____(cheese)?

괄호 안에서 어법에 맞는 것을 고르세요.

1 Be careful. There is [milk / a milk] spilled on the floor.

2 Too much noise [is / are] bad for your health.

3 There [is / are] hundreds of different jobs in the world.

4 One of my favorite subjects [is / are] Korean history.

5 A number of people [is / are] in the stadium to watch the game.

6 There [is / are] two rooms available on the second floor.

7 Mathematics [is / are] more difficult for me than any other subject.

8 Ten dollars a month [help / helps] an African child get a good education.

9 Tolstoy's *War and Peace* [is / are] the longest book I've ever read.

10 We offer our hotel rooms at low rates, but lunch and dinner [is / are] not included.

STEP 3

다음 중 어법에 맞는 문장을 고르세요.

1
① I'll give you more informations.
② He bought two pieces of cakes.
③ Two-thirds of my friends is working part-time.
④ I bought a pair of earrings as her birthday present.
⑤ The number of people visiting the website have doubled.

2
① The player I like best seem to be winning this time.
② People with gray hair often looks older.
③ Half of my money are saved in the bank every month.
④ There is some traditional dishes on the menu for dinner.
⑤ Many of the students at my school want to take swimming lessons.

STEP 4

다음 우리말과 뜻이 같도록 괄호 안의 단어를 이용하여 문장을 완성하세요.

1 나는 매일 아침 한 잔의 토마토 주스를 마신다. (drink, tomato juice)

→ I _____ every morning.

2 그 흑백 사진은 나에게 우리 할머니를 생각나게 한다. (make, think of)

→ The black-and-white photo _____.

3 인터넷에는 우리가 먹는 음식들에 대한 수많은 정보가 있다. (a lot of, information, there)

→ On the Internet, _____ about the food we eat.

4 어린이의 거의 3분의 1이 방에 TV가 있다. (one-third of, kid, have, almost)

→ _____ TVs in their rooms.

5 우리 집까지 걸어가자. 600미터는 걷기에 먼 거리는 아니야. (a long distance, walk)

→ Let's walk to my house. Six hundred meters _____.

부정대명사

부정대명사는 정해지지 않은 불특정한 대상을 가리키며, 형용사처럼 많이 쓰여요.

A some, any

❶ some: 몇몇(의), 조금의, 얼마간(의)

- You'll find **some** in the drawer. 긍정문
- **Some** of the paintings are sold.
- I have **some** *cookies*. Would you like **some**? 권유 의문문

> **More** 「some of+명사」의 수일치
>
> of 뒤에 나오는 명사에 동사의 수를 일치시켜야 해요.
>
> *Some of* **these books** *are* from the school library. (some of+복수명사 → 복수)
> *Some of* **the meat** *has* already become rotten. (some of+셀 수 없는 명사 → 단수)

❷ any: 조금도[누구도] (~않다), 아무(것도) (~않다), 어느 (것도)

- I did**n't** read **any** of these books last month. 부정문: 조금도 ~ 않다
- I did**n't** drink **any** water even though I was thirsty. not ~ any = no ~
 = drank **no** water
- Do **any** of your friends have a laptop? 의문문: 누군가
- Did he want **any** of these books? 의문문: 어느 것인가
- **Any** *student* knows it. 긍정문: 어떤 ~라도

B -thing, -body, -one

-thing, -body, -one은 단수 취급하며 형용사가 뒤에서 수식

some, any, no, every 뒤에 붙어 대명사가 되는데, 주로 -body, [1]_____은 사람을, -thing은 사물을 가리켜요.

- **Nobody** *wants* to feel alone. -body: 단수 취급
- **Everybody** admired your last book.
- He saw **nothing** *special* in the lake. -thing+형용사
- I need **something** *cold* to drink. -thing+형용사+to부정사
- There isn't **anyone** who *wants* to go there. -one+주격 관계대명사+단수동사
- **None** of the students *are* done with their homework. none of+명사구: 대개 복수 취급

C one, another, other(s)

❶ one: 하나, 일반인 (복수형은 ones)

one(s)은 셀 수 2_____ 명사는 대신할 수 없어요.

- He saw **one** of his pictures.　　　　　　one of+복수명사: ~ 중 하나
- **One** has to do **one**'s work.　　　　　　일반인
- I like blue *hats* more than yellow **ones**.　　앞에서 언급된 것과 같은 종류의 불특정한 사물

> **More** 사물을 가리키는 it과 one
>
> 앞에 나온 동일한 사물을 가리킬 때는 it을 쓰고, 동일한 종류 중 막연하게 하나를 말할 때는 3_____을 써요.
>
> He bought a pen. He took notes with **it**. (바로 그 펜)
>
> He lost the pen. He had to buy a new **one**. (펜 하나)

❷ another: 또 다른 하나(의), 하나 더 ~

- This shirt is too large. Show me **another** (one).　　또 다른 하나
- How about **another** *glass* of juice?　　하나 더 ~: another+단수명사

❸ other(s): 다른, 다른 것(들)

- There are many balls in the box.
 Some are red. **Others** are white.　　어떤 것은, ~ 다른 것은 ...
- There are two desks. *One* of them is old.
 The other is new.　　둘 중 나머지 하나
- Mary and **other** *girls* from her class went shopping.　　다른: other+복수명사

❹ one/another/some/other(s)

둘 중 하나는 one, 나머지 하나는 the other	I have *two* houses. **One** is in Daegu, **the other** in Seoul.
셋 중 처음 하나는 one, 또 다른 하나는 another, 나머지 하나는 the other	She brought *three* dishes. **One** was salad, **another** chicken, and **the other** spaghetti.
처음 하나는 one, 나머지 모두는 the others	**One** of five people passed the final audition, and **the others** didn't.
처음 몇 개는 some, 나머지 모두는 the others	**Some** of five people passed the final audition, and **the others** didn't.
어떤 것은 some ~, 다른 것은 others ...	**Some** (people) like fish, while **others** like chicken.

D **each, every**

each: '각각의 (것)' / every: '~마다, 매 ~'
each와 every는 모두 **4** _____ 취급해요.

• **Each is** available with special gift packaging.　　each: 단수 취급
• **Each of the boxes is** empty.　　each of+복수명사 → 단수동사
• **Each student is** provided with his own room.　　each+단수명사 → 단수동사
• **Every student was** tired.　　every+단수명사 → 단수동사

> **More** every가 만드는 표현
> I go to the bookstore **every month**. (매월)
> The Olympic Games are held **every fourth year**. (every+서수+단수명사: ~마다 한 번)
> = The Olympic Games are held **every four years**. (every+기수+복수명사: ~마다 한 번)

E **many, much**

many: (수가) 많은 / much: (양이) 많은
• How **many** of you *know* the answer?　　복수 취급
• **Much** of the water in this area *is* not drinkable.　　단수 취급

> **More** many a+단수명사: 단수 취급
> **Many a tale was** told.
> = **Many tales were** told.

F **all, both, either, neither**

❶ **all: 모든 사람[것], 모두, 전부**
• **All** *are* well in my family.　　모든 사람: 복수 취급
• **All** *is* calm tonight.　　모든 것: 단수 취급
• **All children** *like* chocolate.　　all+복수명사 → 복수동사
• **All the soup** *has* boiled over.　　all+단수명사 → 단수동사
• **All of the information** *is* saved in this file.　　all of+단수명사 → 단수동사
• **All of us** *were* happy with the result.　　all of+복수명사 → 복수동사

❷ **both: 둘 다(의)**
• **Both** *are* pretty.
• **Both of them** *are* my brothers.

❸ **either: 둘 중 어느 하나(의) / neither: 둘 중 어느 것도 아닌 (것)**
보통 단수 취급하지만 구어에서 「of+복수명사」와 함께 쓸 때는 복수 취급하기도 해요.

• **Either** *is* okay with me.
• **Neither** *was* fun.
• **Either of my cousins** *is* married.
• **Neither of the films** *was*[*were*] fun.

PRACTICE

STEP 1

괄호 안에서 어법과 문맥상 맞는 것을 고르세요.

1 I need [some / any] help with this work.

2 I don't have [some / any] idea about what's going on.

3 He gave me [some / any] useful advice about school life.

4 Would you like [some / any] ice cream?

5 I know the band is famous but I haven't heard [some / any] of their music.

6 A: When would be a good time to call you?
B: Please call me [some / any] time you want.

7 I'm looking for a house. I'd like [it / one] with a garden.

8 A: Which shoes do you want?
B: I'd like the red [them / ones].

9 Some of your advice [has / have] been helpful.

10 Some of the questions [was / were] so simple that I easily answered them.

11 Each of the chairs [is / are] named after a donor to the school.

12 Everyone [experience / experiences] stress from time to time, so it is normal.

13 Many students [is / are] taking language courses online.

14 All my friends [agrees / agree] to my plan.

15 There [is / are] nothing better than a good book.

16 Each participant [need / needs] to fill out a form to register for the seminar.

17 Many of her friends [has / have] been getting married recently.

STEP 2

빈칸에 알맞은 것을 〈보기〉에서 골라 쓰세요.

〈보기〉　one　another　the other　the others　others　both　each

1　I have only two suits. _____ is for spring and fall, and _____ is for winter.

2　We invited five friends. Two of the five can come on time, but _____ will be a little late.

3　Some people prefer to travel alone, while _____ prefer to travel with their companions.

4　He has bought _____ car.

5　There are five offices in this building. _____ has a small garden.

6　There are three ways to get there. One is by subway. Another is by bus. _____ is by taxi.

7　_____ of the girls in this picture are very popular singers in Asia.

STEP 3

우리말과 뜻이 같도록 〈보기〉에서 고른 부정대명사와 괄호 안에 주어진 말을 이용하여 문장을 완성하세요.
(단, 동사를 알맞은 형태로 바꿀 수 있음)

〈보기〉　either　　neither　　something　　each

1　내 휴대 전화에 뭔가 이상이 있다. 그것은 작동하지 않는다. (with, wrong, cell phone, my)

→ There is _____. It doesn't work.

2　Sam과 나는 매주 토요일에 테니스를 치지만 우리 둘 다 잘 하지 못한다. (us, play, of, well)

→ Sam and I play tennis every Saturday, but _____.

3　A: 나는 이번 주 목요일과 금요일에 시간이 돼. 너는 어떠니?

B: 난 둘 중 어느 날이나 다 좋아. (is, fine, me, with)

→ A: I am free this Thursday and Friday. How about you?

B: _____

4　사람들 각자 다른 장점을 가지고 있다. (person, different strengths, have)

→ _____

내신
적중

Point

Point 01 단락에서 어법에 맞는 것들 찾기
가리키는 대상의 범위를 고려해서 부정대명사를 선택하세요.

Point 02 틀린 부분 고쳐서 문장 다시 쓰기
-thing, -body, -one 형태의 대명사를 수식하는 형용사의 위치에 유의하세요.

정답 및 해설 p.19

Point

01

● (A), (B), (C)의 각 네모 안에서 어법에 맞는 표현으로 가장 적절한 것은?

Many teenagers (A) worry / worries about acne. Some teenagers
have more acne than (B) another / others . Because severe acne can
leave scars, prevention is important. But if you have severe acne, you
must do two things. One is to make it a rule to wash your skin daily,
and (C) the other / another is to see a professional skin doctor for
proper treatment.

*acne: 여드름 **scar: 흉터

	(A)		(B)		(C)
①	worry	……	others	……	another
②	worry	……	others	……	the other
③	worry	……	another	……	the other
④	worries	……	others	……	another
⑤	worries	……	another	……	another

Point

02

서술형 ▶

● 다음 우리말과 뜻이 같도록 어법상 <u>틀린</u> 부분을 고쳐서 문장을 다시 쓰세요.

왕은 신하들에게 특별한 것을 제공했다.
The king offered his officials special something.

→ _____

Unit 22 전치사

전치사는 <u>명사, 대명사 등과 함께 구를 이루어</u> 문장에서 형용사나 부사 역할을 해요.

A 전치사+ (대)명사

① 전치사의 목적어

전치사 뒤에 나오는 말을 전치사의 목적어라고 하는데, 명사를 비롯하여 명사 역할을 할 수 있는 여러 어구가 올 수 있어요. 대명사는 ¹_____을 써요.

◆ She went out **for a walk**.	전치사+명사
◆ I've heard nothing **from him**.	전치사+대명사 목적격
◆ He entered my room **without knocking**.	전치사+동명사
◆ I don't worry **about what they said**.	전치사+명사절

> **More** 많이 쓰이는 구전치사
>
> 두 단어 이상으로 이루어진 구가 ²_____ 역할을 하기도 해요.
>
> according to(~에 따라서) across from(~의 맞은편에) along with(~와 함께)
> because of/due to(~ 때문에) in spite of(~에도 불구하고) thanks to(~ 덕분에)
> in addition to(~에 더해서) instead of(~ 대신에)

② 형용사나 부사 역할

◆ People **in the park** were feeding the fish.	People을 수식하는 형용사 역할
◆ The kids were playing **in the street**.	장소를 나타내는 부사 역할

B in, on, at

① 시간

- **in**+월, 연도, 세기, 계절 또는 아침, 오후, 저녁
- **on**+날짜, 요일, 또는 특정한 요일의 아침, 오후, 저녁
- **at**+특정한 시각 또는 비교적 짧은 시간

◆ They got married **in** May.
　in the morning, **in** 2021, **in** the 21st century, **in** winter

◆ They will move to Bangkok **on** November 6, 2022.
　on Saturday, **on** Sunday afternoon, **on** a rainy day, **on** Christmas

◆ I woke up **at** 8:40 this morning.
　at dawn, **at** night, **at** the moment

② 장소, 방향

- **in**+넓은 장소: ~ (안)에
- **on**+접촉하고 있는 지역[장소] 또는 거리: ~에
- **at**+좁은 장소 또는 주소: ~에서

- She lives **in** Seoul.
- The dirty laundry is **in** the washing machine.
- The pens are **on** the desk.
- The dental clinic is **on** the fifth floor.
- Her house is **on** Oxford Street.
- Tom and Peggy are **at** school.
- She lives **at** 26 Sejong-ro, Seoul.

❸ 주요한 다른 의미

in	기간	**in** one's teens(10대에), **in** five years(5년 후에)	상태	**in** love(사랑에 빠진)	
	착용	**in** a red dress(붉은 원피스를 입은)	도구	**in** English(영어로)	
on	부착	**on** the ceiling(천장에)	상태	**on** sale(세일 중인)	
	수단	**on** the Internet(인터넷으로)	탈것	**on** the train(열차에서)	
at	시점	**at** the beginning of May(5월 초에)	속도	**at** 60 kilometers an hour (시속 60km로)	
	시절	**at** the age of 15(15세에)	비율	**at** the rate of 30 percent (30퍼센트 비율로)	

C with, for, against, by

❶ with
- I went for a walk **with** my mom. 동반: ~와 함께
- I saw a boy **with** red hair. 소유: ~을 가진, ~의
- It is dangerous for children to play **with** knives. 수단: ~으로, ~을 가지고

❷ for / against
- He will stay here **for** a week. 기간: ~ 동안
- Are you **for** or **against** the proposal? ~에 찬성하여 / ~에 반대하여
- Here's a present **for** you from Eric. 목적, 추구: ~을 위하여
- He was rewarded **for** saving the girl's life. 이유: ~ 때문에

❸ by
- The story was written **by** a German writer. 행위자: ~에 의해서
- You can order flowers **by** phone. 수단: ~으로
- You have to hand in the report **by** Friday. 시간: ~까지
- She goes to school **by** bicycle. 교통수단: ~으로
- The price of a cup of coffee went up **by** 20%. 단위, 정도: ~만큼

PRACTICE

STEP
1

빈칸에 알맞은 전치사를 〈보기〉에서 골라 쓰세요.

〈보기〉	in	on	at	of	to

1　The first *Harry Potter* story was written _____ 1995.

2　I couldn't see the stage very well because _____ the tall man in front of me.

3　Thanks _____ you, I met a lot of nice people.

4　The flight will be delayed. You have to wait _____ the departure gate.

5　The conference is going to begin _____ ten o'clock _____ Monday morning.

6　The milk _____ the table turned sour. You should have put it _____ the refrigerator.

7　Joe doesn't have to get up early _____ Fridays as he has no classes _____ the morning.

8　I'll try to look for it _____ the Internet.

9　According _____ the police report, the crashed car was traveling _____ 140km/h.

10　The zoo becomes more crowded _____ the end of the month.

11　You should solve your problem instead _____ avoiding it.

STEP
2

빈칸에 공통으로 들어갈 전치사를 쓰세요.

1　• _____ her seventies, she taught herself how to use a computer.
　　• Most companies have their websites _____ English.

2　• We are busy _____ this time of the year because of the summer vacation.
　　• I'll wait for you _____ the main gate of the station.

3　• I usually do house chores _____ the weekend.
　　• I could use the Internet _____ the plane for free.

STEP
3

괄호 안에서 어법과 문맥상 알맞은 것을 고르세요.

1 He tried to show his love by [share / sharing] his true feelings.

2 He grew up in London, so he can speak English without [difficult / difficulty].

3 Both of the buildings are painted in unusual [colors / colored].

4 We can get greater benefits from [help / helping] others than we expect.

5 I haven't slept [for / by] three days.

6 I'm sorry, but I'm busy. I have to finish my report [by / for] tomorrow.

7 I'm [for / against] illegal downloading of music from the Internet. It's like stealing a CD from a store.

8 This invention was brought [for / with / from] China to Europe.

9 I plan to go to Europe [in / with] my cousin Hana this summer.

10 If he fails this exam, he will lose the chance to go [to / for] the university.

STEP
4

다음 중 빈칸에 by가 들어가는 문장의 기호를 모두 쓰세요.

ⓐ You will be rewarded according _____ how much you contribute.
ⓑ The painting _____ Rembrandt in the museum was stolen last night.
ⓒ While I was walking home _____ school, I saw a woman with four dogs.
ⓓ It is fun to play _____ some of the camera effects.
ⓔ I don't have any cash now. Can I pay this _____ credit card?
ⓕ Can you repair my computer _____ Thursday?

→ _____

Overall Exercises 08

[1-3] 다음 빈칸에 알맞은 것을 고르세요.

1
> I had two pieces of _____ for breakfast.

① eggs ② bread
③ apples ④ milk
⑤ juice

2
> _____ of the bedrooms in the hotel has its own terrace.

① Each ② All
③ Many ④ Half
⑤ One third

3
> All of the _____ sitting in a circle.

① child is ② child are
③ children is ④ children are
⑤ childs are

4 빈칸에 들어가기에 알맞지 <u>않은</u> 것은?

> Stop worrying about the past and live for _____.

① the present
② yourself
③ what you want to do
④ something valuable
⑤ make you happy

[5-7] 다음 빈칸에 들어갈 말이 바르게 짝지어진 것을 고르세요.

5
> _____ people think that they have many good friends, but in fact, they are not close with _____ of them.

① Every every
② Some any
③ Another any
④ Many much
⑤ Any much

6
> There are three restaurants on the 2nd floor. One is a seafood place, _____ is a sushi place, and _____ is a Chinese restaurant.

① it another
② another the other
③ other the other
④ two three
⑤ second third

7
> A: You look a bit depressed.
> B: I had four exams today and didn't do very well. _____ was alright, but _____ were terribly difficult.
> A: Forget it and cheer up.

① Some others
② Another the others
③ One the others
④ All the other
⑤ Either others

[8-9] 다음 중 빈칸에 들어갈 말이 나머지 넷과 다른 하나를 고르세요.

8
① I hope everything _____ ready.
② Each book _____ written by an expert.
③ Each of the questions _____ easy to answer.
④ All I have _____ a dream.
⑤ Both of my parents _____ in good health.

9
① He has improved his English _____ reading English novels.
② I used to cook _____ my parents.
③ Some companies advertise their products _____ e-mail.
④ I and my sister go to school _____ bike.
⑤ I have to clean up my room _____ noon.

10 다음 두 문장의 뜻이 다른 것은?

① Many a student has bad study habits.
= Many students have bad study habits.
② I don't have any shoes to wear with my uniform.
= I have no shoes to wear with my uniform.
③ I don't want to feel sad anymore.
= I no longer want to feel sad.
④ He lost his wallet, so he needs to buy a new one.
= He lost his wallet, so he needs to buy it.
⑤ Either of them did not come to my graduation ceremony.
= Neither of them came to my graduation ceremony.

[11-12] 다음 대화의 네모 (A), (B), (C)에서 어법과 문맥상 알맞은 것을 고르세요.

11
A: You look really tired. What's up?
B: New neighbors moved in last week. The problem is that the dog they have (A) bark / barks all night, and I can't sleep.
A: Why don't you tell the owner?
B: She's on vacation (B) for / during two months.
A: Two months (C) is / are too long to put up with that.

	(A)		(B)		(C)
①	bark	for	is
②	bark	during	is
③	barks	for	is
④	barks	during	are
⑤	barks	for	are

12
A: Hi, it's Sara. I'm (A) on / at the train. Can you pick me up at the station?
B: What time do you want me to be there?
A: My train will arrive (B) for / in two hours.
B: O.K. I'll come (C) to / by eight o'clock.
A: Thanks. I don't mind if you are a little late.

	(A)		(B)		(C)
①	at	for	to
②	at	in	to
③	at	for	by
④	on	in	to
⑤	on	in	by

[13-14] 다음 중 어법에 맞는 문장을 고르세요.

13
① Neither of us doesn't have much free time any more.
② The number of volunteers were not enough.
③ Physics help us understand the universe.
④ There is no information I want on this site.
⑤ Fifty thousand won are not enough for me.

14
① I haven't heard anything about him.
② Some people does not like pets.
③ I guess I did wrong something to her.
④ Both of my parents is coming to my performance.
⑤ He had five goldfish, but two of them died. Now he takes care of others.

[15-16] 다음 글을 읽고 물음에 답하세요.

There ⓐare many kinds of music. Some people ⓑlike classical music because ⓒone makes them ⓓfeel calm and inspired. _____ like popular music because ⓔit expresses simple but strong human feelings.

15 **윗글의 밑줄 친 ⓐ~ⓔ 중 어법상 틀린 것은?**

① ⓐ ② ⓑ ③ ⓒ ④ ⓓ ⑤ ⓔ

16 **윗글의 빈칸에 알맞은 것은?**

① Other ② The other
③ Others ④ The others
⑤ Another

[17-18] 밑줄 친 부분이 어법상 틀린 것을 고르세요.

17
① Each person <u>has</u> a right to be happy.
② I'd like <u>something cold</u> to drink.
③ Each of the students <u>need</u> to attend the class.
④ A number of people <u>were</u> on the streets.
⑤ The number of tourists from China <u>has</u> increased recently.

18
① I lost my pen. I need another <u>one</u>.
② One of the girls <u>was</u> badly injured.
③ There <u>are</u> two sides to every story.
④ All passengers <u>need</u> to show their passports.
⑤ The furniture we bought <u>have</u> not arrived yet.

[19-20] 빈칸에 공통으로 들어갈 말을 쓰세요.

19
• The Rock Festival is held _____ July every year.
• The girl _____ the blue dress is Julie.
• The article was written _____ French.

20
• I saw a movie star _____ the plane.
• I love my mother's painting hanging _____ the wall in my room.
• Since there was little traffic, I could be there _____ time.

🔵 Writing Exercises

1 다음 우리말과 뜻이 같도록 괄호 안의 단어를 이용하여 문장을 완성하세요.

(1)
> 서로 협력한다면 우리에게 불가능한 일은 없다.
> (nothing, for, impossible, us, be)

→ There _____ if we cooperate with each other.

(2)
> 우리는 개를 두 마리 기른다. 하나는 검은색이고 나머지 하나는 흰색이다.
> (black, white)

→ We raise two dogs. _____

(3)
> 그 축구팀에 있는 모든 소년들이 검정색 축구화를 신는다.
> (of the boys, on the soccer team, wear)

→ _____
black soccer shoes.

2 다음 대화의 밑줄 친 우리말과 뜻이 같도록 괄호 안에 주어진 말을 배열하세요.

> A: Bob, did you sleep well?
> B: Wonderfully. I slept just like a log.
> A: 어젯밤에 이상한 소리 같은 거 못 들었어?
> B: No. Why do you ask?
> A: I found the window downstairs broken this morning.

(you, hear, strange, didn't, anything, last night)

→ _____

3 괄호 안에 주어진 말을 이용하여 사진 속 상황을 묘사하는 문장을 쓰세요.

(1) (all the girls, take a picture)

→ _____

(2) (all the food, the table, delicious, look)

→ _____

4 빈칸에 알맞은 전치사를 넣어 다음 대화를 완성하세요.

> A: Would you like to go to the flea market _____ me?
> B: Sure. When and where does it take place?
> A: It's at 3 p.m. _____ Sunday _____ Seoul City Plaza.
> B: I haven't been there before. Can you pick me up?
> A: Sure. Let's meet _____ two in front of your place.
> B: I can't wait!

독해 사고력을 키워주는

READING Q
시리즈

· READING IS THINKING ·

 영어 독해 완성을 위한
단계별 전략 제시

문장 ▸ 단락 ▸ 지문으로 이어지는
예측 & 추론 훈련

 사고력 증진을 위한 훈련

지문의 정확한 이해를 위한
3단계 Summary 훈련

 픽션과 논픽션의
조화로운 지문 학습

20개 이상의 분야에 걸친
다양한 소재의 지문 구성

쎄듀

 쎄듀런

① 구문 판매 1위 '천일문' 콘텐츠를 활용하여 정확하고 다양한 구문 학습

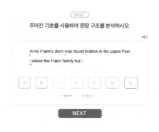

(끊어읽기) (해석하기) (문장 구조 분석) (해설·해석 제공) (단어 스크램블링) (영작하기)

② 문법·서술형 쎄듀의 모든 문법 문항을 활용하여 내신까지 해결하는 정교한 문법 유형 제공

(객관식과 주관식의 결합) (문법 포인트별 학습) (보기를 활용한 집합 문항) (내신대비 서술형) (어법+서술형 문제)

③ 어휘 초·중·고·공무원까지 방대한 어휘량을 제공하며 오프라인 TEST 인쇄도 가능

(영단어 카드 학습) (단어 ↔ 뜻 유형) (예문 활용 유형) (단어 매칭 게임)

④ 선생님 보유 문항 이용

(Online Test) (OMR Test)

 cafe.naver.com/cedulearnteacher

쎄듀런 학습 정보가 궁금하다면?

쎄듀런 Cafe

· 쎄듀런 사용법 안내 & 학습법 공유
· 공지 및 문의사항 QA
· 할인 쿠폰 증정 등 이벤트 진행

✦ Grammar is Understanding ✦

GRAMMAR Q

WORKBOOK

Advanced ❶

GRAMMAR Q

WORKBOOK

Advanced ❶

현재·과거·미래시제와 진행형

정답 및 해설 p.22

A

밑줄 친 부분이 어법상 바르면 ○표를 하고, 틀리면 바르게 고치세요.

1 Every time I <u>saw</u> this movie, I can't stop crying!

2 The train <u>was</u> delayed because of the heavy snow last night.

3 According to the weather forecast, it <u>is going to</u> be foggy this afternoon.

4 An engineer <u>is fixing</u> the printer now, so you can't use it yet!

5 Daniel was very happy when he <u>holds</u> his baby in his arms for the first time.

6 My grandfather retired last year and now he <u>had</u> time to travel around.

7 One study showed that the average person <u>is laughing</u> fifteen times a day.

8 We live outside the city, so my father <u>took</u> the 8:15 train into the city every weekday morning.

B

괄호 안에서 어법에 맞는 것을 고르세요.

1 I have to go. My friend [waits / is waiting] for me at the bus stop now.

2 Anna was almost hit by a truck while she [is crossing / was crossing] the street.

3 He [likes / is liking] fantasy novels and he has hundreds of them.

4 I sometimes feel dizzy while I [am looking / was looking] at my computer screen.

5 A: Shhh, be quiet! The baby [takes / is taking] her nap.
 B: Oh, I'm sorry. I didn't know she was asleep.

6 While everyone [is having / was having] a great time at the party, I was at the library to finish a report.

C

괄호 안에 주어진 동사를 빈칸에 알맞은 형태로 써넣으세요.

1 Dabin wants to work in Italy, so she _____ (learn) Italian these days.

2 My sister _____ (wake up) at six every day. She always keeps regular hours.

3 While I _____ (lie) in bed last night, I heard a strange noise.

4 The space shuttle _____ (make) its first flight in 1981 and was retired in 2010.

5 If you don't hurry, you _____ (be) late for the meeting.

6 A long time ago, people _____ (make) everything for themselves.

D

다음 중 어법상 <u>틀린</u> 문장을 고르세요.

1 ① Cheese is made from milk.
 ② I want to share the poem which I read yesterday.
 ③ I will support you until you will reach your goals.
 ④ They are leaving for London in a few minutes.
 ⑤ He was asleep upstairs when the house caught fire.

2 ① Chemistry is difficult. I can't understand it.
 ② Jane collects model cars. She is having about three hundred.
 ③ I was swimming in the pool when you called me yesterday.
 ④ She's attending Latin American dance lessons these days.
 ⑤ If you eat too much at night, you won't be able to sleep very well.

A

다음 중 밑줄 친 부분의 쓰임이 주어진 문장과 같은 문장을 고르세요.

1

Karen has gone to Italy to study music. She lives in Milan now.

① Have you ever thought about going on a diet?
② Ever since I was a child, I have been interested in animals.
③ Someone has taken the bag that I bought yesterday. I need to buy another one now.
④ In recent years, scientists have learned much more about the brain.

2

Hugh Jackman has visited South Korea several times so far.

① I think I know you. Haven't we met before?
② My parents want me to go abroad but I haven't decided yet.
③ The game has just started. Turn on the sports channel now!
④ My grandmother has been in the hospital for two weeks.

3

How long have you lived in this city?

① I have not completed my research yet.
② She has eaten Mexican food several times.
③ Your car looks so shiny. Have you washed it?
④ People have built wooden houses for a long time.

4

I have already paid them for the service.

① I've never seen a shooting star.
② He has worked for ten years as a firefighter.
③ My brother has been invisible since last night.
④ Hajun has just come home from several years of studying overseas.

B

괄호 안에서 어법에 맞는 것을 고르세요.

1 He [loses / has lost] his umbrella and can't find it anywhere.

2 I [haven't finished / am not finishing] my homework yet.

3 We [waited / have been waiting] for him since six o'clock.

4 World War II [broke / has broken] out in 1939.

5 I [didn't attend / haven't attended] any parties since I came here.

6 Someone [has stolen / stole] my soccer shoes from the locker room yesterday.

C

다음 물음에 알맞은 답을 고르세요.

1 다음 중 밑줄 친 부분이 어법상 바른 문장은?
① How long has it be raining?
② Henry plays the piano since he was five.
③ I think you've been spending too much.
④ I have seen Ted in the cafeteria a few minutes ago.
⑤ I've been visited the forest to study plants for 20 years.

2 다음 대화 중 어법상 틀린 것은?
① A: Have you ever eaten green curry?
 B: Yes, I have. I had it when I visited Bangkok.
② A: How long have you known each other?
 B: We have been friends since we were five.
③ A: When did you visit Paris? You mentioned that you've been there.
 B: I have visited Paris last summer.
④ A: What are you going to order for dinner?
 B: Well, I have never had Hawaiian pizza. I'd like to try it.
⑤ A: Would you like some dessert?
 B: No, thanks. I've already had enough.

Unit 03 과거완료

A

괄호 안에 주어진 단어를 문맥에 맞게 바꾸어 빈칸에 쓰세요.

1 I found the wallet that I _____ (lose) the previous week at the hotel.

2 By the time I went to bed last night, I _____ (already, finish) my homework.

3 Last night, I ate eight slices of pizza. Before that, I _____ (never, eat) pizza at all.

4 Yesterday at the restaurant I bumped into Yujin, an old friend of mine. I _____ (not, see) her for years. *bump into: (우연히) ~와 마주치다

5 They _____ (not, sell) all the tickets yet when I went to the box office. *box office: 매표소

B

우리말과 뜻이 같도록 괄호 안의 단어를 이용하여 문장을 완성하세요. (단, 동사를 변화시킬 수 있음)

1 내가 그녀를 처음 보았을 때, 나는 이전에 그녀를 만난 적이 있다고 생각했다.
(think, meet, before)
→ The first time I saw her, _____.

2 내가 시험에 대비해 공부를 시작했을 때 Bill은 이미 잠자리에 들었다.
(go to bed, already)
→ _____ when I started studying for the exam.

3 우리는 그 식당이 유명해지기 전까지는 그곳에 대해 전혀 듣지 못했다.
(hear, about, the restaurant)
→ _____ before it became famous.

4 Mike는 지난주에 그의 어머니가 사 준 새 재킷을 잃어버렸다.
(buy, last week)
→ Mike lost his new jacket that _____.

C

다음 물음에 알맞은 답을 고르세요.

1 다음 중 어법상 틀린 문장은?

① He said that he had lost his book.

② Ten years have passed since he moved here.

③ I had lived there for five years when the war broke out.

④ I heard that Jenny has gone to New York.

⑤ We have been endlessly texting each other since this morning.

2 다음 대화 중 어법상 틀린 것은?

① A: How's the food?

B: It is great. I have never eaten such a delicious food.

② A: Why are you going to give me this book?

B: I have already read it before.

③ A: Why are you so worried?

B: Because I had broken the camera that my father bought me.

④ A: Did you go out to eat last night?

B: No. By the time I got home, my dad had already made dinner for me.

⑤ A: I don't think he'll be late for the movie. He said he had left his office at 5:30.

B: I know. He sent me a text message, too.

D

다음 두 문장을 한 문장으로 바꿀 때 빈칸에 알맞은 말을 쓰세요.

1

I could recognize her. I saw her picture before.

→ I could recognize her because _____ .

2

I finished washing my dad's car. I told it to my dad.

→ I told my dad that _____ .

수동태의 의미와 형태

A

다음 문장을 수동태로 바꿔 쓰세요.

1 The war destroyed everything.
→ Everything _____.

2 You can change the password by entering a new password.
→ The password _____ (by you).

3 The patient should make the decision to have surgery.
→ The decision to have surgery _____.

4 Global warming causes the rise in the Earth's water temperature.
→ _____

5 The professional photographer took a picture of me yesterday.
→ _____ yesterday.

6 Everyone was dancing while the band was playing the song.
→ Everyone was dancing while _____.

7 They do not serve breakfast on Sundays.
→ _____

8 Oil companies have increased oil prices in the past ten years.
→ _____ in the past ten years.

9 He will invite all the students to the party.
→ _____

10 They raise thousands of cattle in the high plains of New Mexico.
→ _____ in the high plains of New Mexico.

B

괄호 안에서 어법과 문맥상 알맞은 것을 고르세요.

1 My watch [found / was found] in the bathroom this morning.

2 The swimming pool I go to every weekend [belongs / is belonged] to my school.

3 Susan [is resembled / resembles] her mother in face and character.

4 He met obstacles that [seemed / were seemed] impossible to overcome.

5 Your report [should finish / should be finished] by this Friday.

6 A big tree house [is building / is being built] in a forest by him.

C

다음 빈칸에 알맞은 말을 고르세요.

1
Korea _____ for its highly advanced communication technologies for the past decade.

① knows ② has known
③ has been known ④ has been knowing
⑤ is being known

2
The gestures are common all over the world and _____.

① misunderstand ② don't misunderstand
③ have misunderstood ④ are misunderstanding
⑤ are never misunderstood

3
Who _____ chairman of the committee?

① elect ② was elected
③ has been electing ④ electing
⑤ has elected

주의해야 할 수동태

A

다음 문장을 수동태로 바꿔 쓰세요.

1 My grandmother took care of me until I was seven.

→ I _____ until I was seven.

2 A red car ran over my poor cat yesterday.

→ My poor cat _____ yesterday.

3 They should put off the meeting until next week so that the staff can be fully prepared.

→ The meeting _____ so that the staff can be fully prepared.

4 Someone took away empty bottles and things from the garbage can.

→ Empty bottles and things from the garbage can _____.

5 The audience didn't pay any attention to his words.

→ His words _____.

6 He and his colleagues carried out the experiment in a zoo.

→ The experiment _____ in a zoo.

7 Bill picked up his wife at the airport.

→ Bill's wife _____ at the airport.

8 She made her friends a homemade dinner.

→ A homemade dinner _____.

9 The delivery service will bring you the package.

→ The package _____.

B 다음 문장을 두 가지의 수동태로 바꿔 쓰세요.

1 The author of the best-selling book gave us the lecture.

→ We _____ .

→ The lecture _____ .

2 Remember that the interviewer will ask you unexpected questions.

→ Remember that you _____ .

→ Remember that unexpected questions _____ .

3 Ms. Song lent them two spare rooms.

→ _____ by Ms. Song.

→ _____ by Ms. Song.

4 The local organization offered the public a computer course during the summer.

→ The public _____ during the summer.

→ A computer course _____ during the summer.

C 다음 우리말과 뜻이 같도록 괄호 안에 주어진 단어를 이용하여 문장을 완성하세요.
(단, 동사 형태를 변화시킬 수 있음)

1 저녁식사 시간에는 텔레비전이 꺼져 있어야 한다.

(should, turn off, at dinner time)

→ The television _____ .

2 그 정보는 한 어린 소년이 경찰에게 제공하였다.

(give, the police, a little boy)

→ The information _____ .

3 Geoffrey Chaucer는 '영국 시의 아버지'라고 불린다.

(call, "the Father of English Poetry")

→ Geoffrey Chaucer _____ .

4 그 아기는 그녀의 할아버지에 의해 Carol이라고 이름 지어졌다.

(name)

→ The baby _____ .

Unit 06 다양한 수동태 표현들

A

우리말과 같은 뜻이 되도록 〈보기〉에서 알맞은 전치사를 고르고, 괄호 안에 주어진 단어를 알맞은 형태로 바꾸어 문장을 완성하세요.

〈보기〉	by	with	in	at	to	of

1 나는 우리 역사를 더 배우는 것에 관심이 있다. (interest, learn)
→ _____ more about our history.

2 그 산 정상은 언제나 눈으로 덮여 있다. (cover)
→ The top of the mountain _____ .

3 그는 자신의 시험 결과들에 만족하지 못한다. (satisfy)
→ He _____ .

4 물은 수소와 산소로 구성된다. (compose)
→ _____ hydrogen and oxygen.

5 나의 엄마는 그 소식을 듣고도 전혀 놀라지 않으셨다. (surprise)
→ My mom _____ at all.

6 그 항아리는 찬 물로 가득 차 있다. (fill)
→ The pot _____ .

7 Jason의 부모는 그의 성공을 기뻐했다. (please)
→ Jason's parents _____ .

8 그녀의 얼굴은 이 도시의 모든 사람들에게 알려져 있다. (know)
→ Her face _____ in this city.

9 이 셔츠는 면으로 만들어져 있다. (make)
→ This shirt _____ cotton.

B 다음 빈칸에 공통으로 들어갈 말을 고르세요.

1

> • Our school is known _____ its soccer team.
> • This restaurant is famous _____ their giant omelets.

① by ② at ③ for
④ with ⑤ in

2

> • We are satisfied _____ your service very much!
> • The trees are almost covered _____ blossoms.

① on ② about ③ from
④ of ⑤ with

C 빈칸 (A), (B), (C)에 들어갈 말로 알맞게 짝지어진 것은?

> • Sera and Mike were disappointed ____(A)____ your decision.
> • These days many people are worried ____(B)____ the quality of their drinking water.
> • I'm excited ____(C)____ the thought of going on a vacation with my family.

	(A)		(B)		(C)
①	about	……	at	……	to
②	with	……	about	……	at
③	to	……	by	……	for
④	with	……	with	……	to
⑤	to	……	for	……	with

Unit 07 can, may, will

A

문맥상 빈칸에 알맞은 것을 <u>모두</u> 고르세요.

1
> I'm not sure of Ms. Lee's age. She _____ be 25 or 26.

① is able to ② may ③ could

2
> I'm afraid James _____ see you now. He is too busy.

① can't ② could not ③ is not able to

3
> A: _____ you get some medicine for me? I think I've caught a cold.
> B: Sure, but I think you'd better get some rest first.

① Will ② Could ③ May

4
> The concert tickets had already been all sold out. I _____ go to the concert last week.

① am not able to ② could not ③ won't

5
> Tom and I _____ play outside until midnight when we lived next door.

① can ② might ③ would

6
> He decided that he _____ take a trip to Japan.

① will ② would ③ may

B

다음 물음에 알맞은 답을 고르세요.

1 다음 중 밑줄 친 부분의 의미가 다른 하나는?

① He can read and write Chinese.

② No one can predict the future.

③ She can describe it to you very well.

④ I can get to sleep very easily these days.

⑤ It can take a long time to learn new skills.

2 다음 중 어법상 바른 문장은?

① Take an umbrella. It might rained later.

② Rachel will able to drive legally when she is sixteen.

③ Jiho can helps you with your studies.

④ We would help each other when we were in trouble.

⑤ It was a hard test, so he can't pass.

3 다음 중 짝지어진 문장의 뜻이 서로 다른 것은?

① Soccer players may not touch the ball with their hands.

 = Soccer players cannot touch the ball with their hands.

② I think I can do it again.

 = I think I am going to do it again.

③ Can I use your bike this afternoon?

 = May I use your bike this afternoon?

④ When will the festival take place?

 = When is the festival going to take place?

⑤ He couldn't sleep at all last night because of the thunder.

 = He was not able to sleep at all last night because of the thunder.

must, should

A

괄호 안에서 어법과 문맥상 적절한 것을 고르세요.

1 We [must not / have to not] make a noise while he's sleeping.

2 You [must not / don't have to] introduce me to her. We've already met.

3 Visitors [must not / had not better] feed animals in the zoo.

4 A: Where is the leftover chicken from dinner last night? *leftover: 먹다 남은
 B: I just saw it in the freezer. It [must / have to] be there still.

5 A: Can I speak to Fred?
 B: There's no one here by that name. You [must / must not] have the wrong number.

6 You [should confirm / should have confirmed] your flight reservation before leaving. That way you will be safe. *confirm: 확인하다

7 A: I've caught a bad cold.
 B: You [have worn / should have worn] a coat yesterday.

8 A: Robert bought a car from his best friend. He is satisfied with the car.
 B: I know. He [must buy / must have bought] it at a very good price.

9 You [shall tell / shouldn't tell] anyone about her secret.

10 You [must turn / should have turned] off the TV before you leave the room.

11 Your dog [doesn't have to / must not] wait outside. We love animals and dogs are welcomed in our store.

B **다음 물음에 알맞은 답을 고르세요.**

1 주어진 문장과 밑줄 친 부분의 쓰임이 같은 것은?

> Miho was born in Japan and moved to Korea when she was ten. She
> <u>must</u> speak Japanese well.

① You <u>must</u> come to the rehearsal tomorrow if you want to join us.
② You <u>must</u> be twenty before you can drive in this country.
③ Most of my clothes don't fit anymore. I <u>must</u> go on a diet.
④ The movie <u>must</u> be sad. Many people left the theater crying.
⑤ To achieve any goal, you <u>must</u> decide first what you really want.

2 빈칸에 공통으로 들어갈 말로 알맞은 것은?

> • You _____ wash your hands after using the bathroom.
> • You _____ have asked me first before you used my phone.

① could ② have to ③ might
④ should ⑤ must

C **다음 우리말과 뜻이 같도록 괄호 안에 주어진 단어를 이용하여 문장을 완성하세요.**
(단, 동사 형태를 변화시킬 수 있음)

1 너는 꿈을 꿨던 것이 틀림없다. 그런 일은 절대 일어나지 않는다. (dream)
→ You _____ of it. That never happens.

2 내 컴퓨터가 또 고장 났다. 그것을 조심히 다루었어야 했는데 (그러지 않았다).
(treat, carefully)
→ My computer has broken down again. I _____ .

3 나는 어렸을 때 전학을 여러 번 해야 했다. (change, schools, several times)
→ When I was young, I _____ .

4 Karen이 어제 가방을 잃어버렸다고 했다. 저건 그녀의 가방이 틀림없다. (be, bag)
→ Karen said she lost her bag yesterday. That _____ .

used to, ought to, had better, need 정답 및 해설 p.23

A

다음 중 문맥상 빈칸에 알맞은 것을 고르세요.

1
> This building _____ be a church but now is a library.

① used to ② ought to ③ need

2
> You _____ speak so loud in the library.

① had better ② ought not to ③ need not

3
> They _____ get up early on Saturdays. They don't go to school.

① had better not ② ought not to ③ need not

4
> Parents _____ spend as much time as possible with their children. Otherwise, their kids can feel lonely.

① should ② ought not to ③ need not

5
> I _____ go out a lot in winter when I was young, but I don't now.

① used to ② was used to ③ didn't use to

6
> I _____ having toast for breakfast. It's easy to prepare.

① used to ② am used to ③ didn't use to

7
> A: To be good at English, should I learn the grammar completely?
> B: No! You _____ know the entire English grammar at all. But try to learn English with passion.

① ought to ② had better ③ need not

B 다음 중 어법상 **틀린** 문장을 고르세요.

1 ① Need we work tomorrow?
 ② When I was young, we used to live in a big house.
 ③ You had better keep away from the bad kids after school.
 ④ This machine is used to cutting the potatoes into slices.
 ⑤ You ought not to lose this chance.

2 ① We ought to respect our parents.
 ② They ought not to joke about such a serious matter.
 ③ I used to sing in the car when I was younger.
 ④ You need not read the book at once.
 ⑤ You had not better call too late.

C 다음 우리말과 뜻이 같도록 괄호 안에 주어진 단어를 이용하여 문장을 완성하세요.
(필요한 경우, 동사 형태를 변화시킬 것)

1 나는 예전에 안경을 썼지만 지금은 콘택트렌즈를 낀다.
 (wear glasses)
 → I _____, but I wear contact lenses now.

2 그녀는 하루에 두 끼를 먹는 데 익숙하다.
 (eat, two meals)
 → She _____ a day.

3 표가 곧 매진될 것이다. 오늘 몇 장을 사는 게 좋겠다.
 (buy, some)
 → Tickets will be sold out soon. You _____ today.

4 나는 새로운 사람들과 사귀는 데 익숙하지 않다.
 (make friends with, new people)
 → I _____.

Unit 10 to부정사의 형태와 명사적 역할

A

밑줄 친 부분을 어법에 맞게 고치세요.

1 It was not important <u>of Karen</u> to win the speech contest.

2 Some students found <u>them</u> stressful to play in the school orchestra.

3 I bought a new coffee machine but don't know <u>what to</u> use it.

4 It was kind <u>for you</u> to remember my birthday.

5 <u>This</u> is nonsense to say only human beings can feel happy or sad.

6 My dad wants me <u>make</u> many friends at school.

7 Dave let his neighbor <u>to come</u> in.

8 It's not fair <u>them</u> to blame him in public.

9 I found <u>that</u> easy to remember his phone number.

B

주어진 문장과 의미가 통하는 것을 고르세요.

1 We consider it enjoyable to go hiking in cold weather.

① To go hiking in cold weather is enjoyable.
② We're considering going hiking in cold weather.

2 It was nice of you to send her a Christmas present.

① It was nice that you sent her a Christmas present.
② It was nice that you made her send a Christmas present.

3 To eat vegetables is good for our health.

① People enjoy eating vegetables.
② Eating vegetables keeps us healthy.

C

다음 물음에 알맞은 답을 고르세요.

1 밑줄 친 부분과 쓰임이 같은 것은?

> The inventor made <u>it</u> possible to take a picture underwater.

① <u>It</u> rained a lot last night.
② She found <u>it</u> under the rug in the room.
③ I told him that I made <u>it</u> for fun.
④ He found <u>it</u> hard to believe the news.
⑤ <u>It</u> isn't easy to solve these puzzles.

2 다음 중 빈칸에 들어갈 말이 나머지 넷과 <u>다른</u> 하나는?

① It's convenient _____ me to take a bus to work.
② It's dangerous _____ kids to play soccer near a busy road.
③ It's not common _____ men to wear skirts.
④ It's generous _____ you to give food to the homeless.
⑤ It's not good _____ you to eat fatty foods and drink sodas.

D

다음 우리말과 뜻이 같도록 괄호 안의 단어를 배열하여 문장을 완성하세요.

1 나는 형에게 노래를 불러 달라고 부탁했다.
(my, sing, asked, a, brother, song, to)
→ I _____ .

2 내 친구는 내게 테니스 치는 방법을 가르쳐 주었다.
(how, tennis, to, play)
→ My friend taught me _____ .

3 번지점프를 하는 것은 언제나 재미있다.
(do, to, fun, bungee jumping)
→ It is always _____ .

4 내가 너에게 술 마시고 운전하지 말라고 말했잖아.
(to, not, you, drink, drive, and)
→ I told _____ .

to부정사의 형용사적·부사적 역할

A

밑줄 친 부분의 역할을 〈보기〉에서 골라 그 기호를 쓰세요.

〈보기〉 ⓐ 명사적 용법　　ⓑ 형용사적 용법　　ⓒ 부사적 용법

1　The cat moved slowly to catch the duck.

2　He didn't expect to pass the driving test.

3　To tell the truth, I'm younger than your sister.

4　Students are to follow all classroom rules.

5　He was upset to fail the exam.

6　I want to become a content creator.

7　She is the new secretary to help the president.

8　Wear sunscreen to protect your skin from the sun's harmful rays.

9　The time to repair the roof is when the sun is shining.

B

밑줄 친 부사적 용법으로 쓰인 부정사의 역할을 〈보기〉에서 골라 그 기호를 쓰세요.

〈보기〉 ⓐ 목적: ~하기 위해　　　　ⓑ 감정의 원인: ~해서, ~하게 되어
　　　　ⓒ 판단의 근거: ~하다니　　ⓓ 결과: (결국) ~하다, ~되다
　　　　ⓔ 한정: ~하기에 (…한)

1　You have to learn Japanese to work in Japan.

2　The manager was wise to calm the angry customer down.

3　Her daughter grew up to be a famous politician.

4　Your son must be a genius to solve all those puzzles.

5　Mary drank coffee to be awake at night.

6　She felt proud of herself to win the drawing competition.

7　I use the oven to roast chicken or fish.

8　He was happy to join our club.

9　To achieve her goal, she worked very hard.

10　This dirt is difficult to remove.

C

다음 물음에 알맞은 답을 고르세요.

1 짝지어진 두 문장의 뜻이 같지 <u>않은</u> 것은?

① Jake came to Jeonju to learn traditional Korean music.
= Jake came to Jeonju in order to learn traditional Korean music.
② Becky was angry to hear my dog broke her vase.
= Becky was angry because my dog broke her vase.
③ The training is to be completed by the end of June.
= The training will be completed by the end of June.
④ You are to follow the rules posted on your classroom wall.
= You don't have to follow the rules posted on your classroom wall.
⑤ You are silly to trust him again.
= It's silly of you to trust him again.

2 다음 중 어법상 바른 문장은?

① They want an apartment to live.
② I promise to protect our precious natural resources.
③ He bought a toy car for his son to play.
④ Strangely to say, the dog doesn't bark at strangers.
⑤ Mom told me to not watch TV at night.

D

다음 우리말과 뜻이 같도록 괄호 안의 단어를 이용하여 문장을 완성하세요.

1 Lisa는 팔이 부러졌다. 그리고 설상가상으로 감기도 걸렸다.
(make, matters)
→ Lisa had a broken arm. And _____, she caught a cold.

2 솔직히 말해서, 나는 거기 가고 싶지 않아.
(tell, the truth)
→ _____, I don't want to go there.

3 그렇게 어려운 문제를 풀다니 그는 분명히 똑똑할 거야.
(solve, smart)
→ It must be _____ such a difficult problem.

Unit 12 많이 쓰이는 to부정사 구문

A

두 문장이 같은 뜻이 되도록 빈칸을 완성하세요.

1 She was so tired that she couldn't hang out with her friends.

= She was _____ tired _____ hang out with her friends.

2 He seems to know a lot about me.

= It seems that _____ _____ a lot about me.

3 The lake was so cold that we couldn't swim in it.

= The lake was _____ cold for us _____ _____ in.

4 It's warm enough today for us to go outside in shorts.

= It's _____ warm today _____ _____ _____ _____ outside in shorts.

5 We went to the market so that we could buy groceries for the picnic.

= We went to the market _____ _____ _____ buy groceries for the picnic.

6 The festival seems to attract many tourists.

= _____ _____ _____ the festival attracts many tourists.

7 The streets were too crowded for me to walk easily.

= The streets were _____ _____ _____ I couldn't walk easily.

8 I was lucky enough to find a parking space near the mall.

= I was _____ lucky _____ _____ _____ find a parking space near the mall.

9 This box is too heavy for me to lift.

= This box is so _____ that I _____ _____ it.

10 It takes me ten minutes to get to the bus station.

= It takes ten minutes _____ _____ _____ _____ to the bus station.

B 짝지어진 두 문장의 뜻이 같은 것은?

① She ran to catch the train.

= She ran in order not to catch the train.

② They seem to have a good idea.

= It seems that they had a good idea.

③ Most people like to talk in order to feel close to others.

= Most people like to talk so that they can't feel close to others.

④ My brother is humorous enough to make anyone laugh.

= My brother is too humorous to make anyone laugh.

⑤ He seemed to have difficulty in making friends.

= It seemed that he had difficulty in making friends.

C 다음 우리말과 뜻이 같도록 괄호 안에 주어진 단어를 이용하여 두 문장을 완성하세요.
(단, 동사 형태를 변화시킬 수 있음)

1 도둑들은 체포되지 않으려고 도망쳤다. (arrest)

→ The thieves ran away in order _____.

→ The thieves ran away _____.

2 그의 수수께끼는 그녀가 풀기에는 너무 어려웠다. (difficult, answer)

→ His riddle was too _____.

→ His riddle was so _____.

3 네가 Ann을 귀찮게 하는 것 같다. (seem, annoy)

→ It _____.

→ You _____.

4 일주일 후 수지는 퇴원할 수 있을 만큼 충분히 좋아졌다. (well, leave)

→ A week later Suji was _____ enough _____ the hospital.

→ A week later Suji was so _____ the hospital.

Unit 13 동명사의 쓰임

A

괄호 안에 주어진 단어의 알맞은 형태를 빈칸에 쓰세요.

1 I'm thinking of _____ swimming lessons. (take)

2 _____ a lie is often easier than telling the truth. (tell)

3 Drinking enough water _____ good for your health. (be)

4 _____ chopsticks is difficult for many non-Asians. (use)

5 His way of _____ is very impolite. (speak)

6 The problem was _____ eating too much. (he)

7 You can't judge a book by _____ at its cover. (look)

8 On _____ the news, she burst into tears. (hear)

9 _____ bicycles for three days was a big challenge for us. (ride)

10 You were a great teacher. I'm really proud of _____ your student. (be)

B

다음 두 문장의 뜻이 같도록 빈칸에 알맞은 말을 쓰세요.

1 As soon as he saw the thief, he called the police.

= On _____ the thief, he called the police.

2 She is proud that she had won the award.

= She is proud of _____ the award.

3 I could not but be impressed by his speech.

= I could not help _____ by his speech.

4 The rain kept us from starting.

= The rain prevented us _____.

5 We look forward to having you again as our guest.

= We gladly expect _____ you again as our guest.

C

우리말과 뜻이 같도록 괄호 안의 단어를 이용하여 문장을 완성하세요.
(단, 동사 형태를 변화시킬 수 있음)

1 우리는 그 스포츠 행사에 참가하길 고대한다. (look, participate)

→ We _____ in the sports event.

2 나는 그 이상한 메시지에 대해 생각하지 않을 수 없다. (help, think)

→ I _____ about that strange message.

3 그들은 교실을 장식하는 데 많은 시간을 보냈다. (spend, time, a lot of, decorate)

→ They _____ their classroom.

4 나는 내일 있을 회의에서 할 발표를 준비하느라 바쁘다. (busy, prepare)

→ I'm _____ my presentation for tomorrow's conference.

5 너는 스팸 메일을 받자마자 즉시 지워버려야 한다. (on, receive)

→ _____ a spam mail, you need to delete it immediately.

6 그 지역의 소도시들은 한 번 방문해 볼 가치가 있다. (worth, visit)

→ The small towns in the area _____ once.

7 이번 게임에는 참여하고 싶지 않아. 난 빠질게. (feel, join)

→ I don't _____ in this game. I'll sit it out.

8 그 둑은 강이 범람하지 않게 막아 준다.

(1) (prevent, the river, overflow)

→ The banks _____ .

(2) (keep, the river, overflow)

→ The banks _____ .

Unit 14 동명사와 to부정사

A

괄호 안에서 어법에 맞는 것을 <u>모두</u> 고르세요.

1 Would you mind [waiting / to wait] here for a moment?

2 Amy prefers [having / to have] a big breakfast.

3 We're planning [going / to go] to Norway this summer.

4 At the time, they gave up [farming / to farm] and moved to big cities.

5 The audience started [leaving / to leave] before the play was over.

6 I hope [seeing / to see] you again soon.

7 Many stores are quitting [using / to use] plastic bags these days.

8 Kate enjoys [having / to have] a cup of tea after lunch.

9 We are considering [going / to go] to Canada.

10 You can't avoid [going / to go] to jail if you commit a serious crime.

11 They continued [discussing / to discuss] the political issue after class.

12 I regret [leaving / to leave] you alone at the party last night.

B

다음 중 짝지어진 문장의 뜻이 서로 <u>다른</u> 것은?

① My favorite thing is playing with my dog.

= My favorite thing is to play with my dog.

② Kids love reading fairy tales.

= Kids love to read fairy tales.

③ To believe the Earth is round was not accepted in the past.

= Believing the Earth is round was not accepted in the past.

④ I stopped to buy some flowers.

= I stopped buying some flowers.

⑤ It began raining when we left home.

= It began to rain when we left home.

C 주어진 문장과 의미가 통하는 것을 고르세요.

1 I stopped to read the notice.

① I stopped because I wanted to read the notice.
② I kept reading the notice for a while, but then I stopped reading.

2 I remember buying the tickets.

① I have to buy the tickets.
② I bought the tickets.

3 I forgot to ask her about our schedule.

① I asked her about our schedule.
② I had to ask her about our schedule, but I didn't.

4 I deeply regret trusting her so easily.

① I have trusted her.
② I have never trusted her.

5 I stopped staring at her face.

① I stopped because I wanted to stare at her face.
② I stared at her face for a while, but then I stopped staring.

6 I should remember to give her a call.

① I have to give her a call.
② I gave her a call.

분사의 종류와 명사 수식 역할

정답 및 해설 p.23

A

괄호 안의 단어를 알맞은 형태로 바꾸어 빈칸에 쓰세요.

1 The boy _____(wear) a black cap is my little brother.

2 The thief tried to open the _____(lock) cabinet.

3 She looked at her daughter's _____(sleep) face.

4 You can use fresh or _____(freeze) fish for this recipe.

5 The criminal was caught in a _____(steal) car.

6 The river _____(flow) down from Paris was near our hotel.

7 The ambulance _____(take) her to the hospital was delayed by traffic.

8 The museum displayed the treasures _____(find) inside royal tombs.

9 The first credit card was invented by the man _____(call) Ralph Schneider.

10 The candles _____(burn) brightly in the dark gave me a sense of peace.

B

주어진 두 문장의 뜻이 같도록 빈칸을 완성하세요.

1 Jason has many toys. They are made by his father.

= Jason has many toys _____.

2 Look at the girls. They are dancing on the stage.

= Look at the girls _____.

3 The boy is my cousin. He is standing under the tree.

= The boy _____ is my cousin.

4 Egg omelets are ready. They are cooked by my grandmother.

= Egg omelets _____ are ready.

5 She gave a presentation in front of many people. They were watching her.

= She gave a presentation in front of many people _____.

C

빈칸에 들어갈 말로 바르게 짝지어진 것을 고르세요.

1

- I'm looking for my _____ cell phone.
- Look at those people _____ in the lake.
- It was a really _____ movie. I fell asleep while I was watching it.

① lost ······ swum ······ boring
② lost ······ swimming ······ boring
③ lost ······ swum ······ bored
④ losing ······ swimming ······ bored
⑤ losing ······ swum ······ bored

2

- People _____ in crowded cities can hardly have gardens.
- _____ travelers usually carry paper maps.
- In China, red envelopes _____ with money are a symbol of good luck.

① living ······ Experiencing ······ filling
② living ······ Experienced ······ filled
③ lived ······ Experienced ······ filled
④ lived ······ Experienced ······ filling
⑤ lived ······ Experiencing ······ filled

D

다음 우리말과 뜻이 같도록 괄호 안의 단어를 배열하여 문장을 완성하세요.
(단, 굵은 글씨로 된 동사는 분사 형태로 바꿀 것)

1 나는 잃어버렸던 목걸이를 침대 밑에서 우연히 발견했다. (found, necklace, my, **lose**)
→ I accidentally _____ under the bed.

2 한국에서 만든 스마트폰은 세계에서 매우 인기가 있다. (**make**, smartphones, Korea, in)
→ _____ are very popular around the world.

3 나는 지난 여름에 유럽에서 찍은 사진들을 보는 중이다. (in Europe, **take**, pictures, my)
→ I'm looking at _____ last summer.

Unit 16 분사의 보어 역할, 감정을 나타내는 분사

A 괄호 안의 단어를 알맞은 형태로 바꾸어 빈칸에 쓰세요.

1 Scuba diving is _____ (excite) and opens up a new world of marine life.

2 Don't be _____ (depress) when you are facing difficulties in life.

3 He feels _____ (embarrass) about all the attention paid to him.

4 The _____ (exhaust) men sat down to rest under the tree.

5 I want to write an _____ (interest) mystery novel with a very _____ (surprise) ending.

6 Never leave your child _____ (play) alone near water.

7 Yesterday I got my hair _____ (dye) for the first time in my life.

B 괄호 안에서 어법에 맞는 것을 모두 고르세요.

1 Frozen berries have nutrients [lock / locked] inside.

2 When I woke up at midnight, I heard an ambulance [pass / passing / passed] by.

3 She doesn't want to see any animals [treat / treating / treated] cruelly.

4 This way, you can keep your software [updating / updated] easily.

5 I had my bed [designing / designed] by experts.

6 When we were crossing a frozen river, I saw the river ice [cracking / to crack].

C

다음 중 어법에 맞는 문장을 고르세요.

1 ① She wants to have the walls paint yellow.

　　 ② The new reality program looked bored.

　　 ③ I was shocking when I heard the news.

　　 ④ He watched a spider climbing the leg of the table.

　　 ⑤ Who is the most interested fictional book character?

2 ① She became satisfying with her school life.

　　 ② He was so disappointing with the election results.

　　 ③ I was in a very embarrassed situation then.

　　 ④ Can you hear someone screamed from the forest?

　　 ⑤ Keep the curtain closed when you sleep.

D

다음 우리말과 뜻이 같도록 괄호 안의 단어를 배열하여 문장을 완성하세요.

1 널 다시 만나게 되어 기뻐.

　　 (pleased, I'm, again, you, to meet)

　　 → _____

2 새로운 곳에 가는 것은 언제나 흥분된다.

　　 (is, always, places, to, exciting, going, new)

　　 → _____

3 그들은 거대한 고래들이 바다에서 헤엄치고 있는 것을 보았다.

　　 (in the ocean, they, whales, saw, swimming, huge)

　　 → _____

4 너는 얼마나 자주 머리를 자르니?

　　 (you, cut, do, your hair, how often, get)

　　 → _____

5 그는 자신의 경력에 결코 만족하지 않는다.

　　 (with, he, never, career, is, satisfied, his)

　　 → _____

주어+동사/주어+동사+주격보어

정답 및 해설 p.24

A

다음 중 문장 형식이 <u>다른</u> 하나를 고르세요.

1 ① You should come earlier than Teddy.
 ② Will it rain this afternoon?
 ③ I felt nervous on my first day of school.
 ④ There was a car accident on the highway.
 ⑤ He walked away from me that night.

2 ① My friend is living in Mokpo.
 ② She usually wakes up early in the morning.
 ③ A man is swimming in the river.
 ④ The medicine I took tasted bitter.
 ⑤ The bus will arrive soon.

3 ① Her children fell asleep on the sofa.
 ② To be, or not to be, that is the question.
 ③ The customer comes to our shop almost every day.
 ④ Brad was very busy yesterday.
 ⑤ The water in the well ran dry.

4 ① The plane leaves from Incheon International Airport.
 ② The jar broke into hundreds of pieces.
 ③ We can't live without water.
 ④ The sports car sells for $50,000.
 ⑤ His new book is very difficult for me to understand.

B 밑줄 친 부분이 어법과 문맥상 맞으면 ○표를 하고, 틀리면 바르게 고치세요.

1 It's getting <u>wind</u> this afternoon.

2 My grandmother's recipes remain <u>a secret</u>.

3 Tom was very <u>busily</u> this morning.

4 The dictionary is <u>fully</u> of useful expressions.

5 When the accident happened, everybody kept <u>calmly</u>.

6 If they get married, they will become <u>happy</u>.

7 The teacher is very <u>friend</u> to his students.

8 As time went on, he grew more and more <u>bravely</u>.

9 All the players got <u>wet</u> in the heavy rain.

10 The melted chocolate smelled <u>deliciously</u>.

C 다음 중 어법상 <u>틀린</u> 문장을 고르세요.

1 ① Your age doesn't matter for this job.
 ② The concert tickets sell pretty good.
 ③ A famous movie star appeared at the party.
 ④ I stayed at home on Christmas Day.
 ⑤ Kate hesitated before calling Fred.

2 ① That proposal sounds risky.
 ② I tried to cook an Italian dish, but it tasted awful.
 ③ Eat your dinner before it gets cold.
 ④ He looked happily after having lunch with her.
 ⑤ Nothing remained unchanged.

Unit 18

주어＋동사＋목적어/
주어＋동사＋간접목적어＋직접목적어

A

다음 문장에서 목적어, 간접목적어, 직접목적어를 찾아 밑줄을 긋고 각각 O, IO, DO로 표시하세요.

1 He lived a comfortable life when he was very young.

2 Sorry, I didn't want to hurt your feelings.

3 I don't mind opening the window.

4 Roger will keep the money in the basement.

5 Will you walk my dog this evening?

6 Did you give the waiter a tip?

7 I'll show you how to use this copy machine.

B

밑줄 친 부분이 어법과 문맥상 맞으면 ○표를 하고, 틀리면 바르게 고치세요.

1 Sarah married with her old friend.

2 We discussed several topics.

3 The boy's hand didn't reach at the button.

4 The bird laid four eggs in the nest.

5 Kate brought an umbrella her brother.

6 Can you tell to me how to install this software?

7 We can't wait to show our home to you.

8 He didn't want to mention about his childhood.

9 The university gave him to a football scholarship.

10 I sang her a love song on the bridge.

C

다음 중 어법에 맞는 문장을 고르세요.

1　① Who entered into the office?

　　② It may sound strangely, but it is true.

　　③ The actor didn't answer to the questions at the interview.

　　④ My dad used to read books to me.

　　⑤ May I ask a favor to you?

2　① I'd like to buy a pretty dress for you.

　　② My grandfather made this chair to me.

　　③ I sent some chocolate for my uncle in the army.

　　④ Eric sold me to one of his favorite books.

　　⑤ She resembles to her husband.

D

두 문장의 뜻이 같도록 빈칸을 완성하세요.

1　During her travels, she sent postcards to her friends.

　　→ During her travels, she sent _____.

2　He told us scary ghost stories.

　　→ He told _____.

3　I made my parents fried rice.

　　→ I made _____.

4　They gave their guests a warm welcome.

　　→ They gave _____.

5　My aunt bought this necklace for me.

　　→ My aunt bought _____.

6　She showed me pictures of herself as a child.

　　→ She showed _____.

Unit 19 주어＋동사＋목적어＋목적격보어

A

다음 밑줄 친 부분을 O(목적어)와 C(목적격보어) 또는 IO(간접목적어)와 DO(직접목적어)로 표시하세요.

1　His advice gave <u>them</u> <u>energy</u>.

2　I found <u>all of my friends</u> <u>honest</u>.

3　Sally's mother baked <u>her</u> <u>some cookies</u>.

4　Don't leave <u>the window</u> <u>open</u> at night.

5　My friend named <u>his dog</u> <u>Lucy</u>.

6　They are lying. I'll tell <u>him</u> <u>the truth</u>.

B

괄호 안에서 어법에 맞는 것을 <u>모두</u> 고르세요.

1　They advised her [make / to make] a hotel reservation.

2　Mr. Brown encouraged us [enter / to enter] an essay contest.

3　I'm letting my hair [grow / to grow] long.

4　I expected my brother [fail / to fail] his driving test.

5　What caused that accident [happen / to happen]?

6　She felt a tear [drop / to drop] onto her cheek.

7　The Internet enables customers [shop / to shop] anytime and anywhere.

8　Gentle stretching can help your muscles [relax / to relax].

9　Please tell the taxi driver [wait / to wait] for us outside.

10　I watched the boys [play / playing] volleyball at the beach.

C

다음 중 어법상 틀린 문장을 고르세요.

1 ① I think that your sister is smart.

② Her failure made her strongly.

③ The brilliant girl found the questions easy.

④ Thanks to the map, we found the hotel easily.

⑤ How can I keep my house cool in the summer?

2 ① She asked me to wait for her call.

② How can I make my children eat spinach?

③ I saw him looking for something under the table.

④ They won't allow you smoke in the building.

⑤ Emma stopped her car and let a cat run across the street.

D

다음 우리말과 뜻이 같도록 괄호 안의 단어를 배열하여 문장을 완성하세요.
(단, 동사의 형태를 변화시킬 수 있음)

1 십 대들은 우정을 매우 중요하게 생각한다.

(very, important, consider, teenagers, friendship)

→ _____

2 내 동생은 그의 장난감 차에 Bumblebee라는 이름을 지어주었다.

(Bumblebee, toy, his, my brother, car, name)

→ _____

3 Ted는 어머니가 설거지하는 것을 도와드렸다.

(his mother, the dishes, Ted, wash, help)

→ _____

4 나는 내 친구들이 축구 경기를 하고 있는 것을 보았다.

(friends, see, soccer, play, my, I)

→ _____

Unit 20 명사와 수일치

A

괄호 안에서 어법에 맞는 것을 고르세요.

1 All I had today was two bottles of [water / waters].

2 Your personal information [was / were] not sold to anyone.

3 When I make big [decision / decisions], I often ask my sister's opinion.

4 Teachers post [homework / homeworks] on the school website.

5 He spent a lot of money on [furniture / furnitures] for his new house.

6 You can make a yummy sandwich with eggs, lettuce, and [two breads / two pieces of bread].

7 Many of the great leaders in history [has / have] been women.

8 A lot of students attending my class [get / gets] along with one another.

9 Art and culture [make / makes] the world a better place to live in.

10 The number of street crimes [is / are] decreasing since cameras were set up.

11 About ten percent of workers in the office [has / have] not yet received their pay.

12 Two-thirds of the money that my sister spends [is / are] for clothes.

B

다음 중 어법에 맞는 문장을 고르세요.

1 ① She has a beautiful eyes.
 ② I have thing to tell you about my trip to Europe.
 ③ She made a lot of mistakes and didn't get a good grade.
 ④ I don't listen to a lot of musics. But I like jazz.
 ⑤ After we graduated, half of my friends was employed.

2 ① The topic that I chose were about education.

② Five kilograms are what I want to lose.

③ There are a lot of information on the Internet.

④ One of the guests has not arrived yet.

⑤ The number of students in my class are 30.

3 ① The plates on the table is beautiful.

② Economics are my favorite subject.

③ One of the options you can choose are to go there by taxi.

④ Many students was late for class.

⑤ A number of people prefer to watch movies at home.

C **다음 우리말과 뜻이 같도록 괄호 안의 단어를 이용하여 문장을 완성하세요.**
(필요한 경우, 동사의 형태를 변화시킬 것)

1 나는 점심으로 케이크 두 조각과 우유 한 잔을 마셨다. (have, cake, milk, for lunch)

→ _____

2 십대들 모두 그 TV 쇼를 좋아한다. (all of, like, that TV show)

→ _____

3 7일은 그 보고서를 끝내기에 충분한 시간이 아니다. (be, enough time, finish, the report)

→ Seven days _____ .

4 우주에 있는 별의 수는 셀 수 없이 많다.

(the number of, stars, the universe, be, countless)

→ _____

5 내 친구들의 반이 그 파티에 참석했다. (half of, be present)

→ _____ at the party.

Unit 21 부정대명사

A

괄호 안에서 어법과 문맥상 알맞은 것을 고르세요.

1 I tried [any / some] of the cake my mom baked this morning.

2 I don't have [any / some] plans for this winter vacation.

3 A: I wish I had a laptop computer.
 B: But you already have [it / one].

4 A: You should take the medicine three times a day.
 B: I see. I'll try to take [it / one] regularly.

5 A: Which shoes look better on me?
 B: I think the red [them / ones] are better on you.

6 We'd better get a taxi because [either / neither] of us has much time.

7 Each [room / rooms] in the hotel has a balcony with beautiful views.

8 All I know about that country [is / are] what I've read in some books.

9 Every [child / children] in the world has the right to go to school.

10 [Either / Neither] of the movies was not what I wanted to see.

11 I don't see [wrong anything / anything wrong] with what I said.

12 Both of the books that I wanted to buy [was / were] already sold out.

13 Each of the major cities [has / have] its own particular character.

14 Many of the workers in my office [bring / brings] a homemade lunch.

15 This shirt is too big for me. Do you have [smaller something / something smaller] in the same color?

B 다음 중 어법상 **틀린** 문장을 고르세요.

1 ① Some of the information on this site is false.
 ② You can take any seats you like.
 ③ I can't stay here with you any longer.
 ④ I have two uncles. One is married, but the other is single.
 ⑤ In any exam, some need more time but other don't.

2 ① Each of the books in this series is great.
 ② Neither of the stories is new and interesting.
 ③ All of the clothes were of high quality.
 ④ Let's talk about important something.
 ⑤ Each card has different colors and numbers.

C 다음 우리말과 뜻이 같도록 〈보기〉에서 고른 부정대명사와 괄호 안에 주어진 말을 이용하여 문장을 완성하세요. (단, 동사를 알맞은 형태로 바꿀 수 있음)

〈보기〉 either neither something each nothing

1 특별한 건 아니지만 너에게 줄 작은 선물이 있어. (it, be, special)
 → _____, but I have a little gift for you.

2 나는 많은 사람들을 위해 뭔가 가치 있는 것을 하고 싶다.
 (do, valuable, many people, for)
 → I would like to _____.

3 나는 이 두 가지 음식 중 어느 것도 먹어 본 적이 없다. (of, these dishes, try)
 → I _____.

4 학생들 각자가 발표를 해야 합니다. (of, have to, the students, give)
 → _____ a presentation.

5 우리 둘 중 누구도 그것을 혼자 해낼 만큼 충분한 경험이 없다.
 (of, us, enough, have, experience)
 → _____ to do it by ourselves.

전치사

A

괄호 안에서 어법과 문맥상 알맞은 것을 고르세요.

1 Bill thanked us for [invitation / inviting] him to dinner.

2 I'm interested in [make / making] traditional Korean food.

3 [According to / Thanks to] the plan we had set up, we should have finished the project already.

4 We postponed our trip [because / because of] the bad weather.

5 [Instead of / In spite of] his injury, Tim decided to play in Saturday's match.

6 A: How was your trip to Sydney?
 B: It was great! But it was boring being on the plane [for / at] 10 hours.

7 This is a very soft T-shirt made [to / from] 100% cotton.

8 I walked [to / at] the window to draw the curtains.

9 I kept a diary every day [in / with] my teens but not now.

10 Can I take my pet [on / to] the plane with me?

B

빈칸에 with가 들어가는 문장의 기호를 모두 쓰세요.

ⓐ I want you to come _____ me to the movie tomorrow.
ⓑ I saw a black dog _____ red eyes.
ⓒ Protect your skin from sunburn _____ using sunblock.

*sunblock: 자외선 차단제

ⓓ Thor attacked giants _____ a hammer.
ⓔ I enjoy skating and snowboarding _____ winter.
ⓕ It's important to have a vision _____ the future.

C

빈칸에 공통으로 들어갈 전치사를 쓰세요.

1
- A unique gold coin is _____ exhibition at the British Museum.
- Is the black jacket _____ the hanger yours?
- Your favorite movie will be released on DVD _____ the 1st of April.

2
- I heard what happened to Brian _____ the beginning of this week.
- My uncle died _____ the age of 30 during the Korean War.
- She told me she would be at the bus stop _____ five o'clock.

3
- My father said that he was very handsome _____ his twenties.
- Skiing is the most popular outdoor activity _____ winter.
- I found this watch _____ an antique store.

D

다음 우리말과 뜻이 같도록 〈보기〉에서 고른 전치사와 괄호 안의 단어를 배열하여 문장을 완성하세요.
(단, 동사의 형태를 변화시킬 수 있음)

〈보기〉	to	from	by	for

1 불편을 끼쳐 드려 정말 죄송합니다. (I, very, be, sorry, the inconvenience)
→ _____

2 이 탁자 위에 있는 책들은 30% 할인됩니다.
(the books, on, be discounted, this table, 30%)
→ _____

3 Ben과 그의 형은 항상 나에게 매우 친절하게 대해 왔다.
(have, been, always, kind, very, me)
→ Ben and his brother _____ .

4 우리 집은 여기서 멀지 않다. (my, be, not, house, far, here)
→ _____

MEMO

MEMO

Grammar is Understanding!

Starter 1,2 Intermediate 1,2 Advanced 1,2

쎄듀 초등 커리큘럼

영역	예비초	초1	초2	초3	초4	초5	초6
구문		신간 천일문 365 일력 \|초1-3\| 교육부 지정 초등 필수 영어 문장		초등코치 천일문 SENTENCE 1001개 통문장 암기로 완성하는 초등 영어의 기초			
문법			신간 왓츠 Grammar Start 시리즈 초등 기초 영문법 입문	초등코치 천일문 GRAMMAR 1001개 예문으로 배우는 초등 영문법			
					신간 왓츠 Grammar Plus 시리즈 초등 필수 영문법 마무리		
독해					신간 왓츠 리딩 70 / 80 / 90 / 100 A / B 쉽고 재미있게 완성되는 영어 독해력		
어휘				초등코치 천일문 VOCA&STORY 1001개의 초등 필수 어휘와 짧은 스토리			
		패턴으로 말하는 초등 필수 영단어 1 / 2 문장 패턴으로 완성하는 초등 필수 영단어					
ELT	Oh! My PHONICS 1 / 2 / 3 / 4 유·초등학생을 위한 첫 영어 파닉스						
		Oh! My SPEAKING 1 / 2 / 3 / 4 / 5 / 6 핵심 문장 패턴으로 더욱 쉬운 영어 말하기					
		Oh! My GRAMMAR 1 / 2 / 3　쓰기로 완성하는 첫 초등 영문법					

쎄듀 중등 커리큘럼

영역	예비중	중1	중2	중3
구문		신간 천일문 STARTER 1 / 2		중등 필수 구문 & 문법 총정리
문법		천일문 GRAMMAR LEVEL 1 / 2 / 3		예문 중심 문법 기본서
		GRAMMAR Q Starter 1, 2 / Intermediate 1, 2 / Advanced 1, 2		학기별 문법 기본서
		잘 풀리는 영문법 1 / 2 / 3		문제 중심 문법 적용서
		GRAMMAR PIC 1 / 2 / 3 / 4		이해가 쉬운 도식화된 문법서
			1센치 영문법	1권으로 핵심 문법 정리
문법+어법			첫단추 BASIC 문법·어법편 1 / 2	문법·어법의 기초
문법+쓰기		EGU 영단어&품사 / 문장 형식 / 동사 써먹기 / 문법 써먹기 / 구문 써먹기		서술형 기초 세우기와 문법 다지기
				올씀 1 기본 문장 PATTERN 내신 서술형 기본 문장학습
쓰기		거침없이 Writing LEVEL 1 / 2 / 3		중등 교과서 내신 기출 서술형
		개정 중학 영어 쓰작 1 / 2 / 3		중등 교과서 패턴 드릴 서술형
어휘		어휘끝 중학 필수편	중학 필수어휘 1000개	어휘끝 중학 마스터편 고난도 중학어휘 +고등기초 어휘 1000개
독해		Reading Relay Starter 1, 2 / Challenger 1, 2 / Master 1, 2		타교과 연계 배경 지식 독해
		READING Q Starter 1, 2 / Intermediate 1, 2 / Advanced 1, 2		예측/추론/요약 사고력 독해
독해전략			리딩 플랫폼 1 / 2 / 3	논픽션 지문 독해
독해유형			Reading 16 LEVEL 1 / 2 / 3	수능 유형 맛보기 + 내신 대비
			첫단추 BASIC 독해편 1 / 2	수능 유형 독해 입문
듣기		Listening Q 유형편 / 1 / 2 / 3		유형별 듣기 전략 및 실전 대비
		쎄듀 빠르게 중학영어듣기 모의고사 1 / 2 / 3		교육청 듣기평가 대비

Grammar is Understanding

GRAMMAR Q

Advanced ❶
정답 및 해설

쎄듀

✦ Grammar is Understanding ✦

GRAMMAR Q

정답 및 해설

Advanced ❶

Unit 01 현재·과거·미래시제와 진행형

1 현재시제 2 조동사 3 진행

PRACTICE pp. 16~18

> **STEP 1** 1 walk 2 received 3 becomes
> 4 am watching 5 was 6 heard
> 7 was washing 8 made
> **STEP 2** 1 ⓐ 2 ⓒ 3 ⓒ 4 ⓑ 5 ⓐ 6 ⓒ 7 ⓒ
> **STEP 3** 1 goes 2 is 3 chose 4 will help
> 5 flows 6 begin
> **STEP 4** 1 ○ 2 ○ 3 is belonging to → belongs
> to 4 am understanding → understand
> 5 ○
> **STEP 5** 1 ① 2 ②
> **STEP 6** 1 It is snowing. 2 They are building our
> new school library. 3 Susan was reading
> her son a story 4 when class is over

STEP 1

1 현재의 습관을 나타낼 때는 현재시제
2 과거를 나타내는 부사구(the other day)가 있고 진행 중인 동작이 아니므로 과거시제
3 '물이 0℃에서 얼음이 된다'는 일반적 사실, 진리를 말하므로 현재시제
4 말하는 그 순간에 진행 중인 동작이므로 현재진행형
5 과거 시점을 나타내는 말(in 1930)이 있으므로 과거시제
6 when ~ 절의 내용이 과거 시점을 나타냄
7 과거의 특정 시점에 진행 중이었던 동작이므로 과거진행형
8 진행 중인 동작이 아니므로 과거형

STEP 2

1 현재 상태
2 '한 시간 후에'는 가까운 미래
3 가까운 미래에 예정된 일
4 (지금) 음악을 듣고 있는 중
5 '~한 학생들로 구성되어 있다'는 현재 상태
6 '조건'의 부사절에서 현재시제가 미래를 대신함
7 가까운 미래에 일어나게끔 확실히 정해진 일

STEP 3

1, 2 시간을 나타내는 부사절에서 현재시제가 미래를 대신함
3 수학을 선택한 것은 과거의 일
4 if 조건절과 때를 나타내는 부사절이 아니면 미래시제는 그대로 미래형으로 표현
5 일반적 사실은 현재시제
6 시간의 부사절은 현재시제가 미래를 대신함

STEP 4

1 taste가 '~을 맛보다'라는 뜻일 때는 진행형 가능

2 have가 '~을 겪다'라는 뜻이므로 진행형 가능
3 belong to는 소유를 나타내므로 진행형 불가
4 understand는 진행형이 불가능한 인식 동사
5 think가 일시적인 동작을 강조하므로 진행형 가능

STEP 5

1 ⓐ 가까운 미래에 일어나도록 확실히 정해진 일
　 ⓑ when절에서 미래를 대신하는 현재시제
　 ⓒ 현재 진행 중인 동작
2 ②는 가까운 미래. 나머지 ①, ③~⑤는 모두 현재 진행 중인 동작, 상태

STEP 6

1, 2 지금 진행 중인 일
3 과거 어느 시점에 진행 중이던 일
4 when 부사절에서는 현재시제가 미래를 대신함

⊙ 내신 적중 Point p. 19

> 1 ③ 2 ④ 3 When your violin lesson is over

1 시간의 부사절에서는 현재시제가 미래를 대신함
　 ① → sees: 현재의 습관 ② → finished ④ → took
　 ⑤ → spilled[spilt]
2 ④ → was studying
3 시간의 부사절에서는 현재시제가 미래를 대신함

Unit 02 현재완료

1 완료 2 과거 3 현재

PRACTICE pp. 22~24

> **STEP 1** 1 ⓓ 2 ⓒ 3 ⓓ 4 ⓐ 5 ⓐ 6 ⓑ 7 ⓒ
> 8 ⓑ 9 ⓐ 10 ⓓ 11 ⓐ 12 ⓑ
> **STEP 2** 1 haven't seen 2 saw 3 has grown
> 4 hasn't shown 5 has played/played
> **STEP 3** 1 → has enjoyed 2 → has never been
> 3 → have been 4 → has gone 5 → went
> 6 → has played[has been playing]
> **STEP 4** 1 has been doing yoga for two hours
> 2 have been talking on the phone for
> almost an hour 3 has been raining for
> five hours 4 has been learning ballet for
> ten years
> **STEP 5** ⑤
> **STEP 6** 1 have you met since you came here
> 2 have been friends for ten years
> 3 has recently signed a contract

4 has given it to Tim 5 has been cooking
[has cooked] dinner since four o'clock
6 has never traveled abroad before

STEP 1
1 just가 있으면 '막 ~했다' 뜻이 되므로 완료
2 결과: 런던에 가서 지금 없음
5 since(~ 이후로)와 함께 쓰면 계속
7 살을 뺀 '결과' 지금 보기 좋음
8 ever와 함께 쓰면 경험
10 already(이미)와 함께 쓰면 완료
12 never와 함께 쓰면 경험

STEP 2
1 현재완료(계속)
2 과거 시점을 나타내는 부사구가 있으므로 과거시제
3 현재완료(계속)
4 아직 나타나지 않았음(완료)
5 현재완료(계속)
 when절이 과거의 특정 시점을 나타내므로 과거시제

STEP 3
1 현재완료(계속)
2 현재완료(경험)
3 현재완료(계속)
4 결과. has been은 경험을 나타냄
5 현재완료는 과거의 특정 시점을 나타내는 when절과 함께
 쓸 수 없음
6 계속을 나타내는 현재완료 혹은 현재완료 진행

STEP 4
1~4 주어가 3인칭 단수일 때 현재완료 진행형은 has been -ing
 이고, 나머지는 have been -ing

STEP 5
새 일을 시작하느라 부산으로 가서 여기에 없으므로 been →
gone 또는 moved(이사하다)

STEP 6
1, 2 현재완료(계속)
3 현재완료(완료)
4 현재완료(결과)
5 현재완료(계속) 또는 현재완료 진행
6 현재완료(경험)

☺ 내신 적중 Point p. 25

1 ④
2 has read[has been reading] a book for three hours

1 (A) 계속을 나타내는 현재완료 (진행형)
 (B) 결과를 나타내는 현재완료
2 세 시간 전부터 지금까지 책을 읽고 있으므로 계속을 나타내
 는 현재완료나 현재완료 진행형으로 표현

Unit 03 과거완료

1 had 2 after

PRACTICE pp. 27~28

STEP 1 1 ⓓ 2 ⓑ 3 ⓐ 4 ⓒ 5 ⓑ 6 ⓓ 7 ⓓ
STEP 2 1 had given 2 had spent 3 had gone
 4 was 5 had been, met
STEP 3 1 ④ 2 ②
STEP 4 1 had slept enough 2 had talked with a
 shopkeeper for a while 3 had watched
 this movie three times 4 had been
 married for thirty years

STEP 1
1 택시에서 내렸을 때 마지막 기차가 막 떠났음 (완료)
2 백일장에서 우승하기 전에 어떤 대회에서든 한 번도 우승한
 적이 없었음 (경험)
3 그때까지 자고 있다고 생각했음 (계속)
4 열쇠를 잃어버려 열쇠가 없다는 걸 알았음 (결과)
5 김 교수님을 전에 이미 만난 적이 있음 (경험)
6 신문을 건네주기 이전인 아침 식사 때 벌써 읽었음 (완료)
7 문을 열고 들어갔을 때 전화벨 소리가 멈췄음 (완료)

STEP 2
1 목걸이를 잃어버린 시점보다 선물로 준 게 앞선 시제
 (과거완료)
2 차를 사려고 한 시점 이전에 도박으로 돈을 탕진했음
 (과거완료)
3 인류가 출현했을 때는 이미 공룡이 멸종됐음 (과거완료)
4 아들이 태어났을 때는 과거 시점
5 그녀를 만났던 때보다 이전에 그녀는 한 주 동안 아팠음
 (과거완료)

STEP 3
1 ① → had broken ② → had been ③ → have been
 ⑤ → had read
2 경험 ① 완료 ③, ⑤ 결과 ④ 계속

STEP 4
1~4 모두 과거완료형. 주어와 관계없이 「had + p.p.」

☺ 내신 적중 Point p. 29

1 ② 2 They arrived after the party had begun.

1 (A) 잠자리에 든 것이 도착한 것보다 먼저 일어난 일
 (B) 상자를 받은 것이 먼저 일어난 일이므로 과거완료
 (C) when절은 명백한 과거 시점을 나타내므로 현재완료 시
 제를 쓰지 않고 과거시제를 씀
2 파티장에 도착한 것보다 먼저 파티가 시작되었으므로 과거
 완료

1 ④ 2 ③ 3 ① 4 ④ 5 ③ 6 ⑤ 7 ④ 8 will
snow → snows 9 ③ 10 ③ 11 ④ 12 ⑤ 13 ②
14 Have you ever seen 15 ③ 16 ② 17 ②
18 ④ 19 ② 20 has been learning[has learned]

1 3년 전부터 현재까지 쭉 계속되어 온 일. 현재완료 (계속)
2 집에 도착한 과거 시점에 하고 있던 일
3 시간 부사절에서 현재시제가 미래를 대신함
4 과거완료(경험): 발리에 가기(과거) 전에 ~한 적이 없었다
5 과거를 나타내는 말(yesterday)이 있으므로 과거시제
6 잊어버린 것보다 책을 빌린 시점이 먼저이므로 과거완료
7 한 시간째 계속 통화 중인 상태이므로 현재완료 계속
8 조건의 부사절에서 현재시제가 미래를 대신함
9 ① → had already gone ② → wins ④ → (had) called
 ⑤ → is[has been] smiling
10 ① → starts ② → had never been ④ → played
 ⑤ → turns
11 ① → flies ② → were eating ③ → was watching
 ⑤ → ran
12 (A) 현재완료 (계속)
 (B) 과거시제+ 특정한 과거 시점
13 (A) 과거시제+ 특정한 과거 시점
 (B) 과거 특정시점에 결혼한 지 7년째였음 (과거완료 계속)
14 경험을 묻는 현재완료
15 ③ → have played: 현재완료 (계속)
16 ② → messes: 습관을 나타내므로 현재시제
17 ⓐ have bought → bought ⓓ rose → rises
18 ⓐ, ④ 현재완료 (계속) ① 완료 ② 결과 ③, ⑤ 경험

19 조건 부사절에서는 현재시제가 미래를 표현함
20 지금까지 계속하고 있는 행동이므로 현재완료 (진행형)으로
 표현

Writing Exercises p. 33

1 (1) (had) reached home (2) have been
updating[have updated] my personal blog for
three years
2 (1) Have you ever heard of the power of
positive thinking? (2) had already read the
book when I met him yesterday
3 Alfred Nobel had died in France from a heart
attack
4 Tim was late for the meeting because he had
missed the train.
5 My brother has been sleeping all afternoon.

1 (1) 해가 진 것보다 집에 도착한 것이 먼저이므로 과거(완료)
 로 표현
 (2) 3년째 계속해 오고 있는 행동이므로 현재완료(진행형)로
 표현
2 (1) 경험을 묻고 있으므로 현재완료로 표현
 (2) when절(과거)보다 앞선 일이므로 과거완료로 표현
3 사망한 것이 신문에 기사가 실린 때보다 앞선 일이므로 과거
 완료로 표현
4 기차를 놓친 것이 모임에 늦은 것보다 앞선 시제이므로 과거
 완료로 표현
5 현재완료 진행형을 써서 계속되고 있는 동작을 표현

CHAPTER 02 수동태 Unit 04-06

Unit 04 수동태의 의미와 형태

1 수동태 2 목적어 3 목적어

PRACTICE pp. 38~40

STEP 1 1 was composed by Beethoven
 2 Crops are usually planted by farmers
 3 was established by Jeff Bezos in 1994
 4 fashion magazines are read by young
 men too 5 your luggage is being checked
 (by them)

6 My reservation has been canceled by
the hotel 7 The previous prize winners
will be invited (by us)
8 cell phones can be used (by us)
9 their children were being taught by Mr.
Kim 10 train tickets are being sold on the
Internet (by them)
11 Is your computer upgraded (by you)
every year ?
STEP 2 1 disappeared 2 belongs 3 rising
 4 happen 5 seems 6 has been polluted
 7 been spent

STEP 3 1 → published 2 → have been invited
3 → has not been agreed 4 → are being
destroyed 5 → have been exposed
6 → is located 7 → will be repaired
8 → need
STEP 4 1 ⑤ 2 ⑤
STEP 5 1 bad habits can be fixed
2 the files are being downloaded
3 a building was being built
4 Is your stress caused
5 His birthday party will be held

STEP 1

1 단수 주어 과거: was p.p.+by ~
2 복수 주어 현재: are p.p.+by ~
3 Amazon.com은 회사 이름이므로 단수 주어
4 read-read-read
5 현재진행 수동태: is being p.p.
6 현재완료 수동태: has been p.p.
7 미래시제 수동태: will be p.p.
8 조동사 수동태: can be p.p.
9 과거진행 수동태: were being p.p.
10 현재진행 수동태: are being p.p.
11 수동태 의문문: Is+주어+p.p. ~?

STEP 2

1 자동사 disappear(사라지다)는 수동태 불가
2 belong (to) (~의 것이다)은 수동태 불가
3 자동사 rise(오르다)는 수동태 불가
4 자동사 happen(발생하다)은 수동태 불가
5 seem(~인 것 같다)는 수동태 불가
6 pollute가 '오염시키다'라는 뜻이고 the river가 주어이므로
수동태로 써야 함
7 주어가 so much money이므로 수동태로 써야 함

STEP 3

2 손님들은 초대받는 것이므로 수동태로 써야 함
4 현재진행 수동태는 be동사+being p.p.
8 상태동사 need(~할 필요가 있다)는 수동태 불가

STEP 4

1 조동사 수동태: 조동사(should) be p.p.
2 ① resemble(~을 닮다)은 상태 동사 ② 자동사 appear
(나타나다) ③ be lost: 길을 잃다 ④ 자동사 die(죽다)

STEP 5

2 현재진행 수동태: be동사+being+p.p.
4 수동태 의문문: Be동사+주어+p.p. ~?

☺ 내신 적중 Point p. 41

1 ② 2 ④ 3 I don't think a person like him can
be called a leader.

1 ② → was uprooted: 뿌리째 뽑혔다
2 현재진행 수동태: 컴퓨터가 지금 수리중이라서 블로그에
사진을 올릴 수 없음
3 조동사(can)+be+p.p.

Unit 05 주의해야 할 수동태

1 동사 2 전치사

PRACTICE pp. 43~44

STEP 1 1 was caught up with by the police
2 been taken care of by their mothers
3 be looked up to by others 4 was
called off 5 were laughed at by people
STEP 2 1 was taught honesty and kindness
2 was given to them by the teacher
3 are asked of each candidate by
the interviewers 4 was made a very
responsible person by her parents 5 is
called the best artist in the world
STEP 3 1 my friends → by my friends 2 ○ 3 ○
4 me → for me 5 문장 전체 → He has been
called "Father of the Homeless." 6 ○
STEP 4 ②

STEP 1

1 붙잡혔다: was caught up with
2 돌보아진다: have been taken care of
3 존경받을 것이다: will be looked up to
4 취소되었다: was called off
5 비웃음을 당했다: were laughed at

STEP 2

1 SVOO 문형의 간접목적어가 주어인 수동태
2, 3 give는 to를, ask는 of를 씀
4, 5 SVOC의 문장에서 목적격보어는 그대로 보어로 씀

STEP 3

2 by the end of the year(올해 말까지)
5 목적격 보어는 수동태의 주어가 될 수 없음
6 has been looked after: 돌보아져 왔다

STEP 4

(A) was taken care of(돌보아졌다): 구동사의 수동태
(B) give는 간접목적어였던 것 앞에 전치사(to) 넣음

☺ 내신 적중 Point p. 45

1 ② 2 will be bought for

1 '그녀가 구매되었다'는 어색한 표현
2 buy는 간접목적어였던 것 앞에 전치사 for를 씀

1 by 2 -ing

PRACTICE
pp. 47~48

STEP 1 1 with 2 at 3 at 4 with 5 with 6 to
7 in 8 about

STEP 2 1 were surprised at[by] 2 were almost
covered with[by] flowers 3 will be
delighted at[by/with] the news 4 is
covered with ice and snow in the winter

STEP 3 1 → were surprised at[by] 2 → was filled
with 3 → is made of 4 → is known for
5 → are worried about 6 → disappointing
7 → is so boring
8 → is excited at[about/by]

STEP 4 1 are satisfied with 2 were surprised
at[by] the number 3 was interested in
helping 4 is known for its warm climate
and beautiful beaches

STEP 1

1 be covered with: ~으로 덮여 있다
2 be surprised at: ~에 놀라다
3 be pleased at: ~에 기뻐하다
4 be satisfied with: ~에 만족하다
5 be filled with: ~으로 가득차다
6 be known to: ~에게 알려져 있다
7 be interested in: ~에 관심이 있다
8 be excited about: ~에 신이 나다

STEP 2

1 be surprised at[by]: ~에 놀라다
2, 4 be covered with[by]: ~으로 덮여 있다
3 be delighted at[by/with]: ~을 기뻐하다

STEP 3

2 be filled with: ~으로 가득 차다
3 be made of: ~으로 만들어지다
4 be known for: ~로 알려지다
5 be worried about: ~에 대해 걱정하다
6 주어가 감정을 일으킴
7 그(He)가 나에게 '지루함'이란 감정을 일으킴
8 Amy는 감정을 느끼는 주체임

STEP 4

1~4 by 이외의 전치사를 주로 사용하는 수동태 표현을 쓴다.

⊙ 내신 적중 Point
p. 49

1 ⑤ 2 ④ 3 The singer is not known to many
people.

1 be filled with: ~으로 가득 차다 / be satisfied with: ~에
만족하다 / be pleased with: ~에 기뻐하다
2 ① surprising → surprised ② from → about ③ by
→ to ⑤ disappointing → disappointed
3 be known to: ~에게 알려져 있다

Overall Exercises 02
pp. 50~52

1 ② 2 ⑤ 3 ④ 4 ④ 5 ③ 6 ① 7 ③ 8 plant
→ are planted 9 for the lecturer → of the lecturer
10 ④ 11 ② 12 ② 13 ⑤ 14 ① 15 are fed
16 ② 17 has been used 18 ④ 19 ④ 20 be
really surprised

1 문자 메시지가 '보내짐': 수동관계
2 올해의 선생님으로 '인정받음': 현재완료 수동관계
3 즉시 '세척되어야' 한다: 수동관계
4 그들이 '하고 있던' 게임: they와 능동관계, last night는 과거
시점
5 be surprised at(~에 놀라다) / be satisfied with (~에 만
족하다) / buy + for + 간접목적어
6 greeting은 기쁜 감정을 일으킴 / we는 기쁨을 느낌
7 미래시제 수동태 / 조동사(can't)+be+p.p.
8 해바라기는 이른 봄 촉촉한 땅에 '심어져야' 가장 잘 자란다:
수동관계
9 ask + of + 간접목적어
10 his sister를 주어로 하는 수동태는 어색함
11 ① → A carpet was bought for her as ... ③ found →
founded ④ of → with[by] ⑤ asked → was asked
12 ② 상태동사 resemble은 수동태 불가
13 ⑤의 a world traveler는 목적격 보어라서 수동태의 주어가
될 수 없음
14 자동사 lie(눕다)는 수동태로 쓰지 않음
15 사육사들이 '먹이는' 것이므로 수동태
16 ⓑ destroyed → was destroyed
ⓓ called off → was called off
17 올리브오일은 '사용되는' 것이므로 수동
18 ④ → disappointing: 주어가 감정을 일으키는 주체
19 (A) 주어 It은 a play를 받으므로 수동이 적절
(B) 꽃바구니는 '배달되는' 것이므로 수동
20 He가 감정을 느끼는 주체이므로 수동

서술형 만점 Writing Exercises
p. 53

1 (1) is called "the Father of Music" (2) was not
satisfied with the plan (3) was known for his
knowledge and good judgment
2 (1) Endangered animals should be protected.
(2) Animals cannot be taught human language.
3 was written / was, published / is known to

4 A chance to become an actor was given to me by the director.
5 was bought for me as a birthday present by my father

1 (1) ~로 불리는 것이므로 수동
 (2) be satisfied with: ~에 만족하다

(3) be known for: ~로 알려지다
2 (1) 조동사(should)+be+p.p.
 (2) 조동사(cannot)+be+p.p.
3 책이 '쓰이고', '출판되고', '알려지는' 것이므로 모두 수동
4 be given to+간접목적어
5 be bought for+간접목적어

CHAPTER 03 조동사

Unit 07 can, may, will

1 추측 2 요청 3 의지

PRACTICE
pp. 58~60

STEP 1 1 ⓐ 2 ⓐ 3 ⓑ 4 ⓓ 5 ⓓ 6 ⓖ 7 ⓔ
 8 ⓑ 9 ⓐ 10 ⓒ 11 ⓕ 12 ⓓ 13 ⓑ
 14 ⓒ
STEP 2 1 ①, ② 2 ② 3 ①, ③ 4 ① 5 ①, ②
 6 ①, ②
STEP 3 1 ③ 2 ④
STEP 4 1 you be able to get there on time
 2 I would be there at eleven a.m. 3 Could
 [Would, Can, Will] you hold the door

STEP 1
2 = is not able to
4 아파트에 살면 소음이 문제가 '될 수 있다'
6 학생 때 함께 점심을 '먹곤 했다'
7 올해는 축구 동아리에 들기 위해 '노력하겠다'
8 바쁘면 '가도 좋다'
11 여기서 담배를 피우면 '안 됩니다'

STEP 2
1 책을 가져도 좋다: 허가
2 과거의 습관
3 가능성, 추측
4 A가 설거지하려는 것을 말리고 있으므로 B가 자신이 하겠
 다는 확실한 의지를 밝히는 표현이 어울림
5 주어의 '의지'와 '능력' 모두 가능함
6 조퇴해도 될까요?: 허가

STEP 3
1 ① getting → get ② able ride → able to ride ③ 과거
 의 습관 ④ will → would: 주절과 시제 일치 ⑤ helps →

help: 조동사+동사원형
2 과거의 습관: ~하곤 했다
 ①, ③ 정중한 요청 ②, ⑤ 주절과 시제 일치

STEP 4
1 will be able to: ~할 수 있을 것이다
2 주절과 시제 일치
3 요청을 나타내는 조동사

◯ 내신 적중 Point
p. 61

1 ④ 2 ⑤

1 ④ will be able to: 능력, 가능을 나타내는 미래시제
 may: 약한 추측
2 빌려가도 된다: 허가 ⑤ 무엇이든 먹어도 된다: 허가
 ① 추측 ② 가능성 ③ 요청 ④ 능력

Unit 08 must, should

1 의무 2 충고

PRACTICE
pp. 63~64

STEP 1 1 ⓐ 2 ⓐ 3 ⓓ 4 ⓐ 5 ⓑ 6 ⓓ 7 ⓐ
 8 ⓒ 9 ⓖ 10 ⓔ 11 ⓑ 12 ⓕ
STEP 2 1 should have left 2 must have done
 3 must have heard 4 must have
 5 should have waited 6 must be
 7 must have baked
STEP 3 ④

STEP 1
3 피곤할 것임에 틀림없다

5 말을 해서는 안 된다

8 = don't need to[need not]

9 못 지킬 약속은 '하지 말았어야 하는데' (하고 말았다): 과거 일에 대한 후회

10 사러 갔음에 틀림없다

12 좋아하는 직업의 목록을 만드는 것이 좋다

STEP 2

1 한 시간 전에 '떠났어야 했는데': 과거에 하지 않은 일에 대한 후회

2 카메라가 작동되지 않는 걸 보니 뭔가 '잘못했음에 틀림없다': 과거에 대한 강한 추측

3 대화를 '들었던 게 틀림없음': 과거에 대한 강한 추측

4 감기에 '걸린 게 틀림없음': 현재에 대한 강한 추측

5 잠시 '기다렸어야 했는데' (그렇게 하지 않았다)

6 '유명한 음식점임에 틀림없음'

7 엄마가 감자를 '구웠기 때문임에 틀림없음'

STEP 3

④ must not go: 가서는 안 된다(금지)

need not go: 갈 필요가 없다(불필요)

⊙ 내신 적중 Point p. 65

> **1** ④ **2** ⑤ **3** must confuse me

1 (A) 운동을 열심히 했어야 했는데 (안 했기 때문에 과체중이다)

(B) 하루 종일 이동했으므로 도착했을 때는 피곤했을 것임에 틀림없다

2 ⑤ should have enjoyed → should enjoy(~해야 한다)

3 must + 동사원형: ~임에 틀림없다

Unit 09 used to, ought to, had better, need

1 과거 **2** had better not

PRACTICE pp. 67~68

> **STEP 1** 1 ⓐ 2 ⓒ 3 ⓑ 4 ⓓ 5 ⓔ 6 ⓒ 7 ⓐ
>
> **STEP 2** 1 ① 2 ③
>
> **STEP 3** 1 need not 2 had better not 3 ought not to 4 used to 5 getting up 6 do 7 eat 8 have
>
> **STEP 4** 1 used to like candies 2 wasn't used to swimming 3 had better not go to school

STEP 1

1 과거의 습관, 상태

2 필요

3 의무, 당연

4 강한 권고

5 ~하는 데 익숙했다

6 ~할 필요가 없다

7 과거의 습관

STEP 2

1 강한 권고: ~하지 않는 편이 낫다

2 과거에는 ~했는데 (지금은 그렇지 않다)

STEP 3

1 조동사 need는 인칭, 수, 시제의 영향을 받지 않음

2 ~하지 않는 게 좋겠다

4 예전에는 약간 '뚱뚱했다': 과거의 상태

5 일찍 일어나는 데 익숙하다: be used to -ing

6 need가 조동사로 쓰임

7 예전에는 매운 것을 문제없이 드시곤 했다: 과거의 습관

8 had better not + 동사원형

STEP 4

1 과거에는 ~했는데 (지금은 그렇지 않다): used to + 동사원형

2 파도가 높은 곳에서 수영하는 데 익숙하지 않았다

⊙ 내신 적중 Point p. 69

> **1** ② **2** had better wear a helmet for your safety
>
> **3** I had better go to bed now.

1 (과거에는) 자전거를 타고 학교에 갔었는데 지금은 지하철을 타고 감

2 안전을 위해 헬멧을 쓰는 게 좋겠어요

3 had better + 동사원형: ~하는 게 좋다

Overall Exercises 03 pp. 70~72

> **1** ② **2** ③ **3** ⑤ **4** ⑤ **5** ④ **6** ⑤ **7** ③ **8** ⑤
> **9** ④ **10** ① **11** ③ **12** ⑤ **13** ③ **14** must have seen **15** ⑤ **16** ① **17** ② **18** ② **19** ④
> **20** don't have to go / don't need to go

1 제출해야 한다: 의무

2 누군가 카메라를 훔쳐간 것이 틀림없음: 과거에 대한 강한 추측

3 전화할 필요 없다

4 아이스크림을 너무 많이 먹지 말았어야 했는데: 과거 일에 대한 비난

5 is not able to = cannot[can't]

6 모두 '금지'를 나타내고 ⑤만 불필요한 일을 나타냄

7 used to + 동사원형: ~하곤 했다 / be used to -ing: ~하는 데 익숙하다 / be used to + 동사원형: ~하는 데 사용되다

8 모두 '충고'를 나타내고 ⑤만 '집에 가서 쉬자'는 제안
9 ① ought to not → ought not to ② teaching → teach
 ③ needed → need ⑤ should print → should have
 printed
10 ① I'll may → I'll: 조동사 두 개를 겹쳐 쓸 수 없음
11 (A) 여권을 두고 와서 비행기를 '탈 수 없었다'
 (B) 여권을 갖고 있는지 '확인했어야 했다'
12 ⑤ must been → must be: ~임에 틀림없다 (강한 추측)
13 ③ ought to not send → ought not to send
14 과거에 대한 강한 긍정적 추측
15 컴퓨터에 해를 입힐 수 있으니 '열지 않는 편이 낫다'고 하는
 내용
16 가능성
17 ⓐ can stand → cannot stand ⓓ should not talk →
 should talk
18 모두 '의무, 필요', ②만 강한 긍정적 추측(~임에 틀림없다)
19 허가
20 ~할 필요가 없다

p. 73

서술형 만점 Writing Exercises

1 (1) able to answer this riddle (2) would[used to]
 take a walk (3) may[can] come
2 shouldn't have eaten so much for lunch
3 must not drive over
4 used to play chess with her grandfather when
 she was little
5 shouldn't have taken

1 (1) be able to: 능력
 (2) would/used to: 과거의 습관
 (3) may/can: 허가
2 shouldn't have p.p.: 과거에 하지 말았어야 했던 일에 대
 한 후회
3 시속 25마일을 넘어서 운전해서는 안 된다
4 used to+동사원형: 과거의 습관
5 shouldn't have p.p.: 과거에 하지 말았어야 했던 일에 대
 한 후회

CHAPTER 04 부정사

Unit 10 to부정사의 형태와 명사적 역할

1 it 2 가목적어 3 of

PRACTICE

pp. 78~80

STEP 1 1 to lend 2 to complete 3 to make
 4 to have 5 to enter 6 to follow
STEP 2 1 ⓐ 2 ⓑ 3 ⓐ 4 ⓒ 5 ⓑ 6 ⓓ 7 ⓑ
 8 ⓐ 9 ⓒ 10 ⓓ
STEP 3 1 for you to learn 2 of you to help 3 of
 her to believe 4 for us to be aware of
 5 for my brother to solve 6 for us to call
STEP 4 1 → write 2 → how to swim 3 → for me
 4 → to make 5 → shake[shaking]
 6 → when to drink 7 → how to get
STEP 5 1 ⑤ 2 ③
STEP 6 1 very difficult for adults to learn another
 language 2 It is stupid of you to believe
 3 don't know how to solve this problem
 4 promised never to forget him 5 makes
 it easy for us to get information

STEP 1

2 for me가 의미상 주어, to complete ~ 이하가 진주어
3 부정사의 부정형: not to+동사원형
4 의문사(what)+to부정사
5 to enter ~ 이하가 진주어
6 목적어(me)가 to follow ~의 의미상 주어

STEP 2

3 for people이 진주어인 to walk ~의 의미상 주어
4 to be the president가 whose dream의 보어
6 목적어(my brother)가 to clean up ~의 의미상 주어이므
 로 to clean up ~은 문장의 목적격보어로 쓰였음
7 it은 가목적어, to inspire ~ 이하는 진목적어
8 to cry ~ 이하가 진주어
10 목적어(me)가 to take ~의 의미상 주어

STEP 3

1 You가 동사 learn의 주체
2, 3 kind, foolish는 성격을 나타내는 형용사이므로 「of+의미
 상 주어」로 씀
4 We가 동사 be aware of의 주체
5 My brother가 동사 solve의 주체
6 「가목적어 ~ 의미상 주어+진목적어」 형태가 적절함

STEP 4

1 make+O+원형부정사
2 수영하는 '방법'은 how to ~
5 지각동사+목적어+원형부정사[~ing]
6 대화의 응답에서 음료를 마셔야 되는 시간 간격을 알려주므로 when에 대한 대답임
7 의문사+to부정사

STEP 5

1 ① this → it: 가목적어는 it만 가능
 ② of → for: of는 감정, 성격을 나타내는 형용사와 사용
 ③ being → to be: want는 목적격보어로 to부정사를 취함
 ④ to not → not to: 부정사의 부정형은 「not[never]+to+동사원형」
2 ① for → of: nice는 성격을 나타내는 형용사이므로 「of+의미상 주어」로 씀
 ② impolite 앞에 가목적어 it 필요
 ④ to bark → bark[barking]: 지각동사는 목적격보어로 to부정사를 취하지 않음
 ⑤ 가주어 자리이므로 That → It

STEP 6

1,2 「가주어+의미상주어+진주어」 구문
3 「의문사(how)+to부정사」
4 부정사의 부정형은 「not[never]+to+동사원형」
5 「가목적어+의미상주어+진목적어」 구문

☺ 내신 적중 Point
p. 81

> 1 ④ 2 (1) tell me how to edit pictures (2) It is kind of you to invite me to dinner.

1 주어진 문장과 ④는 목적어 역할
 ①, ⑤ 보어 역할 ② (진)주어 역할 ③ 주어 역할
2 (1) 「how +to부정사」: ~하는 방법
 (2) 성격을 나타내는 형용사 다음에는 「of+목적격」

Unit 11 to부정사의 형용사적·부사적 역할

1 전치사 2 결과

PRACTICE
pp. 83~84

STEP 1 1 ⓐ 2 ⓒ 3 ⓑ 4 ⓒ 5 ⓓ 6 ⓐ 7 ⓑ
8 ⓐ
STEP 2 1 ⓑ 2 ⓐ 3 ⓒ 4 ⓓ 5 ⓑ 6 ⓐ
STEP 3 1 to put on 2 to take care of 3 to live in
4 to depend on 5 to listen to
STEP 4 1 happy to meet you 2 very foolish of
him to do 3 went to the library to borrow
4 was surprised to learn 5 has become
a world-famous place to visit 6 are to
adjust to a new environment

STEP 1

1 to make가 a way 수식
2,4 be동사+to부정사: 의무
3,7 be동사+to부정사: 예정
5 be동사+to부정사: 의도
6 to read가 a novel 수식. for high school students는 의미상 주어
8 to see가 a chance 수식

STEP 2

1 사인을 받아서 기쁘다
2 일출을 보기 위해
3 새 컴퓨터를 사주다니 매우 후하다
4 자라서 지도자가 되었다
5 발표하게 되어 기쁘다
6 클럽에 가입하기 위해서

STEP 3

1 내가 신기에 너무 작은
2 돌볼 두 여동생들
3 살 집
4 의지할 누군가
5 들을 좋은 노래들

STEP 4

1,4 감정의 원인: ~해서
2 판단의 근거: ~하다니
3 목적: ~하기 위해서
5 명사 수식: ~할
6 be+to부정사: 의무

☺ 내신 적중 Point
p. 85

> 1 ④ 2 to make pasta

1 ④는 a piece of paper를 수식하는 형용사적 용법이고, 나머지는 부사적 용법(① 목적 ② 판단의 근거 ③ 감정의 원인 ⑤ 독립부정사)
2 그녀는 파스타를 만들기 위해 물이 끓기를 기다리고 있다. 목적을 나타내는 부사적 용법

Unit 12 많이 쓰이는 to부정사 구문

1 주어 2 that

PRACTICE
pp. 87~88

STEP 1 1 so, that he can 2 so, that I can't
3 Larry knows 4 so, that she can
5 too, to finish 6 to be 7 enough
to break 8 not to make 9 you can
remember 10 enough to have

STEP 3 1 sharp for him to move his neck / sharp that he couldn't move his neck 2 seems to know everything / seems that he knows everything

STEP 1

1, 4, 7, 10 형용사[부사]+enough to-v = so+형용사[부사]+that+S+can[could]+ 동사원형

2, 5 too+형용사[부사]+to-v = so+형용사[부사]+that+S+can't[couldn't]+동사원형

3, 8 S+seem(s) to-v = It seems that+S+동사의 현재형[will+동사원형]

6 It seemed that+S+동사의 과거형 = S+seemed to-v

9 in order[so as] to-v = so[in order] that+S+may[will, can]+동사원형

STEP 2

1 ② had → have: 주절과 that절의 시제가 동일해야 함

2 ④ couldn't → could

STEP 3

1 too+형용사+for+의미상 주어+to-v = so+형용사+that+S+can't[couldn't]+동사원형

2 S+seem(s) to-v = It seems that+S+동사의 현재형

☺ 내신 적중 Point
p. 89

1 ⑤ 2 ④ 3 enough to wear men's clothes

1 ⑤ enough cheap → cheap enough

2 ④ '내가 입기에 충분히 작다'는 '내가 입기에 작다'와는 다른 표현

3 so+형용사+that+S+can[could]+동사원형 = 형용사+enough to-v

Overall Exercises 04
pp. 90~92

1 ③ 2 ⑤ 3 ② 4 ④ 5 ④ 6 ③ 7 ③ 8 ③
9 ⑤ 10 ② 11 ① 12 ③ 13 ⑤ 14 ③ 15 ④
16 ② 17 ③ 18 ⑤ 19 to listen → to listen to
20 to not be → not to be

1 ③만 형용사적 용법이고 나머지는 모두 명사적 용법

2 ⑤만 부사적 용법이고 나머지는 모두 형용사적 용법

3 ②만 명사적 용법이고 나머지는 모두 부사적 용법

4 ④만 형용사적 용법이고 나머지는 모두 명사적 용법

5 ④만 부사적 용법이고 나머지는 모두 형용사적 용법

6 나머지는 모두 for가 들어가고, ③만 감정, 성격을 나타내는 형용사와 함께 쓰였으므로 「of+의미상 주어」가 되어야 함

7 사역동사 have는 원형부정사를 목적격보어로 취함

8 주어진 문장의 to부정사는 a place를 수식하는 형용사적 용법. ③은 some cookies를 수식하는 형용사적 용법

9 주어진 문장과 ⑤에 쓰인 it은 가목적어

10 ② of her → for her

11 ② becoming → to become: decide는 to부정사만을 취함
③ traveling → (to) travel
④ they → them
⑤ of → for: 「for+목적격」이 의미상 주어

12 ① enough clean → clean enough: 형용사[부사]+enough+to부정사
② to not → not to
④ learn → to learn
⑤ found → found it: 가목적어 it 필요

13 ⑤ can → cannot[can't]

14 (A) stay at the best hotel에서 수식받는 명사 the best hotel이 to부정사 앞으로 나간 형태
(B) ~ 위에 쓰다

15 (A) seemed와 시제일치
(B) seem +to부정사

16 ② what → how: 그린 카레를 만드는 방법을 가르쳐주었다

17 (A)와 ③은 목적을 나타내는 부사적 용법

18 worry about nothing

19 listen to some good songs에서 some good songs가 앞으로 나간 형태

20 부정사의 부정형: not to-v

☺ Writing Exercises
p. 93

1 (1) happy to hear the news (2) for tourists to experience (3) too short to become[be] a basketball player

2 (1) warm enough for children (2) so warm that children can sleep in it

3 to the airport to pick up

4 (1) where to put (2) how to swim

5 seemed to live a full life

1 (1) 감정 형용사+to부정사: 감정의 원인
(2) for+목적격+to부정사
(3) too+형용사+to부정사

2 (1) 형용사+enough+for 목적격+to부정사
(2) so+형용사+that+S+can+동사원형

3 목적을 나타내는 to부정사

4 (1) 놓을 곳 (2) 수영하는 방법

5 It seemed that+S+동사의 과거형 = S+seemed to-v

CHAPTER 05 동명사

Unit 13 동명사의 쓰임

1 가주어　2 목적어　3 의미상 주어

PRACTICE
pp. 98~100

> **STEP 1**　1 spending　2 building / to build　3 being
> 　　4 getting　5 is　6 using　7 seeing
> 　　8 eating　9 mixing / to mix　10 having
> 　　11 Buying / To buy, requires
> **STEP 2**　1 being　2 not having　3 having done
> 　　4 not having answered　5 his
> **STEP 3**　1 of being　2 to getting　3 her coming
> 　　4 from eating　5 his[him] opening
> **STEP 4**　1 going　2 looking　3 eating　4 hearing
> 　　5 coming　6 starting　7 having made
> **STEP 5**　1 ③　2 ⑤
> **STEP 6**　1 On seeing　2 cannot help breaking
> 　　3 is worth taking part in　4 looking
> 　　forward to meeting　5 feel like running

STEP 1

1 enjoy는 동명사를 목적어로 취하는 동사
2 보어 역할: 동명사와 to부정사 둘 다 가능
3 전치사의 목적어 역할: 동명사
4 전치사의 목적어 역할: 동명사
5 동명사(구) 주어는 단수 취급
6 보어 역할: 동명사
7 look forward to v-ing: ~하기를 고대하다
8 전치사의 목적어 역할: 동명사
9 보어 역할: 동명사와 to부정사 둘 다 가능
10 spend+시간[돈]+(on) v-ing: ~하는 데에 시간[돈]을 쓰다
11 주어 역할: 동명사와 to부정사 둘 다 가능, 동명사나 to부정사가 주어일 때 단수 취급

STEP 2

1 전치사 of의 목적어: 동명사
2 동명사의 부정형은 not[never]+v-ing
3, 4 종속절이 주절보다 앞선 시제이므로 완료형
5 동명사의 의미상 주어는 소유격

STEP 3

1 be proud of v-ing: ~을 자랑스러워하다
2 look forward to v-ing: ~하기를 고대하다
3 전치사+의미상 주어(소유격/목적격)+v-ing
4 prevent A from v-ing: A가 ~하지 못하게 하다
5 on+의미상 주어(소유격/목적격)+v-ing: ~가 …하자마자

STEP 4

2 spend+시간[돈]+(on) v-ing: ~하는 데에 시간[돈]을 쓰다
3 be used to v-ing: ~에 익숙하다
4 on+v-ing: ~하자마자
5, 6 동사의 목적어 자리: 의미상 주어(소유격/목적격)+v-ing
7 잘못된 결정을 한 것은 사과한 때보다 앞선 과거의 일이므로 완료형

STEP 5

1 ③ are → is: 동명사(구) 주어는 단수 취급
2 ① keeping not → not keeping: 동명사의 부정형은 「not+v-ing」
　② To fastening → Fastening 또는 To fasten
　③ to swim → swimming
　④ he → his[him]

STEP 6

1 ~하자마자: on v-ing
2 ~할 수밖에 없다: cannot help v-ing
3 A는 ~할 가치가 있다: A is worth v-ing
4 ~하기를 고대하다: look forward to v-ing
5 ~하고 싶은 생각이 들다: feel like v-ing

☺ 내신 적중 Point
p. 101

> 1 ③　2 ④　3 wasting not → not wasting

1 동사 like의 목적어 자리이므로 v-ing가 와야 함
2 look forward to v-ing: ~하기를 고대하다
　be used to v-ing: ~에 익숙하다
3 동명사의 부정형은 not[never]+v-ing

Unit 14 동명사와 to부정사

1 동명사　2 동명사

PRACTICE
pp. 103~104

> **STEP 1**　1 barking　2 playing　3 to discuss
> 　　4 talking　5 opening　6 living
> 　　7 meeting　8 to turn　9 saying
> 　　10 talking　11 to pick　12 to breathe
> **STEP 2**　1 → taking　2 ○　3 → looking　4 → writing
> 　　5 ○

STEP 3 1 pulling 2 watering 3 to leave 4 to buy 5 listening

STEP 4 1 tried eating fast food
 2 stopped to answer my phone
 3 Don't forget to meet
 4 tried to repair my coffee machine
 5 stop listening to loud music

STEP 1

1 keep v-ing
2 continue v-ing[to-v]
3 start v-ing[to-v]
4 finish v-ing
5~7 mind/imagine/avoid v-ing
8 타는 냄새가 나는 것은 오븐을 '꺼야 한다는 것을' 잊었기 때문: to-v
9 자신에 대해 사실이 아닌 '말을 한 것'은 과거의 일: v-ing
10 지난달에 '얘기했던 것을' 기억했다는 것이 적절: v-ing
11 Sam을 칭찬하는 판단의 근거가 나와야 하므로 쓰레기를 '줍기 위해' 멈춰 섰다는 내용이 적절: to-v
12 물에 빠져 필사적으로 숨을 쉬려고 '애썼다'가 적절함: to-v

STEP 2

1 consider v-ing
2 continue v-ing[to-v]
3 keep v-ing
4 finish v-ing
5 give up v-ing

STEP 3

1 try v-ing: 가벼운 생각으로 한번 해보는 일에 씀
2, 3, 5 forget/regret/remember v-ing: 문장 동사의 시점에서 이미 진행 중인 일이나 과거에 일어난 일을 의미할 때
forget/regret/remember to-v: 동사의 시점보다 나중에 일어날 일을 의미할 때
4 stop to-v: ~하기 위해 멈추다

STEP 4

1 try v-ing: 가벼운 생각으로 한번 해보는 일에 씀
2 stop to-v: ~하기 위해 멈추다
3 forget to-v: 동사의 시점보다 나중에 일어날 일에 씀
4 try to-v: ~하려 애쓰다
5 stop v-ing: ~하는 것을 멈추다

⊕ 내신 적중 Point p. 105

 1 ② 2 to finish reading / put off cleaning

1 want는 목적어로 to부정사를 취함
2 want는 to부정사를, finish는 동명사를 목적어로 취함 / put off는 동명사를 목적어로 취하는 동사이고, to 이하는 진주어

Overall Exercises 05 pp. 106~108

1 ③ 2 ④ 3 being not → not being 4 ② 5 ④
6 ⑤ 7 ② 8 ④ 9 ⑤ 10 ④ 11 ① 12 ③ 13 ②
14 forget to send 15 to visit → visiting 16 ③
17 is worth visiting 18 ④ 19 ② 20 living

1 • mind v-ing: ~하는 것을 꺼리다
 • forget to-v: (미래에) ~할 것을 잊어버리다
 • try to-v: ~하려 애쓰다
2 • remember to-v: (미래에) ~할 것을 기억하다
 • stop v-ing: ~하는 것을 멈추다
 • 전치사의 목적어 역할
3 동명사의 부정형은 not[never]+v-ing
4 ① are → is: 동명사구 주어는 단수 취급
 ③ to sing and dance → singing and dancing: enjoy v-ing
 ④ to take → taking: to부정사는 전치사의 목적어가 될 수 없음
 ⑤ to speak → speaking: finish v-ing
5 ① cry → crying: cannot help v-ing 또는 He couldn't but cry.
 ② skated → skating: go v-ing
 ③ to read → reading: be worth v-ing
 ⑤ he → his 또는 him: 동명사의 의미상 주어
6 ① are → is: 동명사구 주어는 단수 취급
 ② believing → to believe: want+O+to-v
 ③ buying → to buy: afford to-v: ~할 여유가 있다
 ④ win → winning: imagine+v-ing
 ⑤ begin은 동명사, to부정사를 둘 다 목적어로 취할 수 있음
7 ① to study → studying: be busy v-ing
 ③ to practice → practicing: keep v-ing
 ④ notice → noticing: on v-ing
 ⑤ visit → visiting: look forward to v-ing
8 ④ to borrow → borrowing: 과거의 일
9 ⑤ to smoke → smoking: mind는 동명사만을 목적어로 취함
10 ④ having → to have: choose는 to부정사만을 목적어로 취함
11 ① to buy → buying: 어제 산 것을 후회함
12 ③ missed → will miss
13 ⓑ to swim → swimming: to부정사는 전치사의 목적어가 될 수 없음
 ⓒ to chase → chasing: give up+v-ing
 ⓔ going → to go: decide+to부정사
14 Don't forget to-v: ~할 것을 잊지 마
15 remember v-ing: (과거에) ~했던 것을 기억하다
16 be busy v-ing: ~하느라 바쁘다
17 be worth v-ing: ~할 가치가 있다
18 look forward to v-ing: ~하기를 고대하다
19 • keep A from v-ing: A가 ~하지 못하게 하다
 • be good at v-ing: ~을 잘하다
20 be used to v-ing: ~에 익숙하다

Writing Exercises p. 109

1 (1) forgets to lock the door (2) stopped to say hello to her mother (3) mind my[me] sitting here
2 (1) can't understand his[him] being so late
 (2) is not used to getting up early
3 was busy doing research
4 My dog was trying to go out.
5 coming back home, playing

1 (1) forget to-v: ~할 것을 잊다
 (2) stop to-v: ~하기 위해 멈추다
 (3) mind+의미상 주어(소유격/목적격)+v-ing
2 (1) 의미상 주어(소유격/목적격)+v-ing
 (2) be used to v-ing: ~에 익숙하다
3 be busy v-ing: ~하느라 바쁘다
4 try to-v: ~하려 애쓰다
5 on v-ing: ~하자마자
 start to-v = start v-ing

CHAPTER 06 분사

Unit 15 분사의 종류와 명사 수식 역할

1 형용사 2 앞

PRACTICE pp. 113~114

STEP 1 1 falling 2 smiling 3 cooked 4 lost
5 called 6 gaining 7 broken 8 wanted
9 finished 10 running
STEP 2 1 sitting 2 made 3 located 4 sleeping
STEP 3 1 crying 2 floating 3 injured
4 published 5 walking 6 participating
7 stored 8 growing
STEP 4 1 ④ → suffering 2 ① → left 3 ③ → spoken 4 ① → led 5 ④ → watching

STEP 1

1 '떨어지는' 빗방울 소리: 명사 수식(능동, 진행)
2 '웃고 있는' 얼굴: 명사 수식(능동, 진행)
3 '요리된' 생선: 명사 수식(수동, 완료)
4 '잃어버린' 가방: 명사 수식(수동, 완료)
5 수동태: be동사+p.p.
7 '고장 난' 장난감: 명사 수식(수동, 완료)
8 (과거부터 지금까지) 늘 수의사가 되기를 원해 왔다: 현재완료(계속)
9 내일까지 '완료되어야' 한다: 수동태
10 '흐르는' 물에: 명사 수식(능동, 진행)

STEP 2

1 who[that] are 생략됨
2 which[that] are 생략됨
3, 4 which[that] is 생략됨

STEP 3

1 '울고 있는' 아기: 진행
2 물에 '떠 있는' 큰 얼음 덩어리

3 '다친' 주자: 수동. injure(~을 다치게 하다)의 p.p.
4 지난주에 '출간된': 수동
5 지팡이(a stick for walking)
6 이 여행에 '참가하는' 사람들 모두: 능동
7 '저장된, 축적된' 칼로리: 수동
8 '자라는' 어린이: 진행

STEP 4

1 ④ '고통받고' 있는 사람들
2 ① 잠긴 방에 '남겨진' 소년
3 ③ 200개국에서 '말해지는[사용되는]'
4 ① Ken에 의해 '이끌어지는'
5 ④ 그를 '지켜보는' 많은 사람들

☺ 내신 적중 Point p. 115

1 ① 2 repairing, broken

1 ①은 동명사(목적어), ②, ④는 현재분사(명사 수식), ③, ⑤는 현재분사(진행형)
2 남자가 자전거를 고치고 있으므로 진행형(현재분사)을 쓰고, 고장 난 자전거는 명사를 수식하는 과거분사로 씀

Unit 16 분사의 보어 역할, 감정을 나타내는 분사

1 현재분사 2 과거분사

PRACTICE pp. 117~118

STEP 1 1 watching 2 looking 3 pleased
4 annoying 5 called 6 satisfying
7 disappointing 8 sinking
9 embarrassed 10 turned

STEP 2 1 to fix → fixed 2 satisfying → satisfied
3 depressing → depressed 4 stolen →
stealing[steal] 5 barked → barking[bark]
STEP 3 1 boring / bored 2 Excited / exciting
3 frightened / frightening 4 depressed /
depressing
STEP 4 1 found himself lying 2 was very tiring
3 saw my sister memorizing

STEP 1

1 '보면서' 앉아 있다: 능동, 진행
2 '보면서' 서 있다: 능동, 진행
3 내가 '기쁨을 느낌'
4 '짜증나게 하는' 소리
5 '내 이름이 불리는' 것을 들었다: 수동
6 성공은 '만족을 느끼게 하는' 경험
7 그녀의 새 소설은 '실망스러움'
8 '태양이 지(고 있는)' 것을 보았다: 목적어와 목적격보어의
관계가 능동
9 넘어졌을 때 '창피함을 느꼈음'
10 '휴대 전화를 꺼진' 채로 놔두다: 수동

STEP 2

1 '차가 수리되게' 하다
2 그들이 '만족을 느꼈다'는 문맥이므로 과거분사 필요
3 그가 '우울함을 느꼈음'
4 '도둑이 보석을 훔치(고 있는)' 것을 보았다
5 '개가 짖(고 있는)' 것을 들었다

STEP 3

1 a. 수학 공부가 '(나를) 지루하게 함'
b. 나는 '지루함을 느끼지' 않음
2 a. '흥분한' 팬들
b. '(관중을) 흥분시키는' 경기
3 a. 자신의 모습에 '겁먹은'
b. 자신에게 일어나고 있는 일을 깨닫는 것은 그에게 '무서
움을 느끼게 함'
4 a. 슬픈 노래를 듣고 '우울함을 느꼈음'
b. 어린 시절의 어떤 기억은 나를 '우울하게 함'

STEP 4

1,3 지각동사+목적어+v-ing: 능동, 진행

☺ 내신 적중 Point
p. 119

1 ③ 2 ②

1 ③ pleased → pleasing: 음악이 '즐거움을 느끼게 함'.
pleased는 사람이 즐거움을 느끼는 경우에 사용
2 (A) '흥미롭게 하는' 장치
(B) ~라고 이름 지어진: 수동
(C) = who were hanging

Overall Exercises 06
pp. 120~122

1 ④ 2 ③ 3 ③ 4 ② 5 ③ 6 ② 7 exciting →
excited 8 ② 9 ③ 10 ④ 11 ④ 12 ④ 13 ④
14 ② 15 sleeping 16 ⑤ 17 ④ 18 ③ 19 ④
20 staying

1 '흥미를 갖게 하는' 주제
2 '범죄 현장에서 채취된 지문': 수동의 의미
3 '소책자에 제공된 정보': 수동의 의미
4 침대 밑에 '숨어 있는' 동생: 능동, 진행의 의미
5 • 감정을 느끼는 주체에는 과거분사 사용
• hear +O +p.p.: the song은 불리는 대상이므로 수동
6 • 생선이 '요리되도록' 했다
• 그의 작품이 '놀라움을 주는' 것을 알게 될 것이다
7 동생이 '신이 난' 것이므로 과거분사를 씀
8 모두 현재분사이고 ②만 주어로 쓰인 동명사
9 모두 동명사이고 ③만 명사를 수식하는 현재분사
10 ④ → grown: 문맥상 '지역 농장에 의해 재배된 신선한 야
채'란 뜻으로 vegetables를 뒤에서 수식하는 과거분사
grown이 되어야 함
11 ④ → watching: 많은 사람들이 나를 '지켜보는' 것이므로
능동의 의미가 있는 현재분사를 써야 함
12 ④ → made: 벽은 '만들어지는' 것이므로 수동을 나타내는
과거분사가 되어야 함.
13 ① interested → interesting: 아시아 미술이 '흥미를 느끼
게' 함
② blocked → blocking: 도로를 '막고 있는' 큰 돌
③ to fix → fixed: 컴퓨터가 '수리되게' 함
⑤ writing → written: 십 대들을 위해 쓰인 책
14 ① risen → rising[rise]: 해가 '뜨(고 있는)' 것을 보아라
③ waited → waiting: 그는 내가 두 시간 동안 '기다리도록'
놔두었다
④ filling → filled: '병이 채워지게' 했다
⑤ exhausted→ exhausting: '지치게 하는' 하루
15 현재분사: 명사 수식
16 (A) 동명사+명사: ~하기 위한 … (목적)
(B) 과거분사: (주어가) 감정을 '느끼는'
(C) ~라고 '말하고' 있는: 능동, 진행
17 주어진 글과 ④의 밑줄 친 부분만 동명사이고 나머지는 현재
분사
18 ③ → made: 영화로 '만들어진' 소설, 수동
19 ④ → covered: 흰 구름으로 '덮인' 산꼭대기, 수동
20 '머무는' 손님: 능동

☺ Writing Exercises
p. 123

1 (1) the sound of raindrops falling (2) the bike
covered with dust (3) have your eyes examined
2 I saw Tim playing soccer with his friends.
3 riding a bike[bicycle] / wearing a hat

4 (1) the T-shirt displayed in that shop
 (2) the koala climbing the tree
 (3) the man singing a familiar song

1 (1) '떨어지는' 빗방울 소리: 능동, 진행
 (2) 먼지에 '덮인' 자전거: 수동, 완료
 (3) '눈이 검사되게' 하다: 수동

2 지각동사+목적어+v-ing[동사원형]: 여기서는 '분사'를 사용하라는 조건이 있으므로 playing만 가능
3 '자전거를 타고 있는' / 모자를 '쓰고 있는' 소녀: 능동, 진행
4 (1) '진열된' 티셔츠: 수동
 (2) 나무에 '오르고 있는' 코알라: 진행
 (3) 지각동사+목적어+v-ing

CHAPTER 07 문장의 형식 Unit 17-19

Unit 17 주어+동사/주어+동사+주격보어

1 동사 2 목적어 3 형용사

PRACTICE pp. 128~129

STEP 1 1 comes 2 beautifully 3 at the party
 4 lovely 5 sweet 6 safely
 7 happiness 8 open 9 cold 10 easily
 11 silently 12 fast
STEP 2 1 calm 2 bad 3 sleepy 4 gray
 5 happy
STEP 3 1 ④ 2 ②
STEP 4 1 He went mad 2 didn't taste good
 3 They kept silent 4 I felt dizzy 5 looks
 very pale

STEP 1

1 「S+V」문형에 쓸 수 있는 동사
2 「S+V」문형에서 동사를 수식하는 부사
3 「S+V」문형으로만 쓰이는 동사이므로 뒤에 목적어(the party)가 올 수 없음
4 아기의 상태 = lovely: 아기 자체가 '사랑'이라고 할 수는 없음
5 감각동사+형용사
6 동사 arrived를 수식하는 부사
7 인생에서 가장 중요한 것 = happiness
8 밤에도 열려 있을 것이다
9 turn+형용사: ~하게 변하다
10 동사 burn을 수식하는 부사
11 동사 looked를 수식하는 부사
12 fast는 형용사와 부사의 형태가 같은 단어이며 fastly라는 단어는 없음

STEP 2

1 stay calm: 침착함을 유지하다
2 go bad: 우유가 상하다

STEP 3

1 ④ arriving Seoul → arriving in Seoul: arrive(도착하다)는 목적어를 취할 수 없는 자동사
2 ② greatly → great: look+형용사

STEP 4

1~5 go mad, taste good, keep silent, feel dizzy, look pale은 「주어+동사+주격보어」 문형으로 자주 쓰이는 표현임

Unit 18 주어+동사+목적어/주어+동사+간접목적어+직접목적어

1 전치사 2 간접목적어 3 전치사

PRACTICE pp. 132~133

STEP 1 1 his mind(O) 2 to go outside(O) 3 him
 (IO) a good English grammar book(DO)
 4 his wife(O) 5 them(IO) that he would
 finish his homework on time(DO) 6 its
 owner's orders(O) 7 a message(O)
 8 her(O) 9 their new song(O) 10 the
 local children(IO) a new playground(DO)
 11 almost all of the author's novels(O)
 12 us(IO) that he might have a connection
 to the crime(DO)
STEP 2 1 resembles 2 survived 3 my teacher
 4 us
STEP 3 1 to 2 to 3 for 4 to 5 to 6 to 7 of
 8 for 9 to 10 to
STEP 4 1 a happy song 2 a tree house for his
 children 3 hand the book to me 4 find my
 lost wallet for me 5 May I ask a favor of

STEP 1

1, 2, 4, 6, 7, 8, 9, 11 동사 뒤에 명사가 나올 경우, 주어와 동일한 대상을 나타내면 보어이고, 동작을 당하는 대상을 나타내면 목적어.

16 정답 및 해설

3, 5, 10, 12 「주어+동사+간접목적어(IO)+직접목적어(DO)」 문형에서 '~에게'에 해당하는 부분이 간접목적어, '~을'에 해당하는 부분이 직접목적어. 간접목적어 자리에는 대개 사람이 옴

STEP 2
1 resemble(~와 닮다)은 타동사
2 survive(~에서 살아남다)는 타동사
3, 4 「주어+동사+간접목적어(IO)+직접목적어(DO)」 문형

STEP 3
1, 2, 4, 5, 6, 9, 10 write/hand/sell/give/send/tell/teach+목적어+to+(대)명사
3, 8 buy/make+목적어+for+(대)명사
7 ask+목적어+of+(대)명사

STEP 4
S+V+IO+DO = S+V+O+to/for/of+(대)명사
1, 3 sing/hand+목적어+to+(대)명사
2, 4 build/find+목적어+for+(대)명사
5 ask+목적어+of+(대)명사

Unit 19 주어+동사+목적어+목적격보어

1 동격 2 동사 3 to부정사

PRACTICE
pp. 136~138

STEP 1 1 clean 2 head of the sales department
3 The Great Explorer 4 useful
5 cry 6 boring 7 Little Einstein
8 brilliant / a genius 9 touch her
shoulder 10 cross the street 11 to buy
you a ticket for the concert 12 to study
overseas
STEP 2 1 ⑤ 2 ④ 3 ②
STEP 3 1 confident 2 interesting 3 stay 4 to
keep 5 pack / to pack 6 fix 7 to take
8 to be 9 talk / talking 10 to fasten
11 sweep
STEP 4 1 → do 2 ○ 3 → to fall 4 ○ 5 →
cross[crossing] 6 → to agree 7 ○
8 → play 9 → clean 10 → to make
STEP 5 1 named their daughter Sojin 2 elected
him leader of our meeting 3 will turn
the grass brown 4 Let me have another
chance. 5 he asked her to help him

STEP 1
1 책상을 깨끗하게
2 그녀 = 영업부 부서장
3 배의 이름이 The Great Explorer
4 도구가 유용하다는 것을

5 내가 울도록 (← I always cry when I peel onions.)
6 영화가 지루한
8 brilliant는 주격보어, a genius는 목적격보어
9 ← Someone touched her shoulder.
10 ← The dog crossed the street.
12 아들이 해외에서 공부하게 됨

STEP 2
1 ⑤ happily → happy: 부사는 보어로 쓰일 수 없음
2 ④ to tell → tell: let+O+원형부정사
3 ② feels → feel: make+O+원형부정사

STEP 3
1, 2 make/find+O+형용사
3, 6 사역동사(make/have)+O+원형부정사
4, 7, 8, 10 allow/get/want/ask+O+to부정사
5 help는 원형부정사, to부정사 둘 다 목적격보어로 취할 수 있음
9, 11 지각동사(hear/see)+O+원형부정사[v-ing]

STEP 4
1, 8, 9 사역동사(make/let/have)+O+원형부정사
2, 5 지각동사(watch/see)+O+원형부정사[v-ing]
3, 4, 6, 7, 10 cause/tell/get/ask/force+O+to부정사

STEP 5
1 name+O+C: ~을 …라고 이름 짓다
3 turn+O+형용사: ~을 …로 변하게 하다
4 let+O+원형부정사
5 ask+O+to부정사

☺ 내신 적중 Point
p. 139

1 ③ 2 ③ 3 She saw her dog barking[bark] at a
stranger.

1 • have+O+원형부정사
• 과거완료: had+p.p.
2 주어진 문장과 ③은 SVOC 문형, ①, ②는 SVO, ④는 SVOO, ⑤는 SVC 문형임
3 지각동사(see)+O+원형부정사[v-ing]

Overall Exercises 07
pp. 140~142

1 ② 2 ③ 3 ④ 4 ⑤ 5 ② 6 ④ 7 to me → me
8 ③ 9 ⑤ 10 ③ 11 ② 12 ⑤ 13 ③ 14 ①
15 ③ 16 ④ 17 You made me feel better. 18 ④
19 ③ 20 to

1 to부정사를 목적격보어로 취할 수 없는 동사는 make
2 ③ popularly → popular: 부사는 보어가 될 수 없음
3 ④ on → 삭제: 목적어 자리에는 명사 상당어구가 와야 함
4 사역·지각동사+O+원형부정사 / order+O+to부정사

5 • see+O+원형부정사[v-ing]

　　• have+O+원형부정사: ~가 …하게 하다

6 • help+O+to부정사[원형부정사]

　　• let+O+원형부정사

7 teach+IO+DO

8 모두 주격보어이고, ③은 목적어

9 모두 목적격보어이고, ⑤는 목적어

10 ③ make+O+for+(대)명사. 나머지 문장의 동사들은 모두 to를 필요로 함

11 주어진 문장과 ②는 SVC 문형

12 주어진 문장과 ⑤는 SVOO 문형

13 ① neatly → neat

　　② → to 삭제: enter(~으로 들어가다)는 타동사

　　④ going → go

　　⑤ to sing → sing[singing]

14 ② be → to be

　　③ → with 삭제: marry(~와 결혼하다)는 타동사

　　④ carefully → careful: 목적격보어

　　⑤ for → of

15 ③ rest → to rest: allow+O+to부정사

　　ⓐ 진주어 ⓑ make+O+원형부정사 ⓓ 목적어를 필요로 하지 않는 자동사 ⓔ 동사를 수식하는 부사

16 ④만 SVOC(~가 …하게 하다)이고, (A)와 나머지 문장들은 SVO 문형임

17 make+O+원형부정사

18 ④ softly → soft: 주격보어

19 ③ to join → join: have+O+원형부정사

20 lend/give/offer+O+to+(대)명사

✏️ Writing Exercises 　　　p. 143

1 (1) He survived the war. (2) He found his brother's advice very helpful. (3) help you (to) keep your hair shiny and smooth

2 (1) wrote a letter (2) gave a book to Sophie [gave Sophie a book] (3) cooked a pizza for Sophie[cooked Sophie a pizza]

3 made the[her] dogs sit down

4 (1) saw her walk[walking] (2) heard him cough[coughing] (3) help you (to) bake

1 (1) survive(~에서 살아남다)는 타동사

　　(2) SVOC문형

　　(3) help+O+to부정사[원형부정사] / keep+O+형용사 보어

2 (1), (2) write/give+O+to+(대)명사

　　(3) cook+O+for+(대)명사

3 make+O+원형부정사: ~가 …하게 하다

4 (1), (2) see/hear+O+원형부정사[v-ing]

　　(3) help+O+to부정사[원형부정사]

CHAPTER 08 품사

Unit 20 명사와 수일치

1 동사 **2** 단수형 **3** of

PRACTICE 　　　pp. 148~149

STEP 1　**1** furniture **2** paper **3** information **4** advice **5** students **6** knowledge **7** Happiness **8** bread **9** cheese

STEP 2　**1** milk **2** is **3** are **4** is **5** are **6** are **7** is **8** helps **9** is **10** are

STEP 3　**1** ④ **2** ⑤

STEP 4　**1** drink a glass of tomato juice **2** makes me think of my grandmother **3** there is a lot of information **4** Almost one-third of kids have **5** is not a long distance to walk

STEP 1

1, 2, 3, 4, 6, 7, 8, 9 셀 수 없는 명사: 부정관사(a/an)를 붙일 수 없고 복수 불가, 단수 취급함

5 셀 수 있는 명사: 복수형으로 쓸 수 있으며 수를 나타내는 말이 바로 앞에 올 수 있음.

STEP 2

1, 2 셀 수 없는 명사이므로 단수 취급

3, 6 There are+복수명사

4 「one of+복수명사」는 단수 취급

5 「a number of」는 복수 취급

7 과목: 하나로 보고 단수 취급

8 금액: 하나로 보고 단수 취급

9 《전쟁과 평화》라는 문학 작품

10 and로 연결된 명사는 복수 취급

STEP 3

1 ① informations → information

　　또는 pieces of information

② cakes → cake

③ is → are

⑤ have → has

2　① seem → seems

② looks → look

③ are → is: 「half of + 셀 수 없는 명사」는 단수 취급

④ is → are

STEP 4

1　셀 수 없는 명사의 수량 표현: a glass of juice

2　The black-and-white photo는 단수

3　there is + 셀 수 없는 명사: 단수 취급

4　one-third of + 복수 명사: 복수 취급

5　Six hundred meters는 거리를 나타내므로 단수 취급

Unit 21 부정대명사

1 -one　2 없는　3 one　4 단수

PRACTICE
pp. 153~154

STEP 1　1 some　2 any　3 some　4 some
5 any　6 any　7 one　8 ones　9 has
10 were　11 is　12 experiences　13 are
14 agree　15 is　16 needs　17 have

STEP 2　1 One, the other　2 the others　3 others
4 another　5 Each　6 The other　7 Both

STEP 3　1 something wrong with my cell phone
2 neither of us plays[play] well　3 Either
is fine with me.　4 Each person has
different strengths.

STEP 1

1, 3, 4　긍정문, 권유 의문문: some

2, 5, 6　부정문, 의문문: any(단, 긍정문의 any는 '어떤 ~라도,
모든 ~'이란 뜻)

7, 8　one: 동일한 종류의 불특정 사물 (it은 앞에 언급한 사물).
복수일 때는 ones

9　some of + 셀 수 없는 명사 → 단수 취급

10　some of + 복수명사 → 복수 취급

11　each of + 복수명사 → 단수 취급

12　-one은 단수 취급

13, 17　many는 복수 취급

14　all + 복수명사 → 복수 취급

15　-thing은 단수 취급

16　each + 단수명사 → 단수 취급

STEP 2

1　2개 중 하나는 one, 나머지는 the other

2　5명 중 2명을 제외한 나머지 전부는 the others

3　막연한 다수 중 몇몇은 some, 다른 몇몇은 others

4　또 다른 하나의

6　3개 중 하나는 one, 또 다른 하나는 another, 나머지 하나
는 the other

7　둘 다

STEP 3

1　-thing/-body/-one은 단수 취급하며 형용사가 뒤에서 수식

2　neither: 둘 중 어느 것도 아닌

3　either: 둘 중 어느 하나

4　each: 단수 취급

⊙ 내신 적중 Point
p. 155

1 ②　2 The king offered his officials something
special.

1　(A) many는 복수 취급
(B) 막연한 다수 중 몇몇은 some, 다른 몇몇은 others
(C) 2개 중 하나는 one, 나머지는 the other

2　-thing, -body, -one을 수식하는 형용사는 뒤에 옴

Unit 22 전치사

1 목적격　2 전치사

PRACTICE
pp. 158~159

STEP 1　1 in　2 of　3 to　4 at　5 at, on　6 on /
in　7 on, in　8 on　9 to, at　10 at
11 of

STEP 2　1 In / in　2 at　3 on

STEP 3　1 sharing　2 difficulty　3 colors
4 helping　5 for　6 by　7 against
8 from　9 with　10 to

STEP 4　ⓑ, ⓔ, ⓕ

STEP 1

1　in + 연도: 1995년에

2　because of: ~ 때문에

3　thanks to: ~ 덕분에

4　at + 좁은 장소

5　at + 특정한 시간 / on + 특정한 요일의 아침

6　on: ~ 위에 / in: ~ 안에

7　on + 요일 / in + 아침

8　on + 수단

9　according to: ~에 따르면 / at + 속도

10　at the end of the month: 월말에 (시점)

11　instead of: ~ 대신에

STEP 2

1　• 70대에(기간)　• 영어로(도구)

2　• 이 기간에　• at + 좁은 장소

3　• on + 특정한 날　• 비행기에서(탈 것)

STEP 3

1,2,3,4 전치사의 목적어자리에는 명사상당어구(명사, 대명사, 동명사, 명사절)가 와야 하며, 형용사, to부정사, 동사 등은 올 수 없음

5 for+기간의 길이

6 by tomorrow: 내일까지

7 for: ~에 찬성하여, against: ~에 반대하여

8 ~로부터(장소)

9 ~와 함께

10 ~로(목적지)

STEP 4

ⓐ according to: ~에 따라서 ⓑ by+행위자 ⓒ ~로부터(from)
ⓓ ~을 가지고(with) ⓔ 수단 ⓕ ~까지(시간)

Overall Exercises 08　pp. 160~162

1 ②	2 ①	3 ④	4 ⑤	5 ②	6 ②	7 ③	8 ⑤
9 ②	10 ④	11 ③	12 ⑤	13 ④	14 ①	15 ③	
16 ③	17 ③	18 ⑤	19 in	20 on			

1 두 조각의 빵: 셀 수 없는 명사의 수량 표현

2 each of+복수명사: 단수 취급.
all/many of+복수명사: 복수 취급.
half/one third는 of 뒤의 명사에 수일치

3 all of the+복수명사: 복수 취급

4 ⑤ 동사구는 전치사의 목적어가 될 수 없음

5 ② 막연한 다수의 몇몇 some
부정문 any (누구와도 가깝지 않다)

6 ② 세 개가 있는 경우: one, another, the other (하나는, 또 다른 하나는, 나머지 하나는)

7 ③ 하나는 ~, 나머지들은 …

8 ⑤ both는 항상 복수 취급하므로 are가 들어감. 나머지는 모두 is

9 나머지는 모두 by이고, ②는 with(~와 함께) 필요

10 ④ 이때 it은 his wallet을 가리킴

11 (A) 주어가 the dog이므로 3인칭 단수
(B) for+기간의 길이
(C) two months가 하나의 개념(시간)이므로 단수 취급

12 (A) 열차에서: on+탈것
(B) 2시간 후에: in+기간
(C) 8시까지: by+시간

13 ① Neither → Either: neither는 부정어와 함께 쓰지 않음
또는 Neither of us has[have] much free time.
② were → was
③ help → helps
⑤ are → is

14 ② does → do
③ wrong something → something wrong
④ is → are
⑤ others → the others: 나머지 세 마리는 정해진 것이므로 the 붙여야 함

15 ⓒ → it: 앞의 classical music을 가리키는 대명사
ⓐ many kinds가 복수 ⓑ 주어 Some people이 복수
ⓓ make+O+원형부정사 ⓔ 앞의 popular music을 가리키는 대명사

16 some ~, others …: 몇몇은 ~, 다른 몇몇은 …

17 ③ → needs: each of+복수명사 → 단수동사

18 ⑤ → has: 셀 수 없는 명사는 단수 취급

19 • in+월
• in the blue dress: 푸른 드레스를 입은
• in French: 프랑스어로(도구)

20 • on the plane: 비행기에서(탈것)
• on the wall: 벽에(부착)
• on time: 제시간에, 정시에

Writing Exercises　p. 163

1 (1) is nothing impossible for us (2) One is black and the other is white. (3) All of the boys on the soccer team wear

2 Didn't you hear anything strange last night?

3 (1) All the girls are taking a picture. (2) All the food on the table looks delicious.

4 with / on, at /at

1 (1) -thing+형용사
(2) one ~, the other …: (두 개 있을 때) 하나는 ~, 나머지 하나는 …
(3) all of+복수명사 → 복수 취급

2 -thing+형용사

3 (1) all+복수명사: 복수 취급
(2) all+셀 수 없는 명사: 단수 취급

4 with: ~와 함께 / on+요일, at+좁은 장소 / at+특정한 시각

◆ Grammar is Understanding ◆

GRAMMAR Q

Advanced ❶

CHAPTER 01
동사의 시제

Unit 01
pp. 2~3
현재·과거·미래시제와 진행형

A　1 → see　2 ○　3 ○　4 ○　5 → held　6 → has
7 → laughs　8 → takes
B　1 is waiting　2 was crossing　3 likes　4 am looking
5 is taking　6 was having
C　1 is learning　2 wakes up　3 was lying　4 made
5 will be　6 made
D　1 ③　2 ②

Unit 02
pp. 4~5
현재완료

A　1 ③　2 ①　3 ④　4 ④
B　1 has lost　2 haven't finished　3 have been waiting
4 broke　5 haven't attended　6 stole
C　1 ③　2 ③

Unit 03
pp. 6~7
과거완료

A　1 had lost　2 had already finished　3 had never
eaten　4 had not seen　5 had not sold
B　1 I thought (that) I had met her before　2 Bill had
already gone to bed　3 We had never heard about
the restaurant　4 his mother had bought him last
week
C　1 ④　2 ③
D　1 I had seen her picture before　2 I had finished
washing his car

CHAPTER 02
수동태

Unit 04
pp. 8~9
수동태의 의미와 형태

A　1 was destroyed by the war　2 can be changed by
entering a new password　3 should be made by the
patient　4 The rise in the Earth's water temperature
is caused by global warming.　5 A picture of me
was taken by the professional photographer　6 the
song was being played by the band　7 Breakfast is
not served on Sundays (by them).　8 Oil prices have
been increased by oil companies　9 All the students
will be invited to the party by him.　10 Thousands of
cattle are raised (by them)

B　1 was found　2 belongs　3 resembles　4 seemed
5 should be finished　6 is being built
C　1 ③　2 ⑤　3 ②

Unit 05
pp. 10~11
주의해야 할 수동태

A　1 was taken care of by my grandmother　2 was run
over by a red car　3 should be put off until next week
(by them)　4 were taken away (by someone)　5 were
not paid any attention to by the audience　6 was
carried out by him and his colleagues　7 was picked
up by Bill　8 was made for her friends by her　9 will
be brought to you by the delivery service
B　1 were given the lecture by the author of the
best-selling book / was given to us by the author of
the best-selling book　2 will be asked unexpected
questions by the interviewer / will be asked of you by
the interviewer　3 They were lent two spare rooms
/ Two spare rooms were lent to them　4 was[were]
offered a computer course by the local organization /
was offered to the public by the local organization
C　1 should be turned off at dinner time　2 was given to
the police by a little boy　3 is called "the Father of
English poetry"　4 was named Carol by her grandfather

Unit 06
pp. 12~13
다양한 수동태 표현들

A　1 I am interested in learning　2 is always covered
with[by] snow　3 is not satisfied with his exam results
4 Water is composed of　5 was not surprised at[by]
the news　6 is filled with cold water　7 were pleased
with[at] his success　8 is known to all the people
9 is made of
B　1 ③　2 ⑤
C　②

CHAPTER 03
조동사

Unit 07
pp. 14~15
can, may, will

A　1 ②, ③　2 ①, ③　3 ①, ②　4 ②　5 ③　6 ②
B　1 ⑤　2 ④　3 ②

Unit 08
pp. 16~17
must, should

A　1 must not　2 don't have to　3 must not　4 must

5 must 6 should confirm 7 should have worn
8 must have bought 9 shouldn't tell 10 must turn
11 doesn't have to
B 1 ④ 2 ④
C 1 must have dreamed[dreamt] 2 should have treated it carefully 3 had to change schools several times 4 must be her bag

Unit 09
pp. 18~19

used to, ought to, had better, need

A 1 ① 2 ② 3 ③ 4 ① 5 ① 6 ② 7 ③
B 1 ④ 2 ⑤
C 1 used to wear glasses 2 is used to eating two meals 3 had better buy some 4 am not used to making friends with new people

CHAPTER 04
부정사

Unit 10
pp. 20~21

to부정사의 형태와 명사적 역할

A 1 → for Karen 2 → it 3 → how to 4 → of you
5 → It 6 → to make 7 → come 8 → for them
9 → it
B 1 ① 2 ① 3 ②
C 1 ④ 2 ④
D 1 asked my brother to sing a song 2 how to play tennis 3 fun to do bungee jumping 4 you not to drink and drive

Unit 11
pp. 22~23

to부정사의 형용사적·부사적 역할

A 1 © 2 @ 3 © 4 ⓑ 5 © 6 @ 7 ⓑ 8 © 9 ⓑ
B 1 @ 2 © 3 @ 4 © 5 @ 6 ⓑ 7 @ 8 ⓑ 9 @
10 ⓔ
C 1 ④ 2 ②
D 1 to make matters worse 2 To tell the truth 3 smart of him to solve

Unit 12
pp. 24~25

많이 쓰이는 to부정사 구문

A 1 too, to 2 he knows 3 too, to swim 4 so, that we can go 5 in order to 6 It seems that 7 so crowded that 8 so, that I could 9 heavy, can't lift
10 for me to get
B ⑤

C 1 not to be arrested / (so as) not to be arrested
2 difficult for her to answer / difficult that she couldn't answer it 3 seems that you annoy Ann / seem to annoy Ann 4 well, to leave / well that she could leave

CHAPTER 05
동명사

Unit 13
pp. 26~27

동명사의 쓰임

A 1 taking 2 Telling 3 is 4 Using[To use]
5 speaking 6 his[him] 7 looking 8 hearing
9 Riding[To ride] 10 having been
B 1 seeing 2 having won 3 being impressed
4 (from) starting 5 to have
C 1 look forward to participating 2 cannot[can't] help thinking 3 spent a lot of time decorating 4 busy preparing 5 On receiving 6 are worth visiting
7 feel like joining 8 (1) prevent the river (from) overflowing (2) keep the river from overflowing

Unit 14
pp. 28~29

동명사와 to부정사

A 1 waiting 2 having / to have 3 to go 4 farming
5 leaving / to leave 6 to see 7 using 8 having
9 going 10 going 11 discussing / to discuss
12 leaving
B ④
C 1 ① 2 ② 3 ② 4 ① 5 ② 6 ①

CHAPTER 06
분사

Unit 15
pp. 30~31

분사의 종류와 명사 수식 역할

A 1 wearing 2 locked 3 sleeping 4 frozen
5 stolen 6 flowing 7 taking 8 found 9 called
10 burning
B 1 made by his father 2 dancing on the stage
3 standing under the tree 4 cooked by my grandmother 5 watching her
C 1 ② 2 ②
D 1 found my lost necklace 2 Smartphones made in Korea 3 my pictures taken in Europe

Workbook **23**

Unit 16
pp.32~33

분사의 보어 역할, 감정을 나타내는 분사

A 1 exciting 2 depressed 3 embarrassed
4 exhausted 5 interesting / surprising 6 playing
7 dyed

B 1 locked 2 pass / passing 3 treated 4 updated
5 designed 6 cracking

C 1 ④ 2 ⑤

D 1 I'm pleased to meet you again.
2 Going to new places is always exciting.
3 They saw huge whales swimming in the ocean.
4 How often do you get your hair cut?
5 He is never satisfied with his career.

CHAPTER 07
문장의 형식

Unit 17
pp.34~35

주어+동사/주어+동사+주격보어

A 1 ③ 2 ④ 3 ③ 4 ⑤

B 1 → windy 2 ○ 3 → busy 4 → full 5 → calm
6 ○ 7 → friendly 8 → brave 9 ○ 10 → delicious

C 1 ② 2 ④

Unit 18
pp.36~37

주어+동사+목적어/
주어+동사+간접목적어+직접목적어

A 1 a comfortable life(O) 2 to hurt your feelings(O)
3 opening the window(O) 4 the money(O) 5 my
dog(O) 6 the waiter(IO) a tip(DO) 7 you(IO) how to
use this copy machine(DO)

B 1 → with 삭제 2 ○ 3 → at 삭제 4 ○ 5 → to her
brother 6 → to 삭제 7 ○ 8 → about 삭제 9 → to
삭제 10 ○

C 1 ④ 2 ①

D 1 her friends postcards 2 scary ghost stories to
us 3 fried rice for my parents 4 a warm welcome
to their guests 5 me this necklace 6 pictures of
herself as a child to me

Unit 19
pp.38~39

주어+동사+목적어+목적격보어

A 1 them(IO) energy(DO) 2 all of my friends(O)
honest(C) 3 her(IO) some cookies(DO)
4 the window(O) open(C) 5 his dog(O) Lucy(C)
6 him(IO) the truth(DO)

B 1 to make 2 to enter 3 grow 4 to fail
5 to happen 6 drop 7 to shop 8 relax / to relax
9 to wait 10 play / playing

C 1 ② 2 ④

D 1 Teenagers consider friendship very important.
2 My brother named his toy car Bumblebee.
3 Ted helped his mother (to) wash the dishes.
4 I saw my friends playing[play] soccer.

CHAPTER 08
품사

Unit 20
pp.40~41

명사와 수일치

A 1 water 2 was 3 decisions 4 homework
5 furniture 6 two pieces of bread 7 have 8 get
9 make 10 is 11 have 12 is

B 1 ③ 2 ④ 3 ⑤

C 1 I had two pieces[slices] of cake and a glass of milk
for lunch.
2 All of the teenagers like that TV show.
3 is not enough time to finish the report
4 The number of stars in the universe is countless.
5 Half of my friends were present

Unit 21
pp.42~43

부정대명사

A 1 some 2 any 3 one 4 it 5 ones 6 neither
7 room 8 is 9 child 10 Either 11 anything
wrong 12 were 13 has 14 bring 15 something
smaller

B 1 ⑤ 2 ④

C 1 It is nothing special 2 do something valuable for
many people 3 haven't tried either of these dishes /
have tried neither of these dishes 4 Each of the
students has to give 5 Neither of us has[have]
enough experience / Either of us doesn't[don't] have
enough experience

Unit 22
pp.44~45

전치사

A 1 inviting 2 making 3 According to 4 because of
5 In spite of 6 for 7 from 8 to 9 in 10 on

B ⓐ, ⓑ, ⓓ

C 1 on 2 at 3 in

D 1 I'm very sorry for the inconvenience.
2 The books on this table are discounted by 30%.
3 have always been very kind to me
4 My house is not far from here.